From the Great Exhibition of 1851

Pub. by D. Bogue 86 Fleet
Street London

The Origins of Comics

The Origins of Comics

From William Hogarth to Winsor McCay

Thierry Smolderen

Translated by Bart Beaty and Nick Nguyen

UNIVERSITY PRESS OF MISSISSIPPI

JACKSON

Furthermore:
a program of the J. M. Kaplan Fund

Publication of this book was made possible, in part, by a grant
from Furthermore: a program of the J. M. Kaplan Fund.

Cet ouvrage a bénéficié du soutien des Programmes d'aide à la
publication de l'Institut français.
This work, published as part of a program of aid for publication,
received support from the Institut Français.

www.upress.state.ms.us

The University Press of Mississippi is a member of the Association
of American University Presses.

This English edition of *The Origins of Comics: From William
Hogarth to Winsor McCay* is published by arrangement with Les
Impressions Nouvelles.

First printing 2014
∞
Library of Congress Cataloging-in-Publication Data

Smolderen, Thierry.
[Naissances de la bande dessinée. English]
The origins of comics : from William Hogarth to Winsor McCay /
Thierry Smolderen ; translated by Bart Beaty and Nick Nguyen.
pages cm
Includes index.
ISBN 978-1-61703-149-6 (hardback) — ISBN 978-1-61703-909-6
(ebook) 1. Comic books, strips, etc.—History and criticism. I. Title.
PN6710.S613 2014
741.5'9—dc23
2013024100

British Library Cataloging-in-Publication Data available

Contents

Bibliography

Index

The Origins of Comics

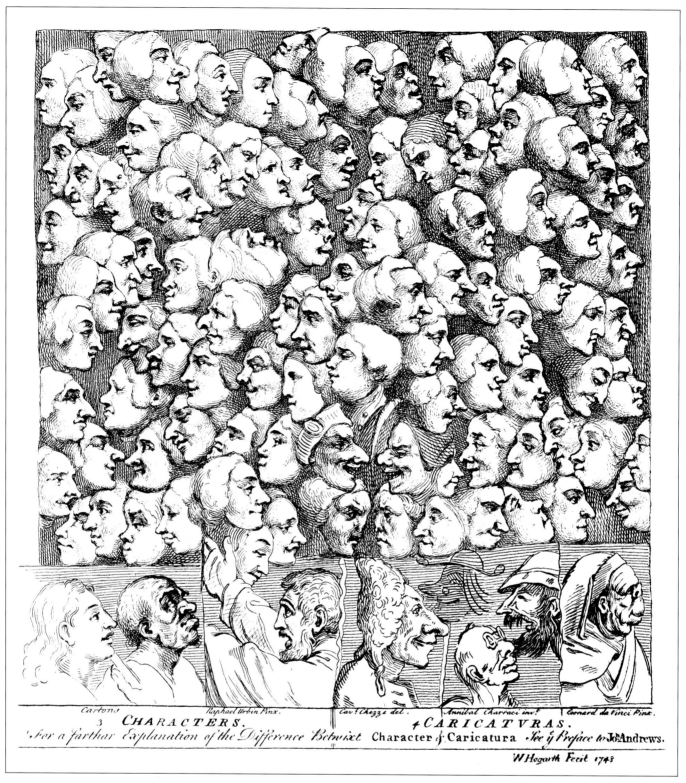

Figure 1.1 **William Hogarth, *Characters Caricaturas*, 1743. Etching.**

This subscription voucher for Hogarth's third novel in prints (*Marriage-a-la-Mode*) was part of a joint operation with Henry Fielding's preface to his own *Joseph Andrews*. For both the artist and the novelist, it was a matter of clearly marking the difference between the monstrous burlesque of the caricature and the comic register of the character study—and simultaneously underlining the convergence between Hogarth's stories without words and the emerging form of the novel.

"He who should call the ingenious Hogarth a burlesque painter, would, in my opinion, do him very little honour: for sure it is much easier, much less the subject of admiration, to paint a man with a nose, or any other feature of a preposterous size, or to expose him in some absurd or monstrous attitude, than to express the affections of men on canvas. It has been thought a vast commendation of a painter, to say his figures seem to breathe; but surely, it is a much greater and nobler applause, that they appear to think" (Fielding 1981).

1

William Hogarth: Readable Images

The First Form of the Novel in Prints

Since the end of the twentieth century, French comics artists have exhibited a growing interest in literature and now enjoy speaking about drawing as if it were a form of writing, an *écriture*. Without realizing it, they have reactivated a very

old tradition that can be definitively located in the work of the eighteenth-century English painter and engraver William Hogarth. This conception of drawing dates to a time when the image, and in particular the engraved image, lent itself to forms of reading and writing whose richness and sophistication we no longer recognize. In reality, each time a contemporary illustrator relies upon solutions transmitted from this distant past (the clear line, the modeled line, the combination of heterogeneous graphic styles, the schematic representation of instantaneous movement, the use of postures or physiognomic expressions, caricature, speech balloons, etc.), he or she is connected to Hogarth's lineage, and, through this lineage, to the deep history of the culture of the printed image. By combining, in an ironic way, an older tradition of edifying picture narratives with the humorous literature that emerged in England during his time, Hogarth is the artist who brought the art of the print into modernity.

The publication, in 1732, of a narrative series composed of six engravings (based on his own original tableaux) helped to establish Hogarth's reputation across England and Europe. Despite its brevity, *A Harlot's Progress* (1732) must be regarded as a genuine novel in pictures. Four years later, *A Rake's Progress* (1735) appeared, composed of eight engravings. This was followed by *Marriage-a-la-Mode* (1745), a drama in six engravings, and then *Industry and Idleness* (1747), which was made up of twelve engravings. The last series in the genre, published by Hogarth in 1750, was developed over four engravings: *Four Stages of Cruelty*.

At the time, only a few polemicists were interested in the territory being explored by Hogarth and foresaw the importance of its artistic dimension. These readable images situated themselves between the *news* and the *novel*—that is, between journalism and the new literary form that had begun in England and revolutionized novelistic writing in Europe (Paulson 1996). By returning to Hogarth's work, we can observe the defining moment when the prehistory of comics intersected with that of literature and the modern press.

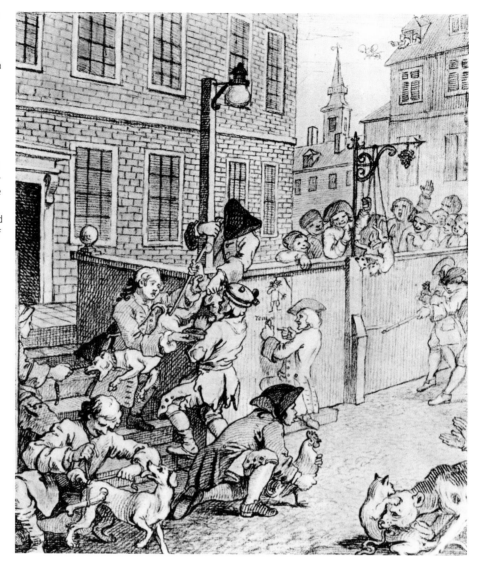

Figure 1.2 **William Hogarth, *Four Stages of Cruelty*, 1751. Sketch for plate 1.**

Hogarth is solely preoccupied by the idea that he wants to transmit to the reader: his lines eliminate all parasitic details, he stylizes and schematizes. From this point of view, this preparatory sketch is not that different from the majority of roughs drawn by modern cartoonists. From Hogarth and the nineteenth-century trend of humoristic illustration that he inspired, modern comics have inherited the schematism of the culture of engravings and many graphic solutions from the field of graphic satire and illustration, some of which date back to the Renaissance.

The son of a humble Latin professor who had departed the provinces by the end of the 1680s, Hogarth was shaped by the ideas of John Locke and Joseph Addison, who regarded Man as an autonomous subject whose self-identity was constructed on the basis on his own experiences. It is worth noting that Hogarth spent part of his childhood with his parents and two sisters inside an enclosure of Fleet Prison reserved for the indebted, and that this enclosure was called "the Rules of the Fleet." From a very early age he was able to observe the "Rules" that originated from on high—those of Latin grammar that were taught (unsuccessfully) by his father, those of a society that had no pity for the weak and that had thrown his family into prison.

It is not surprising that imprisonment became a central motif in Hogarth's work: every one of his narrative series ends in an asylum or a jail, or with an execution. Hogarth's principal theme was that of freedom compromised by prescriptively rigid religious, social, and artistic models. None of his characters escaped the suffocating geometry of the "prison of the Rules." That said, his satires never enclosed their readers within this jail. On the contrary, the language that he used was one of liberation. Hogarth invites us to decode his images in a relaxed and whimsical fashion, to lose ourselves as he himself did as a child, in the alleys of the Bartholomew Fair.

Every summer, the Bartholomew Fair was held over several weeks in the Smithfield neighborhood where Hogarth was raised. There was an incredible variety of sights. One could hear famous West End actors spouting comical verses next to silent pantomime numbers, and see tightrope walkers treading twenty-five feet above pens where pigs' throats were slit. Within this scattered labyrinth, each visitor inevitably con-

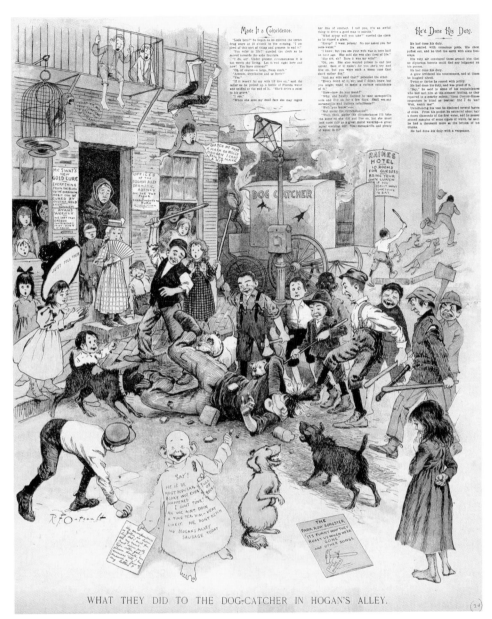

WHAT THEY DID TO THE DOG-CATCHER IN HOGAN'S ALLEY.

Figure 1.3 **Richard F. Outcault,** *Hogan's Alley*, **September 20, 1896.**

Buzzing with incidents, Outcault's full-page illustrations are part of Hogarth's satiric (and baroque) legacy. They invite readers to scan the image at their leisure and to discover the declension of the same theme in multiple variations. The first image of *Four Stages of Cruelty* (see fig. 1.2) was certainly one of the major references for Outcault's series. However, in this example, Outcault inverses the theme of its model: instead of martyring the animals, the alley kids avenge the animals by attacking the dog-catcher.

structed a singular experience, and each left with a different story.

Prints depicting fairs and bazaars had been popular since the time of Brueghel and Jacques Callot; they strove to reproduce "in miniature" the euphoria of a leisurely stroll at a fair, where one's gaze can joyfully move from one subject to another in the disorderly chaos. Hogarth based a new mode of reading on this principle. All of his engravings invite a variable, zigzagging circulation of the reader's gaze. Occasionally they directly refer to the space of the fairground, as in the *Southwark Fair* (an engraving from 1733).

In the nineteenth century, Hogarth's images inspired a number of cartoonists. The chaotic pages of the *Yellow Kid*, for example, which were rife with isolated incidents, deliberately evoked

this tradition. Subsequently, the swarming effect created by such images established itself as one of the great graphic constants of the comics aesthetic, which, in many ways, continued to convey the baroque values of variety and intricacy that were so dear to Hogarth. The first glance at a page teeming with tiny characters effectively constitutes the prologue for the reading of any comic. American artists at the turn of the twentieth century—Winsor McCay chief among them—were quick to use this analogy with the swarming spaces of carnivals, fairs, and amusement parks to invite readers to immerse themselves in their comics. Thus, the progression dictated by the panels becomes a sort of reassuring "guided tour" in a labyrinthine space that resonates with virtual trajectories.

WILLIAM HOGARTH: READABLE IMAGES

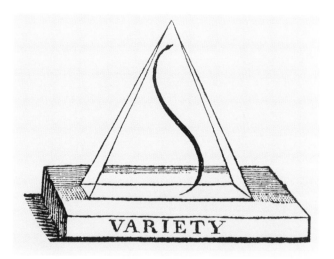

Figure 1.4 **William Hogarth, frontispiece, *The Analysis of Beauty*, 1753. Engraving.**

Diagram of the serpentine line, the symbol of variety.

Figure 1.5 **Léon Roger-Milès, *Architecture, Décor, and Furnishing of the Eighteenth Century*, n.d.**

The "capricious curves" of the rococo style. Clearly related to the rococo spirit, Hogarth gave this style a precise philosophical framework that drew on John Locke's empiricism.

In his book *The Analysis of Beauty*, Hogarth returned to the very particular syntax of intricacy, which, at multiple levels, underlies his art of the readable images. He devoted an entire chapter to explaining how the eye, moving simply by its natural curiosity, can find beauty and pleasure in objects that oblige it to constantly vary its path:

> *Pursuing is the business of our lives; and even abstracted from any other view, gives pleasure.*
> *... The eye hath this sort of enjoyment in winding walks, and serpentine rivers, and all sorts of objects, whose forms, as we shall see hereafter, are composed principally of what, I call, the waving and serpentine lines.*
> *Intricacy in form, therefore, I shall define to be that peculiarity in the lines, which compose it, that leads the eye a wanton kind of chace. (Hogarth 1997, 32–35)*

For Hogarth, there was no doubt: the engine of life was curiosity, its field of exploration the variety of the world, and the search for meaning an empirical process—*a wanton kind of chance.* The frontispiece of the book emphasizes the central character of this declaration of faith. A serpentine line encapsulates the very essence of living processes caught in their capricious path. The principle property of his line is that of life itself, with its capacity for endless variation. In this, it is categorically opposed to the coercive geometry of institutionalized and disembodied systems that Hogarth represents in order to demystify them.

By inviting the reader to a "winding walk" from one detail, one clue, to another, Hogarth's novels in prints offer the opposite of the edifying stories that the author ironically evokes. These tirelessly repeated the same eternal truths, while Hogarth in reality was offering a different story—sometimes even a different moral—with each reading. His reader was invited to escape, as should every free-thinking person, from the confining walls of the Prison of Rules.

Displayed in clubs and coffeehouses, Hogarth's five novels in prints generated conversations and passionate debates. This was the author's intended goal, and he had already heard such discussions play out in his studio, where he liked to present his works in progress to visitors.

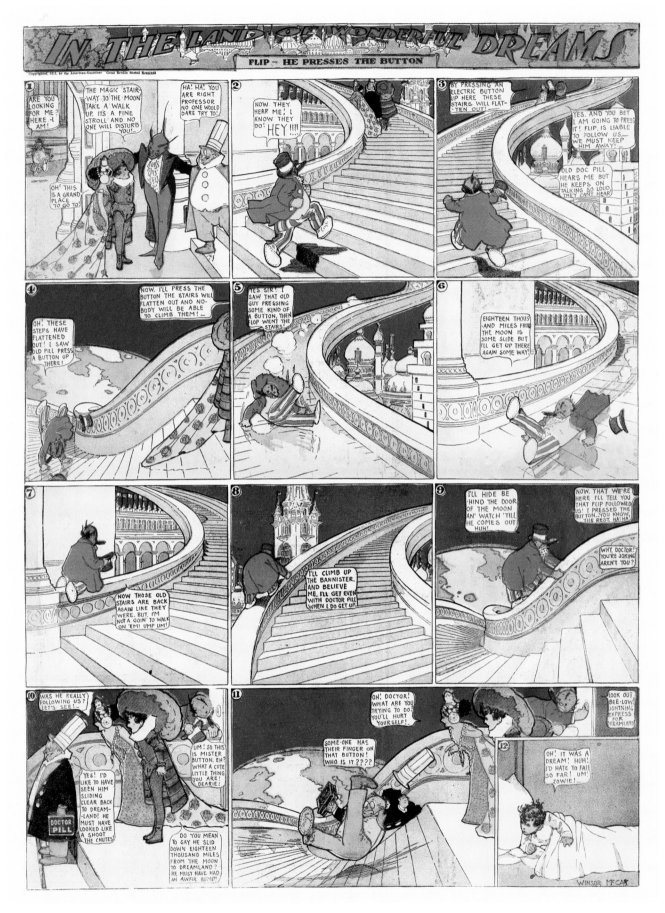

Figure 1.6 **Winsor McCay, *Little Nemo*, November 26, 1911.**

The line of beauty reinterpreted by Winsor McCay: flamboyant baroque in the age of cinematography and theme park attractions.

WILLIAM HOGARTH: READABLE IMAGES

Figure 1.7　**William Hogarth, *Breakfast at Stoke*, illustrations for *Five Days' Peregrination*, 1732.**

These three sketches (figs. 1.7 and 1.8), which Hogarth drew during a short stay on the banks of the Thames with some of his friends, bear witness to the diagrammatic mode of expression that came by default to an artist trained in the culture of the engraved print. This pictorial report is as much a theoretical view (Hogarth represents himself "drawing this drawing") as a truly observational sketch. The use of reference letters and captions to give the names and activities of the protagonists, and the choice of the attitudes and gestures that are most relevant to the ideas the artist wishes to convey, are typical of this schematic mode of writing.

Today, it would be hard to imagine how an artist could hope to stimulate a reader's interest by presenting a work comprising several large images, without dialogue or explanation, and replete with incidents, allusions, and secondary plots. This is what stops us from seeing the sequence of images (presented in the following pages) as a legitimate example of comics, although the essential elements are all there: indeed, the images form a temporal and causal sequence that narrates, in clearly articulated stages, the fate of an individualized fictive character. If we stick with the most generic definitions, there is no doubt that Hogarth's series belongs to the category of sequential art. Yet in terms of the effort that is required to link the images there is something that doesn't quite ring true. Instead of the fluid, quasi-automatic reading of a typical comic strip, we have, on the contrary, a slow read, one that invites the eye to lose itself in the details and to return to them in order to generate comparisons, inferences, and

endless paraphrases. Hogarth's series demand genuine interpretive effort, even detective work, on the part of a reader. They are intended to be read, but they depend on a conception of readability that has little in common with today's comics.

This conception belongs to a visual culture that we know only from a distance. It is a tradition that attaches almost no intrinsic value to what constitutes for us the most natural mode of narrative representation—the objective, documentary reproduction of a visible reality.

Here, we touch upon a crucial point that concerns the prephotographic tradition of illustration from which the culture of comics ultimately originates: in a culture where images are copied onto copper plates or wood with each new printing, and thus are frequently degraded (Ivins 1996, 60–63), it is the form of the schematized illustration—the language of the diagram—that represents the ideal graphic compromise. It allows for the quick sketching of an

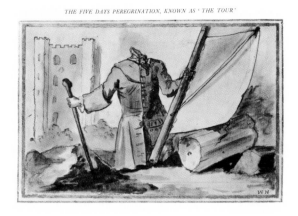

Figure 1.8 William Hogarth, *Mr. Somebody* and *Mr. Nobody*, illustrations for *Five Days' Peregrination*, 1732.

Drawn during the same trip (see fig. 1.7), these two sketches provide a good example of the use of emblems and the way they were deciphered at the time. Similar to allegories and rebuses, this very particular form of diagrammatic writing was the favorite weapon of the (graphic or literary) satirists of Protestant culture.

In the first figure, the headless Mr. Somebody clings to a mast ("follows the dominant wind," that is to say, the fashion of the times), next to an overturned column and a ruined tower. We can deduce from these vestiges that Mr. Somebody is the sort of antique lover against whom Hogarth often spoke out, one who thinks himself to be "someone" even though he does nothing but follow fashion and continental and classical taste.

The second emblem is a kind of encoded self-portrait that can only be understood if compared to the first: Mr. Nobody's large smile and the props that are attached to him (spoon, glass, pipe, knife, etc.) make him an unpretentious bon vivant, capable of counting on his own strength (the oars) to think with his own head and walk on his own feet.

event, an object, a mechanism, a phenomenon, or even a concept, of which the illustrator manages to convey only the most significant aspects by eliminating any unnecessary details.

The purpose of the diagram is not to transmit visual information (in the realistic, photographic sense of the term) so much as to stabilize visual signification (most often in relation to the accompanying text). Given the limits imposed by the techniques of the era, a schematized representation offers the best support for the idea conveyed by the image—that is to say, the idea that the image seeks to elicit in the reader.

Under their well-varnished appearance, Hogarth's prints addressed a culture already saturated with a seemingly infinite variety of graphic systems of representation; his satire pushed the humoristic tradition toward the domain that I propose to call *polygraphic* humor. "Cherchez le diagramme" was truly the name of the game. To decipher Hogarth's images, the reader had to navigate a multilayered visual text saturated with allusions to conflicting systems of representation (ranging from the highly rhetorical language of history painting to the rebellious insolence of graffiti drawings). It was a game of stylistic collisions, ironic contrasts, and hybridization, and it gave Hogarth a powerful visual tool for making sense of the modern metropolitan world. The usefulness of this tool could only grow in the later age of the illustrated press.

One can readily apply the polygraphic concept to the twentieth- and twenty-first-century comic strip. It pervades the whole field and is absolutely central to the works of the most influential and respected artists, from Richard Felton Outcault, Winsor McCay, George Herriman, and Hergé to Harvey Kurtzman, Robert Crumb, Art Spiegelman, Bill Watterson, Chris Ware, Marjane Satrapi, David B., David Mazzucchelli, and others. Indeed, the polygraphic approach, as an expressive tool, appears to play an even more prominent role in the contemporary form of the graphic novel than it does in the popular comic strip. This is because the concept connects powerfully with the linguistically hybrid form of the novel, which Mikhail Bakhtin explored in many of his books and essays (1982). This parallel illuminates the deep relationship between the eighteenth- and nineteenth-century humoristic illustrators, today's graphic novelists, and the literary tradition that began in Hogarth's time with the novels of Joseph Fielding, Tobias Smollett, and Laurence Sterne, and developed, in the nineteenth century, with those of Charles Dickens and William Makepeace Thackeray.

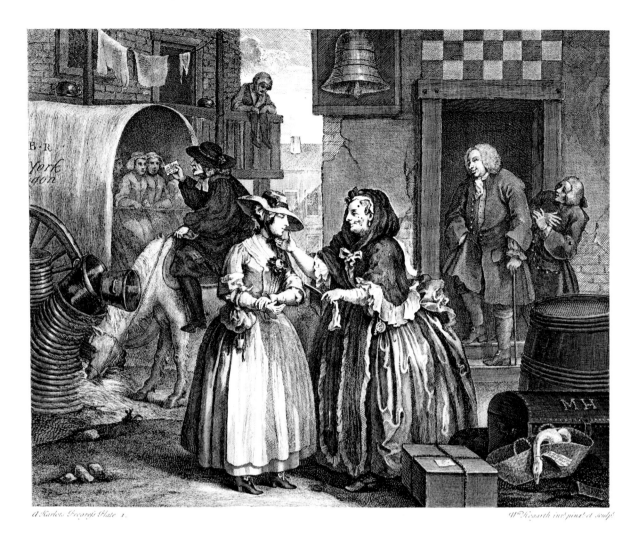

d Harlot Progress Plate 1. *W. Hogarth inv.t pinx.t et sculp.t*

Figure 1.9 **William Hogarth, *A Harlot's Progress*, 1732, plate 1. Etching and engraving.**

This first plate of *A Harlot's Progress* shows the arrival of Molly Hackabout in London. Fresh from her province, the young girl immediately falls into the clutches of a famous madam of the era, while a religious man (to her left) is totally disinterested in her fate. This "contemporary" scene, inspired by the scandals that were widely reported in the newspapers of the time, is neither documentary nor realistic. Hogarth is alluding to the popular edifying cycles of the prior century while juggling with all kinds of pictorial and allegorical references, deliberately playing on the clashes between different registers (particularly of posture, setting, and the various genres he evokes).

IN 1730, VISITORS TO HOGARTH'S STUDIO WERE struck by one of his new paintings. According to one of his colleagues, engraver George Vertue, "it was a small picture representing a common harlot." The woman's negligee was in disarray and her bearing had a pleasant aspect, much like her air. "This thought pleased many. Some advised him to make another painting in order to form a pair, which he did. Then other thoughts increased and multiplied by his fruitful invention, until he made six different subjects, which he painted so naturally, of thoughts and expressions so striking that everyone wanted to see them—and which he proposed to engrave on six plates" (Hogarth 1955, xviii).

What Vertue does not say is that the six tableaux of *A Harlot's Progress* scrupulously followed the framework of a Venetian picture story dating from the preceding century. For a virtuoso painter like Hogarth, the adaptation of a popular subject that had circulated as prints in the Catholic world was already an incongruity. When he printed the six images of *A Harlot's Progress*, he pushed the incongruity even further. Rather than adopting the anonymous appearance of the Venetian model, his plates displayed a distinguished style, one that was comparable to those of the best copies of famous tableaux that were circulating in England at the time (Paulson 1991, 258). The "ironic elevation"

of a popular picture story was at the heart of his humorous, typically polygraphic approach.

Moreover, his version of the Venetian fable evoked several "phantom works" that were associated with very different media. As Ronald Paulson has shown in his invaluable analyses, we can interpret Hogarth's images as (luxurious) illustrations prepared for a novel that does not exist, or as an ensemble of historical paintings existing solely in their reproduction—all the while recalling the metaphor of the "dumb show" (the pantomime) that Hogarth liked to use when speaking of his invention. By evoking these models and making them virtual participants in the reading of his novels in prints, Hogarth opened a major avenue in the history of comics: a dialogue with other media, both ancient and emergent, that would occupy all the great creators in this domain in the nineteenth century (and beyond).

Of all the interpretive strategies, the most apt for this first narrative series must invoke historical painting. In *A Harlot's Progress*, the satirist attacks the ideological a priori of the "Grand Genre" and the way allegorical personification generally serves the cause of "great eternal truths." As Paulson has shown, the story of poor Molly Hackabout, the naïve young girl recently arrived from the provinces, does not reveal its true moral unless the reader is able to recognize behind the apparently realistic contemporary scene an inversion of *The Choice of Hercules*,

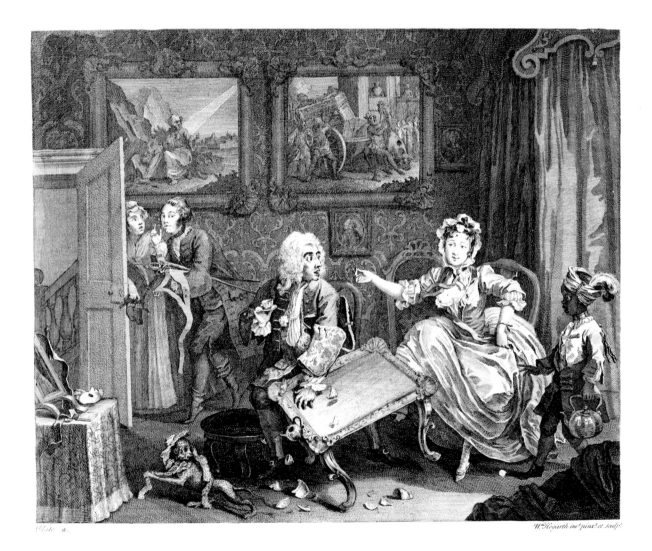

Figure 1.10 **William Hogarth, *A Harlot's Progress*, 1732, plate 2.**

Maintained by a rich Jewish merchant, Molly has become a real courtesan. But she cheats on the merchant with a much younger lover who we see slipping away in the background while Molly overturns a table as a diversion. This moment, of course, marks the very beginning of her downfall.

one of the major motifs of allegorical culture at the time (Paulson 1991, 260–271).

In the original myth, Hercules was confronted by two figures (two personifications) who offered him very different paths to arrive at his life's goal. Vice invited him to take up the way of pleasures and ease, while Virtue advised a much more difficult route.

To read Hogarth's image properly, one must be aware of the hidden reference to Hercules's choice, which completely changes the moral of the story: to the left of the young Molly, Virtue, embodied as a religious man, turns his back on her and is completely disinterested in her fate. This modification of the conventional diagram of *The Choice of Hercules* leaves the field open to Vice (appearing as a celebrated London madam), who lures her prey with promises under the bawdy gaze of Colonel Charteris (a sexual predator well known to newspaper readers of the period).

By turning the conventional lesson upside down, the image thus denounces the lack of options presented to the innocent heroine: if Virtue doesn't even speak to her, what chance does she have to take the proper path?

As Paulson's analysis has shown, this first question can hardly exhaust the meaning of the image. If one's gaze slides to the right, another eminently "readable" structure appears to the reader. This time, the procuress is at the center of a triad that recalls the motif of the Annunciation. The partial superposition of the two triadic structures (or diagrams) allows us to reconstitute Hogarth's thoughts: by disinteresting itself from the fate of innocents, by condemning them in advance in the name of fixed truths (the moral myth of the "free arbiter"), the Church has perverted the essence of the biblical lesson.

In Hogarth's novels, the moral stakes of contemporary times were in direct conflict with the immutable truths that had frozen society within ossified schemas. The polygraphic character of his work stems directly from this confrontation. It is no accident that the fugitive gesture of the libertine masturbating in the doorway contrasts starkly with the poses of the young woman and her corrupter that are so charged with literary and pictorial allusions.

But let's go back to George Vertue's story of the creation of *A Harlot's Progress*. He identifies plate 3 of the series as Hogarth's actual starting point: a (single) tableau that was so pleasing to his visitors that they suggested he make another one, "in order to form a pair."

Previously, Hogarth had painted two satirical canvases that worked together to propose a game of comparisons. Simply entitled *Before* and *After*, they contrasted the attitude and the expressions of a young couple before and after the sexual act.

The only scene in *A Harlot's Progress* that could possibly be combined with an earlier tableau in order to form a similar diptych is the one that directly precedes it in the completed sequence (plate 2). The young prostitute receives the wealthy Jewish merchant who supports her. Meanwhile, in the background, aided by a servant, her lover skulks away. As in *Before* and *After*, the reading of the diptych rests essentially on the differences between the two scenes: the lover who escapes through the back door is replaced in the following plate (the first scene Hogarth painted) by a judge who arrives to arrest the prostitute. In the interval, one can see that the rich bourgeois decor of the courtesan is transformed (almost item for item) into a sordid apartment pitifully attempting to maintain the illusion of a certain stature (a stool being used as a table, a chair as a dressing table). The young woman "plays" the Lady, but her pretension— much like her furniture—has become pathetic. She has slipped from the rank of a luxurious courtesan to that of a whore. In comparing the two images, the attentive reader will have noted that this change in status (and comportment) is reflected in the choice of pets: we shift from a little monkey adorned with ribbons to a kitten who is only interested in what is happening underneath Molly's skirt.

Details of this kind are too numerous to enumerate here: every accessory, every tableau hanging on a wall alludes to the moral situation of the story's heroine. Mixed in with these digressive elements (which are located in the background of the image) are clues that allow the reader to deduce, in almost detective-like fashion, the actual events that led to the given situation. These clues are arranged along a tem-

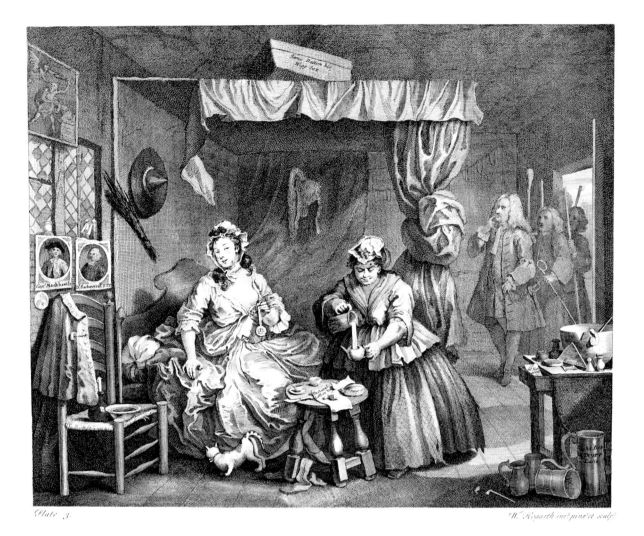

Figure 1.11 **William Hogarth, *A Harlot's Progress*, 1732, plate 3.**

This scene, the first conceived by Hogarth, shows the arrest of the heroine by a famous judge. While it plays with the most sophisticated structures of visual reading—emblems, metaphors, allusions, comparison—the image can also be properly described as "topical."

poral reading axis that can be deciphered from left to right in the engravings (Paulson 1991, 265). In this arrangement, Hogarth is employing a conventional device of historical painting that consists of filling the "pregnant moment" of the narrative with clues concerning the actions that preceded it, and warning signs of what is to come (Shaftesbury 1790, 294–296).

The first image of the series (fig. 1.9) provides an excellent example of this device: situated at the far left of the image, the inscription on the wagon refers to Molly's past (she is from Scotland), while the central scene defines the present. Her career as a courtesan is announced by the presence of the well-known libertine, Colonel Charteris, who observes the scene while stand-

ing in the entryway. Finally, at the far right of the image, the dead goose symbolically announces the predictable outcome of this story. This last detail illustrates how narration and digression interpenetrate in Hogarth's compositions: the label attached to the neck of the goose indicates that it was destined for a beloved cousin of Molly, who clearly missed the rendezvous (narrative detail); but the goose also makes reference, by a visual and verbal metaphor, to the compromised innocence of the heroine, who, at this very moment, extends her long, white neck toward her corrupter, as if she is to be sacrificed.

In reality, the distinction between narration and digression loses much of its pertinence in the novelistic practices of the eighteenth cen-

Figure 1.12 **Anonymous, *The Mirror of Destiny of the Prostitute*, Venice, ca. 1657.**

Two engravings from the anonymous Venetian series of the second half of the seventeenth century that inspired *A Harlot's Progress*. The first of the two images gave rise to Hogarth's plates 2 and 3 (figs. 1.10 and 1.11). By first painting, then engraving these scenes with all the care generally given to the most noble subjects, Hogarth appears to elevate the popular genre of edifying picture stories to the level of historical painting—with an obviously ironic perspective.

tury. This is particularly true for Hogarth's contemporaries, including Henry Fielding, Laurence Sterne, and Samuel Richardson, who were also seeking to develop an original point of view in a culture where the phases of a narrative—of a progressive action—inevitably return to rhetorical developments inspired by earlier literature (generally biblical or mythological).

At the time, it was practically unthinkable to start from a blank slate when composing a narrative story—or an image—without running the risk of falling into insignificance. Under these conditions, we can see what pushed Hogarth to refer to the Venetian cycles: the real target of his satirical digressions was their timeless templates, with their endless rehashing of the battle between vice and virtue. On this rigid rhetorical scaffolding, Hogarth digresses ironically about the hypocritical discourses that present every moral issue as if it depended on a (metaphysical) free arbiter, whereas the choices of the poor, in contemporary London, are really limited to a few

Figure 1.13 **William Hogarth, *A Harlot's Progress*, 1732, plate 4.**

Condemned to forced labor, Molly beats hemp with other prisoners. She still wears her prostitute's dress, ridiculous in this context. Her haggard, defeated face shows the characteristic expression of Hogarthian "heroes," who for the most part find themselves trapped by forces beyond their control: the forces of their own impulses and those, equally blind, of the institutions that subsequently punish them. The satirical world of Hogarth revolves around this empty hub—a kind of stupor that summarizes a total absence of choice. From stupor to stupidity—which will constitute the principal theme of cartoonists of the nineteenth century—is but one step.

catastrophic preordained scripts. By jumping at leisure from one clue, one significant detail, to another, the reader reads the text beneath the image with the sharp conscience of the author's presence and liberating independence.

Hogarth's "dumb shows" are digressive and permeated by the spirit of their author. In that regard, they are situated at the opposite pole from the wordless genre of slapstick, which comic-strip authors favored around 1900. At that time, the emerging technologies of chronophotography and the Kinetoscope incited illustrators to create stories without words that could be read effortlessly, like a series of technical diagrams. We will see that this "automatic" reading, which,

in principle, seems to exclude any digression on the part of the author, nevertheless preserves a good deal of its potential for ironic expression. In a certain way, the example of Hogarth already provides the key to this paradox. There was no template more rigid and more impersonal than the stereotypical Venetian cycles from which he took his inspiration. It was only the polygraphic play, the ironic hybridizing of graphic registers, that allowed him to breathe life into this inert material. Without that innovation, which Hogarth shared both with the novelists of his time and with the entire lineage of cartoonists of the nineteenth century, comics would have exhausted their potential and petered out (before they

Figure 1.14 **William Hogarth, *A Harlot's Progress*, 1732, plate 5.**

Dying from syphilis, Molly agonizes in the arms of her servant. At her bedside, two charlatans argue, while a shrew picks over the young woman's belongings: the trunk is all that remains of her poor life. No one pays attention to Molly's child, who is playing with fire on the right side of the image—a transparent allusion to the fate that awaits him.

even existed) along with the Épinal prints, which were the genuine heirs of the edifying genre of picture stories.

We would have to wait until the twentieth century for researchers (such as Ronald Paulson) to elaborate on the profound structure of Hogarth's work, whose ironic backgrounds were probably accessible only to a minority of informed readers even during their time. In the nineteenth century, Victorian critics praised the "morality" of Hogarth's series, as if his images conveyed a simple and unambiguous discourse.

For them, it was his depiction of human nature that ensured his work's posterity. The depiction of primary and secondary characters, street people, thieves, beggars, and prostitutes had been an integral part of artistic discourse since antiquity, but contemporary critics considered

Hogarth a radical innovator in this domain. By playing the role of a spectator in his own time, he had created an anti-academic language that was both stylized and autonomous, one that allowed him to contrast the actual world with the conventional types and postures that defined the pictorial tradition.

In a series of autobiographical notes written at the end of his life (Hogarth 1955, 201–231), Hogarth very precisely situated the origins of this new language. Everything began during his formative years, when he discovered that the education offered to young painters rested on the slavish copying of rigid and institutional models.

Sickened by the slowness and sterility of this approach, he created a totally personal, empirical method rooted in his own capacity for visual memory and his keen sense of observation. At

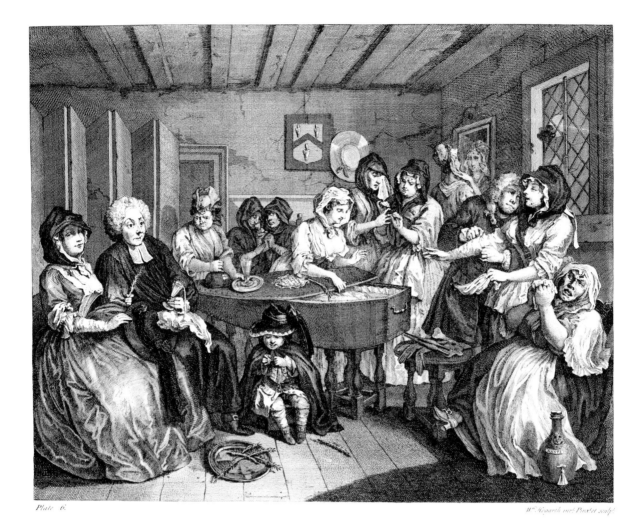

Figure 1.15 **William Hogarth, *A Harlot's Progress*, 1732, plate 6.**

Around Molly's coffin, the comedy of hypocrites and thieves is still in full swing. Hogarth's contemporaries were fascinated by the subtlety of his character studies, which owed more to his talent for observation and stylization than to the study of "types" taught at the Academies.

the age of twenty, Hogarth loved nothing better than to loiter in the streets of London. Through his contact with the life of the city, he perceived that "remarkable incidents and striking subjects" exerted a powerful attraction for him, allowing him to formulate images that were "more truly a picture than one that was drawn by a camera obscura" (Hogarth 1955, 209): "I therefore endeavored a habit of retaining whatever I saw in such a manner as by the repeating in my mind the parts of which objects were composed I could by degrees put them down with my pencil" (210).

Hogarth, who never made the effort to recopy the models that were given to him to draw, "took the short way of getting . . . by heart" the objects he fortuitously met on the street, "so that wherever he was . . . he was apt to catch momentary actions and expressions" (Hogarth 1955, 202).

This is a point that Hogarth insisted upon repeatedly in his notes on his mnemonic system: it is necessary to approach an object (or a scene) in the same way that we penetrate the global meaning of a text with regard to its grammatical structure. With this system, whoever sought to formulate "perfect ideas of such objects as he might want to draw by memory with facility" would have as clear a knowledge of the figure "as anyone who can write freely has of the twenty-four letters of the alphabet, and their infinite combinations" (Hogarth 1955, 208). This is a fundamental affirmation of the expressive possibilities of a diagrammatic language that is capable of opening up the infinitely varied world of the contemporary and the new. It is also a resolutely empirical way to break with the rigid typology of characters developed in pictorial tradition.

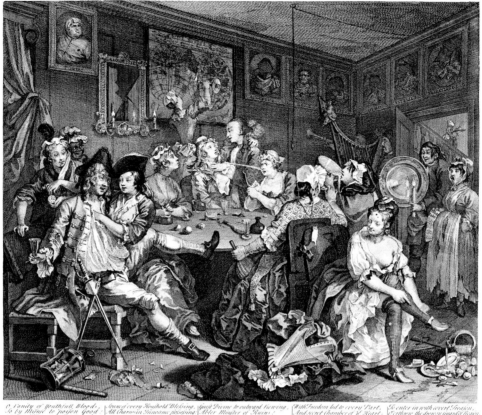

Figure 1.16　**William Hogarth, *A Rake's Progress*, 1735, plate 3.**

Most of the scenes in Hogarth's novels in prints are precisely inscribed in the present time—the world of instantaneous action and modern topical issues. In plate 3 of *A Rake's Progress*, the hero's watch (he is seated on the left) shows three o'clock at the very moment it is stolen from him. At the same instant, a prostitute spits a mouthful of gin into the face of one of her colleagues (in the background).

In his notes explicating the basis of his mnemonic method, Hogarth returns again and again to the verb "to catch," which we use today to describe the action of taking a snapshot with a camera. In fact, practically all his images reserve a strategic place for an instantaneous action: a scaffold collapses during the training of a carnival troupe; a table is upended after being kicked; hit with a brick in the face, a man is propelled backward from his chair. A comparison with photography is nevertheless deceptive: Hogarth's mnemonic system is not mechanical or automatic. We have seen that he explicitly claimed it as a manner of "writing freely"—the antithesis, therefore, of slavish copying.

If the scenes that are vividly engraved in his memory appear as "more truly a picture" than the image produced in a camera obscura, it should be understood in this context: in Hogarth's day, the "reality" of an image was the exclusive concern of human judgment. Even caught in the blink of an eye by the artist, the vision of some incident that occurred on the street is a grammatical and rhetorical construction, an utterance charged with meaning and intention. A century later, Hogarth's heirs would recall this when they stylized chronophotography and instantaneous photography in order to introduce these "novelties" into their polygraphic and humorous constructions.

In reality, two fundamentally different ways of halting time in order to produce an image come together in Hogarth's work, creating an interface through which the ancient culture of engraving can interact with modernity.

Indeed, Hogarth continued to exploit the ancient rhetoric of symbols and allegories. Most of the accessories found in his images are used to convey meaning, making "things" speak in the hieroglyphic mode of *ars emblematica*.

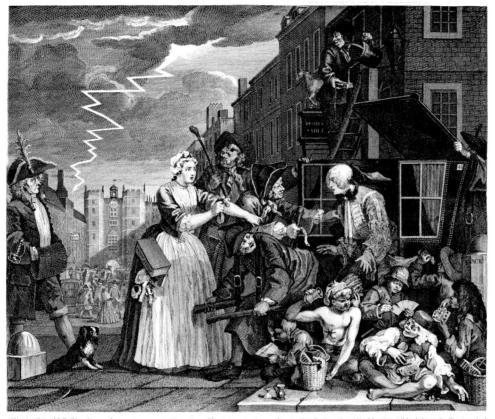

Figure 1.17 **William Hogarth, *A Rake's Progress*, 1735, plate 4.**

The clock on the tower of St. James's Palace shows one forty, and other clues allow us to deduce the calendar date of the action. Added to these purely chronological elements are many more (sometimes minute) signs of real-life and contemporary connections (such as the roll of black material, in the first scene of the rake's story, on which a label gives the address of a friend of Hogarth who was a draper in Covent Garden).

If time, in Hogarth's images, is often frozen in the fraction of a second in which an object falls, it is all the better to mark a contrast with the language of eternal truths. The tableaux hanging on the wall and the pretentious postures adopted by certain characters evoke the allegorical stations of a baroque pantomime. Yet at the key moment where these actors are frozen and transformed into living emblems, the artist performs a conjuring trick: the codified postures of baroque drama and historical painting come face to face with the attitudes and fugitive expressions of liars and hypocrites who are capable of stealing your watch—or your honor—in a mere fraction of a second. In this same flashbulb moment, a thousand and one facets of the real world are revealed and made readable. In the third engraving of *A Harlot's Progress*, Molly plays with a watch that she has stolen from one of her clients. At the moment when the judge enters her room, the clock shows fifteen minutes past noon. The time corresponds to that which is mentioned in a contemporary newspaper article describing the arrest of a prostitute named Hackabout (like Hogarth's heroine), by the same Judge Gonson.

Thus, the course of time is not interrupted in Hogarth's images, to be plunged into a readable eternity and frozen within emblems and allegories. On the contrary, the freeze-frame invites the public to connect this new kind of "tableaux vivants" to current affairs (the news and the novel). At every level, the vocabulary, the syntax of the two forms of arrested movement, clash to produce meaning. For the large part, this explains the chaotic, dissonant, even violent character of Hogarth's scenes. Only "the battle of the images" (the title of one of his satirical engravings) allows his depiction of contemporary life to be *read* in a provocative and ironic manner.

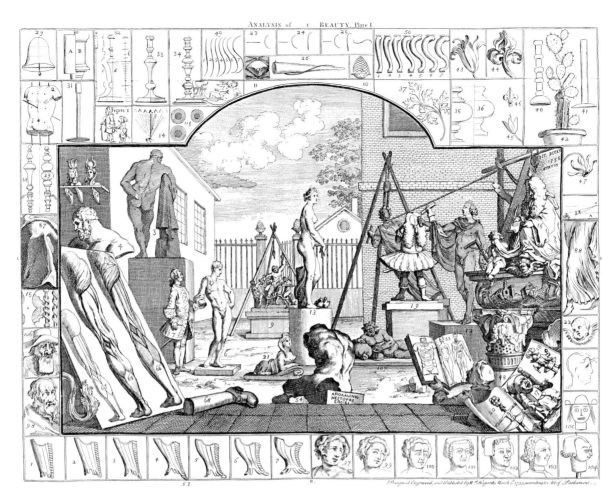

Figure 1.18 **William Hogarth, *The Analysis of Beauty*, 1753, plate 1. Etching and engraving.**

The two plates that accompany Hogarth's sole theoretical text, *The Analysis of Beauty* (1753), illustrate to what degree his thought is founded on the analytical language of the diagram. The principal thesis of his book is established with the aid of two hundred schematized sketches: *Beauty is synonymous with the infinite variety of Nature and its forms.* To this principle, Hogarth opposes the mechanism of ridicule and of the artificial, which he locates at the opposite pole—that of uniformity. To verify his hypothesis, a variety of sketches compare things like table feet, plants, postures both comic and graceful, caricatures, portraits, and so on.

Analysis of Beauty rigorously defines the humorous register of forms: simple shapes that are too regular or too boring do not belong to the realm of natural variety. By definition, simplistic or overtly symmetrical shapes are artificial to the point of becoming comical. Now how can one combine this formalism with the other dichotomy that permeates Hogarth's images—the

opposition between the world of academic (and timeless) postures and that of the attitude and gestures of contemporary times?

Hogarth explores this opposition in the large images that occupy the center of each of the two plates. Depicting the backyard of a famous statue merchant, the first scene alludes to the world of allegory and eternal myth. All the vocabulary derived from the authority of conventional art and unchanging truth can be found crammed in the junkshop of this pathetic merchant, whom Hogarth notes does nothing more than copy the classical models. Some of these copies have lost their variety to the point that they have become comical and ridiculous.

This process is essential for Hogarth's theory, because the theme of the clumsy and inelegant copy allows him to extend his formal definition of the comical to all objects or behavior pretending to be inspired by higher models, including academically inspired works of art but also all the ridiculous characters who, in his images,

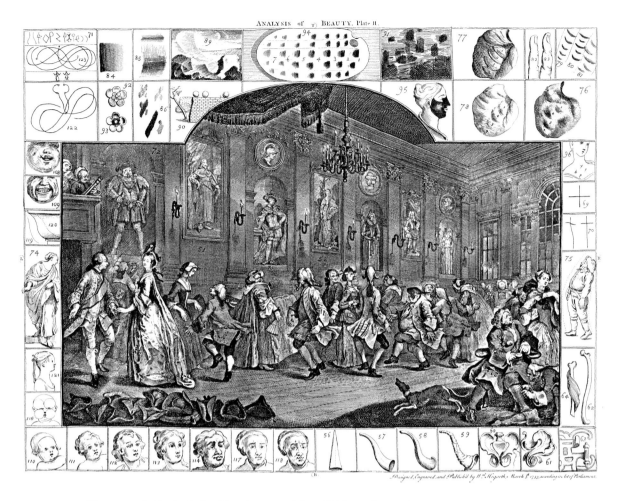

Figure 1.19 **William Hogarth, *The Analysis of Beauty*, 1753, plate 2. Etching and engraving.**

try to reproduce the ticks, the postures, and the "grammar" of authority.

The central image of the following plate is in stark contrast to the first. Hogarth tells us that it depicts a country dance and illustrates "a suspended action" rather than "an attitude." In other words, it connects us to the living, actual, and natural time. Yet the humor of the forms stems from a completely different source: by catching an action in midcourse, it is the freeze-frame, here, that generates clumsy or ridiculous figures,

> for [Hogarth tells us] were it possible in a real dance to fix every person at one instant of time, as in a picture, not one in twenty would appear to be graceful, though each were ever so much so in their movements; nor could the figure of the dance itself be at all understood. (Hogarth 1997, 103)

Frozen in full movement, the bodies are incapable of conforming to the requirements of variety advocated by Hogarth. If the action is arbi-trarily suspended, the dancers will be arrested in graceless postures, composed of lines and simple curves that a rudimentary outline can easily summarize. It is here that Hogarth's mnemonic system intervenes: a series of very rudimentary diagrams—actually comparable to letters—serves to explain the grammar of the suspended action (plate 2, top left).

Hogarth's humorous polygraphism rests in large part on this improbable dialogue between idealized or affected postures (which are "descended" from canonical and institutionalized models) and the unnatural and ridiculous representations that characterize suspended action (seized in flight by empirical observation). On the formal plane (according to his theory), the two families of symbols are equally comical, but for diametrically opposite reasons. Later, we will see how this comically polarized interpretative grid will evolve in the nineteenth century, and crystallize particularly in Rodolphe Töpffer's novels in prints, as Hogarth's work provided to

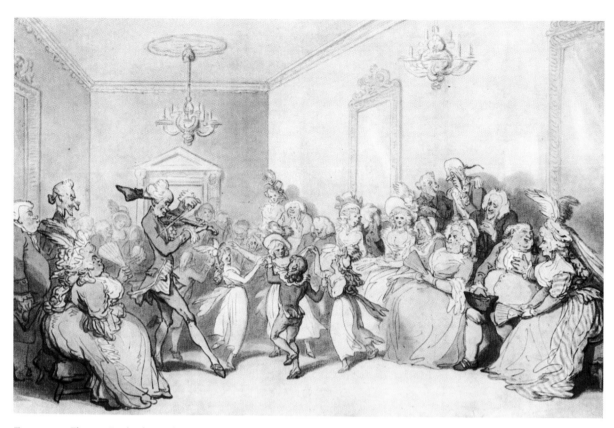

Figure 1.20 **Thomas Rowlandson, *The Assembly Room at Bath* (from *The Comforts of Bath*), 1798.**

The comic verve of Rowlandson depends entirely on the dynamism and spontaneity of his line. His example will encourage Töpffer to claim the same freedom and to theorize on the singular and energetic character of graphic expression.

his heirs the elements of a hybrid graphic language that could stand up to every challenge posed by the Industrial Revolution.

The earliest stories drawn by Töpffer appeared at the beginning of the 1830s, exactly one century after *A Harlot's Progress*. Töpffer was particularly keen on Hogarth's work, but he completely renewed the form of novel in prints. The language of graphic hybridization was called upon to play a primary role in this invention. At the time, most satirical cartoonists had already adopted the technique, but since Hogarth's death in 1764 many other elements had had the time to change. The Industrial Revolution, romanticism, a new conception of relations between painting and poetry, the triumph of the English caricature, and a public taste that was increasingly interested in archaic and primitive forms had all provided new ways of thinking about Hogarth's legacy.

During this intermediary period, due to the influence he exerted on Töpffer, the English artist Thomas Rowlandson particularly stands out. Indeed, even if Töpffer had read Hogarth's *ro-*

mans en estampes, it was especially due to Rowlandson's example that his drawings came to inherit the formal theories outlined in *Analysis of Beauty*.

Apparently situated poles apart from Hogarth's work, Rowlandson's graphic production seems almost barbaric in comparison: both repetitive and lavish, it does not provide the kinds of reading intended by the moral satires of his predecessor. Hogarth's engravings offered structures that were readable, complex, and intricate; Rowlandson's drawings are reduced to the molecular state, so to speak. They only depict isolated, superficial, and fragmentary incidents. But this is precisely what makes them interesting. If we look closely, we can see that they take the formal principles developed in *Analysis of Beauty* to their most absurd limit. In Rowlandson's drawings, everything happens as if the stratified structure of Hogarth's pictures had dissolved, leaving only a series of what a chemist would call "free radicals."

Rowlandson's pictures endlessly combine elementary accidents, purely formal contrasts, with

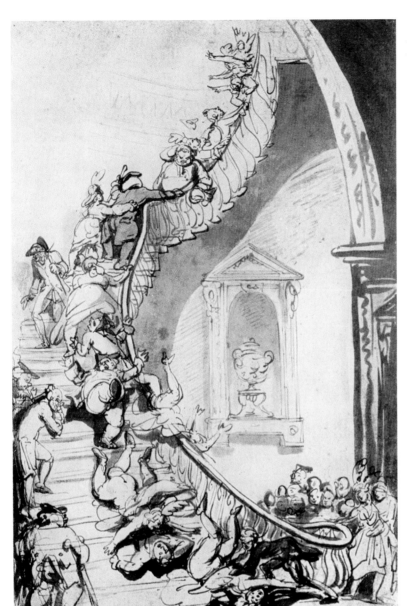

Figure 1.21 **Thomas Rowlandson, *The Exhibition Stare-Case*, preparatory sketch, ca. 1800.**

Hogarth's "line of beauty," as seen by Rowlandson. Between figures suspended in action (clumsy and comical) and the capricious curves of the rococo architecture, the contrast is, as is often the case with Rowlandson, typically Hogarthian.

a marked predilection for the kinds of collisions and collapses that play out in a fraction of a second (Paulson 1972, 29). He was only interested in the sensory impact of his comical incidents and in the sensational contrasts—violently attractive or repulsive—that he provoked: for example, when the emaciated form of an old man meets the sinuous silhouette of a fresh young girl, or when the spiral of a rococo staircase plays with the coarse geometry of bloated bodies that hurtle downward, head over heels.

This valorization of the accident in its most elementary form makes sense if we consider Rowlandson's chosen medium—watercolor pen-and-ink drawings. Hogarth engraved each of his compositions slowly, laboriously, aiming for a neutral halftone that brought his pictures close

to the typographical gray of books and newspapers. In one sense, his "line of beauty" was only virtual, its dynamism entirely dependent on the capricious path of the reader's eye across the picture. Rowlandson reinvented Hogarth's theory by bringing it to the domain of the lively and cursive gesture, turning Hogarth's comedy of forms into an issue of energy, emotion, and vitality. Töpffer would recall this when he set out to breathe life into the syntax that he invented in order to tell the love stories of Mr. Vieux Bois and the objet aimé. It is through this energetic and molecular interpretation of *Analysis of Beauty*—via the drawings of Rowlandson—that we must consider the relation between Töpffer's stories and the formal theories of Hogarth.

George Cruikshank

Figure 2.1 **George Cruikshank (illustrations), *Jack Sheppard* (London: Richard Bentley, 1839). Etching.**

A novel written by William Harrison Ainsworth and devoted to the criminal adventures of the bandit Jack Sheppard gives George Cruikshank the chance to lay claim to Hogarth's polygraphic heritage. This scene, from the bandit's infancy (the real-life bandit was a contemporary of Hogarth), recalls the graffiti of plate 1 of *Four Stages of Cruelty* (see fig. 1.2). Destiny was to make Jack Sheppard a hero of popular ballads, and his name would flourish on all the walls of the kingdom.

2

Graffiti and Little Doodle Men

Töpffer and the Romantic Preference for the Primitive

Rodolphe Töpffer was born in Geneva in 1799, a century after William Hogarth. The son of a painter and caricaturist (he himself seemed destined for a career in painting before an eye disease discouraged him), Töpffer was penetrated by

the literary values of the first German romantic period, and he knew the modern tendencies of English caricature intimately. In the following chapter we will return to his picture stories, which played a decisive role in the history of comics. In the interim, the question of his drawing deserves our attention. His style, which could be said to fall somewhere between amateurishness and clumsiness, is by deliberate choice. In accord with both his theories of art and the general trend in English caricature, it provided a canvas that was perfectly adequate for the satirical picture stories he began publishing in the 1830s.

There is a startling gap between Hogarth's images and those of Töpffer: the engravings of the former take extraordinary care to pastiche the noble style, whereas the latter's albums are fundamentally unconcerned with the laws of classical drawing. This difference stems from the flaunted taste of romantic-era illustrators for "primitive" forms of expression including graffiti, children's drawings, caricature, Gothic

illumination, and the grotesque. More than any other single factor that arose in the seventy years separating Hogarth's death from Töpffer's first albums, the attention paid to naïve and archaic forms of drawing changed the tonality of humoristic illustration (Gombrich 2006). In the orchestra of styles, this new register would take on considerable importance: it had the great merit of highlighting all that was artificial and pompously academic in other visual languages.

In his preface to the novel based on his own *Dr. Festus*, Töpffer warned that "within the confines of the region of the serious and the reasonable, there is an immense, hazy space, peopled by extravagant ghosts, recreative visions, and crazy figures that sometimes touched the borders of the Real, but never staying" (Maggetti 1996, 138). Graffiti, children's drawings, and scribbling would define this new site "at the edge of seriousness" from which cartoonists of the nineteenth century spoke whenever they pretended to express themselves.

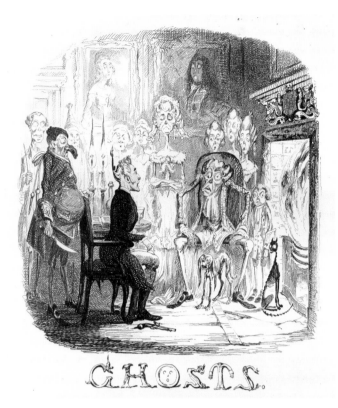

Figure 2.2 **George Cruikshank, *Cruikshank's Comic Almanack* (London: Charles Tilt, 1840). Etching.**

„Ob der Herr Pfarrer mir wohl wieder ein Zuckerl

Figure 2.3 **Adolf Oberläder, *Le Petit Moritz*, *Fliegende Blätter*, no. 2352, 1890.**

The English illustrator George Cruikshank played a considerable role in establishing this new tonality, which paved the way for drawing in comics. Over the course of his long career, Cruikshank often populated his satirical etchings and hieroglyphic puzzles with little doodle men, which can also be found in his later collections of comic cartoons and in his book illustrations. It was Cruikshank who inaugurated this particularly casual tone in the polygraphic tradition of the nineteenth century, and his influence on his colleagues would grow over the course of time. Töpffer was perfectly conscious of the influence Cruikshank exerted on French and English illustrators in the 1820s, and of the debt that his own conception of cartooning owed to this model. In an undated letter to the editor of *L'Illustration*, he even used the name as an adjective to summarize all the qualities necessary to remain faithful to the spirit of his picture stories. "And if Mr. Cham cannot and will not [take the job of adapting Mr. Cryptogame], show me some other English farcical, humorous, Cruikshank artist that sees in my characters an idea and not limbs, someone who would constantly sacrifice limbs to the idea and never the idea to

limbs which, after all, interest no one" (Kunzle 1984, 141–142).

In fact, Cruikshank was the least academic of artists; but not everyone shared Töpffer's enthusiasm. In an 1857 text dedicated to "quelques caricaturistes étrangers" (some foreign caricaturists), Baudelaire was unable to praise Cruikshank's grotesques without remonstrating with him for his casual approach: "The only fault for which he can be reproached is . . . not always

drawing in a conscientious manner. . . . He draws too much like a man of letters who amuses himself by scribbling drawings. His prestigious little creatures are not always born viable. This entire miniscule world tumbles, flutters, and mingles with an indescribable exuberance, without worrying whether all of its members are situated in their natural place. Too often they are nothing but human hypotheses who hop around as they can" (Baudelaire 1999).

Perhaps because he was himself one of these "[men] of letters who amuses himself by scribbling drawings," Töpffer devoted some of his theoretical reflection to the question of graffiti and doodling.

He knew that the most elaborate hypotheses and the most comical situations could be clarified by an informal, even awkward doodle. No philosopher, scientist, or man of letters at the time could scorn this culture of sketches and diagram (Bender and Marrinan 2010). Töpffer also knew that such awkwardness of expression (in which he saw the very signature of spirited creation) was present in art from faraway places and times: the graffiti at Pompeii, the naïve illuminations of medieval manuscripts, the statues on Easter Island . . .

The question of "doodles" thus became one of the cornerstones of Töpffer's art theory (Töpffer 1998, 256–264). Completely overlooked today, Töpffer's thoughts on art clarify the origins of a preference that was to amplify with time: after being carried by the tradition of humoristic illustration, the awkward, infantile, spontaneous drawing would, under the direct influence of caricature and satirical drawing, settle down for the long term in the world of contemporary art at the start of the twentieth century.

Figure 2.4 **Wilhelm Busch, *Max und Moritz*, original manuscript, 1865.**

Figure 2.5 **Lyonel Feininger, *City at the Edge of the World* (photo by Andreas Feininger).**

Lyonel Feininger, the Bauhaus painter and colleague of Paul Klee, created brilliant characters for the American press during the mid-1900s. A major component of the language of cartoons and of nineteenth-century picture stories, the "graffiti" style would gradually permeate the world of contemporary art at the beginning of the twentieth century.

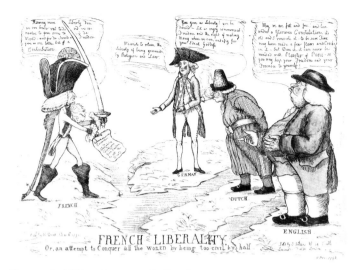

Figure 2.6 **William Dent, *French Liberality*, 1792. Hand-colored etching.**

English caricature, which became popular some years before Hogarth's death, was at first the domain of aristocratic amateurs. The genre underwent an extraordinary expansion during George III's reign (Donald 1996). Professional caricaturists such as William Dent, Mary Daly, and Isaac Cruikshank (George's father) often imitated this unpolished character in their drawings, thereby giving a degree of cultural legitimacy to the graffiti style that Töpffer would later use in his comic albums.

Figure 2.7a **James Peller Malcolm, *An Historical Sketch of the Art of Caricaturing*, 1813.**

However, Töpffer didn't venture into "the confines of the serious" alone and unarmed. At the beginning of the nineteenth century, illustrated books about the history of caricature began to appear, most notably in England. They were already brewing the raw material upon which Töpffer based his reflections and practice. Published in London in 1813, *An Historical Sketch of the Art of Caricaturing* by James Peller Malcolm, for instance, defined the corpus that would be taken up by a majority of subsequent works: everything from medieval chimeras and gargoyles to the pagan totems of Pacific islands, not to mention emblematic satires, vagaries, and caricature sketches. *The Art of Caricaturing* cast a wide net; it was interested in all sorts of artistic margins, all forms of ugliness, madness, and excess.

What interested Töpffer most about this art was that it allowed him to escape from the grip of taught drawing: of proportions, of pure and correct contours, of accurate anatomy and reasoned perfection.

I saw, in vignettes made during the Middle Ages by some unskilled monk, a face drawn in such a way that it would make a teacher shrug his shoulders, and yet all the knowledge of the professor would

not be able to reproduce its energetic appeal, its singular grace. They know all about it, those who browse through these vignettes, and sit for long hours in public libraries with fifteenth-century books to study art at its infancy, the merits of which are erased, utterly lost in sophisticated art. (Töpffer 1998, 126)

Against academic art that is "all studies," always "reasoned" and "measured," Töpffer proffers this essential criticism: academic drawing lacks "the principle of life that should animate all parts of art; the divine breath that cannot be measured or captured, which can be helped by study, but remains independent from it; which one can meet but cannot learn" (Töpffer 1998, 126). All of Töpffer's theory is founded on this profession of faith. But where many of today's artistic instructors are happy to paraphrase this postulate in the form of a mantra (and in less devout terms), Töpffer used it as a basis from which he constructed a sophisticated semiotics of anti-academic drawing, as a form of art that is all about the processes of creative intention and thought and quite indifferent to the challenge of imitating reality per se.

Fig. 1.

Plate I. p. 8.

Fig. 2.

Fig. 3.

Fig. 4.

Fig. 5.

Fig. 6.

Figure 2.7b **James Peller Malcolm, *An Historical Sketch of the Art of Caricaturing*, 1813.**

Figure 2.8 **George Cruikshank,**
Lines and Dots, London, 1817.
Etching.

"Striking effects produced by LINES
and DOTS, for the assistance of
young Draftsmen." Lines-and-dots
figures often appeared in drawing
manuals. This etching from 1817
presents a striking example of
Cruikshank's most minimalistic vein.
The print collates many variation on
the lines-and-dots theme, resort-
ing to puns on familiar turns of
language. We will return later to the
nonnarrative use of balloons in this
type of context (see chapter 7).

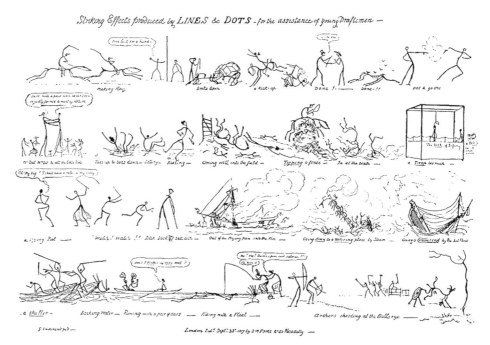

*Have you ever been to Herculaneum, at Pompeii?
. . . Me neither. But they say that on the exterior
walls of the houses . . . of this buried city, we can
see awkward sketches, some in charcoal, others
in chalk or blood, of figures that are stationary,
that walk, and that act. It's funny, and unexpected
before we think about it, to find the same little
"doodle men" from 1800 years ago that our kids
now fashion with their impudent clumsiness on
the walls of our streets. (Töpffer 1998, 256)*

This is how the chapter "When It Comes to
Little Doodle Men" (A propos de petits bon-
shommes) begins, which is the section of *Ré-
flexions et menus propos* where Töpffer's theo-
ries most clearly connect with his practice as a
comic illustrator. And here, Töpffer establishes
a crucial distinction: there are doodle men and
doodle men. Some hardly merit the title because
they are purely imitative and nothing more than
imitative: they already carry the stigma of the
academy. "Precisely because of this lack of artis-
tic conception, which is to the detriment of their
spirit, a soldier, for example, is seen and under-
stood only by his uniform: the rows of buttons,
the shoulder strap, the pompom, the distinctive
signs of the army, the regiment, the company.
. . . Such doodled figures are created from a
purely imitative instinct, if you want, and even
then, this instinct is limited to *exterior signs of*

organization, of rules, of measure, of division; it
doesn't care for a real sensitive and expressive
imitation of the object" (Töpffer 1998, 258; italics
added).

I have italicized several of Töpffer's words
because they express the pivotal point of his
thinking: academicism imposes rational, and
thus external, principles of organization onto
the artist. All works of art that derive their unity
from the application of rules, measures, or divi-
sion inevitably cut themselves off from genuine
inspiration, "which cannot be measured or cap-
tured." Yet there is not an ounce of mysticism
in Töpffer's reflections. Quite simply, he defends
another kind of unity: *individuality*, expressed
in vigorous artistic thought and discourse, in-
finitely energetic and tinged with the genius of
William Shakespeare or François Rabelais. It is
individuality that gives birth to real doodle men,
who, "as awkward and badly drawn as they may
be, vividly reflect, with reference to thoughtful
intention and imitative intention, the point at
which the former, because of the very ignorance
of the author, is always infinitely more pro-
nounced and successful than the latter" (Töpffer
1998, 259).

All of Töpffer's graphic and theoretical work
rests on the opposition between academic art
(dictated by rational procedures) and genuine art
(imbued with lively individuality). Rational pro-

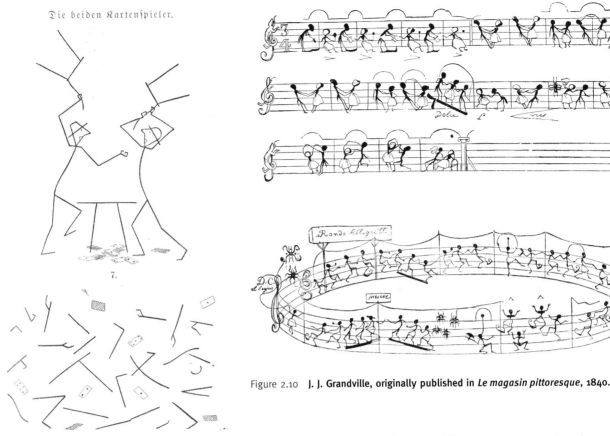

Die beiden Kartenspieler.

7.

8.

Figure 2.9 Anonymous, *Fliegende Blätter*, 1890.

The taste for stick figures would last throughout the century in cartoons, most notably in the pages of Munich's *Fliegende Blätter* in the 1890s.

Figure 2.10 J. J. Grandville, originally published in *Le magasin pittoresque*, 1840.

cedures "by means that are comparatively crude, from the perspective of their limited, successive, and subjugated action can, in truth, create a whole," Töpffer acknowledges, but that is not enough: "It is neither the objective nor the result of aesthetic unity to simply produce a whole." Its true aim is much more ambitious. It is "to create a being" (Töpffer 1998, 331).

It is self-evident that the semiotic system generated by such a being (as the soulful creation of an authentic individual) is much more robust, energetic, and varied than the product of reasoning: "A whole can be destroyed by a lacuna of several parts and a rupture of several links; but a being continues to be a being no matter the rupture of several links and the gap of several parts." It is this robustness that Töpffer observes in the most incomplete graffiti. His entire semiotic system is based on the mysterious way in which these

kinds of symbols and diagrams can survive the operations of subtraction (or stylization) that are inflicted upon them. "If I sketched before you, very imperfectly, an animal that would have four fine limbs, an ample belly, a thin tail, and two long ears, you would say, in fact you're already saying, 'It's a donkey.' However, this sketch has no resemblance to an actual donkey; but it is already so similar to your idea of a real donkey that immediately, instantaneously, the real donkey is plainly evoked" (Töpffer 1998, 392).

Töpffer constantly reminds us that "a sign can be shortened indefinitely": rather than destroying it, subtractions actually move us closer to the intended idea of the illustrator. "And if these proofs are not enough . . . let's pay a visit to Mr. Grandville and ask him to draw, with only five lines (one for the chest, four for the limbs), men that dance, that salute, that bear arms, entire scenes full of spirit, of reality, of movement, of life. . . . here we have suppressed color, form, line; worse: we have suppressed the face, the body, the feet upon which they dance, the hands used to carry a sword, the head that is used to salute, and nevertheless these rascals still salute, dance, and fence with such grace that it is a pleasure" (Töpffer 1998, 389).

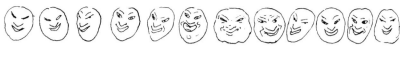

"Ceaselessly trying (and during spare time, to have no regrets) to trace human figures that always and necessarily have a specific expression that is sometimes much more lively and comical than we could ever have hoped to expect, is, of course, recreational. After all, these faces live, speak, laugh, cry. . . . Personally, we have always preferred these partners to whist or picket partners" (*Essai de physiognomonie*, 1845).

From the vantage point of a twentieth-century reader, all symbols and diagrams that are indefinitely reduced move toward an evident limit: the arbitrariness of the sign. We cannot follow Töpffer in his cascade of subtraction without imagining the tipping point that, from the ideogram to the letter, would definitively hasten the symbol into the state of abstraction that is constituent of all written language. And yet Töpffer uses Grandville's stick figures to come to a radically different conclusion: we can suppress color, form, lines, faces, bodies, feet, hands, head, "and yet these rascals still salute, dance, fence with such grace that it is a pleasure." In other words, pushed to the limits of abstraction, Töpffer's graffiti does not become an arbitrary sign. On the contrary, it gets even closer to the living, breathing core of its creator. Most readers today would probably be hard pressed to take Töpffer's conclusion seriously, but it is a most important distinction.

When Töpffer started to draw his picture stories, the canvas of his little theater was very different from the one on which today's reader is tempted to ground Töpffer's "primitive" style (as a kind of code, a conventional shorthand). The true background of his picture stories is an arabesque fresco populated with cheerful and lively graffiti. From this source, his little graphic actors sprout to bring the thoughts of the author to life. And if (verbal) language is a part of these festivities, it is because it shares the same energy, the same verve, the same freedom, much like the pen strokes themselves: cursive, incomplete, bouncing, lively. Töpffer always took great care in leaving some visible clues to remind the reader that his paper pantomimes were not the product of the "other kind of doodle": the imitative, rational, conventional kind. In examining the profound reasons that brought him to invent the comic strip, we will better understand why it was so important to keep this distinction well in sight; to read his comic strips as if they were written in some sort of rational code or conventional shorthand would be to utterly miss their irony.

Figure 2.12 **Rodolphe Töpffer, doodles taken from the original manuscript of *Mr. Trictrac*, ca. 1830.**

In different essays and articles, Phillippe Kaenel has provided a precious perspective on Töpffer's graphomania (Kaenel 1996). Every sheet of paper within Töpffer's reach was immediately covered with improvised arabesques and mixtures of grotesque creatures and stock characters, sometimes placed in situations, sometimes piled up like furniture or a house of cards. In his *Essai de physiognomonie*, Töpffer established a direct link between his mania for doodling and the creation of characters for his stories.

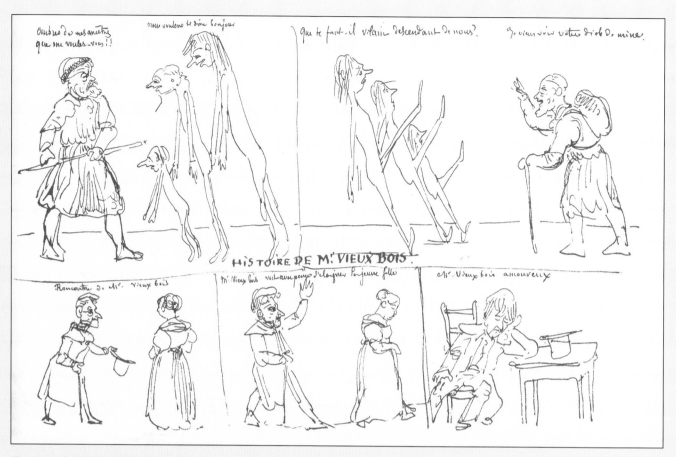

Figure 3.1 **Rodolphe Töpffer, _Storia del signor Vieux Bois_ (Milan: Aldo Garzanti Editore, 1973).**

The first page of the manuscript of _L'histoire de M. Vieux Bois_, drawn in 1827 in the presence of Töpffer's students. Although the two upper vignettes have no apparent relation to the narrative, they are by no means trivial. As indicated in the following passage, the story is (most likely) born of a little exercise based on "the theory of gesture and theatrical action" by the German specialist Johann Jakob Engel.

"The oblique position of the body is a general and common trait in the expression of all types of desire. If the desire is an attractive one, the head, the chest, and generally the entire body move forward, with the feet promptly following this impulse. The body throws itself suddenly backward and with great haste if the desire is a repulsive one, thus uniting all characters in their fear and aversion. The position in which one finds oneself, the nature of the desired object, the sense or the series of thoughts in response, all bring about many changes in expression." "On Imitated Physiognomies and On the Relation between Physiognomy and the Art of the Comedian" (Lavater 1820, 258).

3

The Arabesque Novels of Rodolphe Töpffer

The Second Form of the Novel in Prints

The second form of the novel in prints was born at the end of the 1820s before a small group of students whose teacher, Rodolphe Töpffer, wanted to share his interest in pantomime and the theory of theatrical action. A very busy amateur

actor in his home town of Geneva, this son of a painter, who earned his living in a private school, had good reason to be interested in the rhetoric of gesture, a subject that carried a great deal of formative baggage for him both as an artist and as an actor.

Fortunately, Töpffer's first paper pantomime has reached us in its original form, in a manuscript from 1827 that contains the initial version of *Les aventures de Mr. Vieux Bois*. The very first leaf of the story (fig. 3.1) gives us an indication of the logical manner in which a quick experiment in the semiotics of theatrical action developed into a vast anti-academic parody. By pulling this thread, one can unravel an entire chapter of the history of comics and rewrite it so that the foundational myth of the invention of comics by Rodolphe Töpffer is turned on its head.

The first three images of the adventure are not isolated but are placed under two enigmatic vignettes. In the first image of this pair, a bearded man in a defensive posture reacts to the ap-

pearance of three ghosts, exclaiming: "Shadows of my ancestors, what do you want of me!!" One of the ghosts responds: "We want to say hello." In the image next to it, we find the same protagonists in an inverted position. The bearded man is now smiling, with one hand raised in greeting, while the three ghosts fall back in fear: "What are you doing, O villainous descendent of ours?" "I'm here to see your funny faces."

The presence of these two vignettes on the first page of the story of Mr. Vieux Bois is n ot accidental. We are watching, here, the start of a half-scholarly, half-whimsical discussion on the semiotics of body language, inspired by the seminal reference work of the era: Johann Jakob Engel's *Ideen zu einer Mimik* (1785). Engel's ideas were discussed at length in an (unsigned) essay (Anonymous 1820) published in the annexes of Gaspard Lavater's *L'art de connaître les hommes par la physionomie* (1820), which Töpffer likely owned. The paragraph reproduced in figure 3.1 is taken from this text. It is the starting point of Töpffer's classroom demonstration.

Figure 3.2 **Henry Siddons, *Practical Illustrations of Rhetorical Gestures and Action*, from a work on the subject by Johann Jakob Engel, London, 1822. Rodolphe Töpffer, *Les Amours de M. Vieux Bois* (Geneva, 1839).**

A comparison between figures taken from the English adaptation of Johann Jakob Engel's *Ideen zu einer Mimik* (1785) and the beginning of *Mr. Vieux Bois* (the 1839 version actually furthers the similarities between the two). Töpffer adapts the melodramatic attitudes to the different situations but generally respects the (strictly codified) position of the feet, as well as the attractive and repulsive movements of the head and chest. Töpffer's personal experience as an actor evidently gave him a large margin of invention and interpretation in his theatrical pastiches.

Theatrical melodrama, the sentimental genre par excellence, dominated the scene at the time, and the pantomimes that were performed during the musical interludes of the plays constituted their high points. Desire (attractive or repulsive) was naturally at the heart of Engel's system of theatrical gestures. By confronting both versions of "the ghost's salute," Töpffer wanted to show his students how pantomime was a language in which an actor, with a simple trick of visual syntax, could invert the meaning of a scene by inverting the "arrow" of desire.

Given the context, it was logical to complete this example with a small melodramatic action, and that is precisely what Töpffer did by drawing the three images that constitute the starting point for the adventures of Mr. Vieux Bois. While the first two sketches invited the students to compare two opposing versions of the same event (the "ghost's salute"), the experiment this time was about the creation of a visual syntagm—the pictorial equivalent of a verbal phrase. The graphic language most capable of treating this type of operation was found in the specialized books on theatrical gestures. Numerous convergences indicate that in drawing the first sequences of *Mr. Vieux Bois*, Töpffer was largely inspired by the illustrations of the 1822 English adaptation of Engel's book.

Figure 3.3 **Joseph Franz von Goez, *Lenardo und Blandine: Ein Melodram nach Bürger* (Augsburg, 1783). (Iconographic source: Andy Bleck)**

In the romantic era, the interest in progressive action, in the rhetorical and dramatic sense of this expression, had burgeoned since the 1766 publication in Germany of Gotthold Ephraim Lessing's *Laocoon*, a pivotal essay on the respective limits of painting and poetry. Lessing was a leading playwright in Germany, and after the publication of *Laocoon* he continued to reflect, in articles dedicated to the stage and to the language of pantomime, on the radical conception of action that he had initiated in the domain of poetry. Engel's *Ideen zu einer Mimik* continued the thread of Lessing's thinking on the subject.

Lessing's and Engel's books implicitly encouraged the creation of diagrammatic systems that would allow a dramaturge to note the phases of a theatrical progressive action for didactic purposes. After *Laocoon*, the illustrated books destined for actors and orators demonstrated a growing interest in this question.

Lenardo and Blandine by Franz von Goez (1783) offers a striking example of an early isolated attempt in this direction. The work is composed of 160 captioned engravings that detail—pose by pose—the staged progression of one of the first German melodramas. It is a unique example, for its time, of a pantomime on paper that runs the complete length of a volume. However, the book has an essential difference from Töpffer's picture stories: Goez's sequence records the action without the slightest ironic distance, while Töpffer's comic strip cannot be understood properly without taking into account the author's irony. When Töpffer draws on Lessing's and Engel's enthusiastic views on progressive action in order to compose the adventures of Mr. Vieux Bois, his borrowing, as we shall see, implies the most stringent theoretical and philosophical reservations.

Figure 3.4 **Gilbert Austin, *Chirono-mia; or, A Treatise on Rhetorical Delivery*, 1806.**

The treatise on rhetorical gesture by Gilbert Austin aims to provide a "rich and simple language, apt to express, with brevity and perspicacity," the different changes in body language of an actor or an orator. Although there is no evidence to suggest that Töpffer knew this method (which combined an abstract system of nota-tion with an index of postures), the rhetorical sequences of his albums show that he and Austin had learned the same lessons from the works of Lessing and Engel.

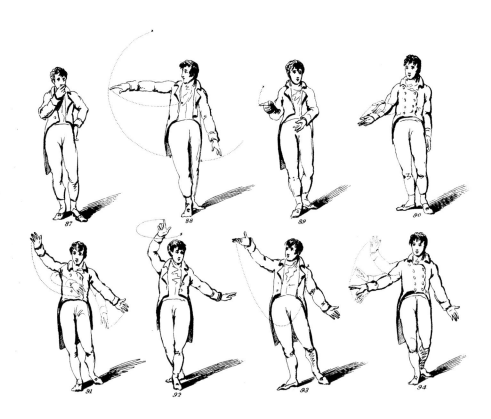

In *Laocoon*, Lessing memorably criticizes the genre of descriptive poetry, which for centuries had been considered the legitimate way to "paint a tableau with words." In opposing this tradition (which dominated German poetry of the era), Lessing proposes to base poetry exclusively on *action*, a choice of which Homer offers the best classical example. In contrast to descriptive poets, says Lessing, the author of the *Iliad* can never be mistaken for a painter: he essentially describes *progressive actions*, and bodies and objects only appear in the poem in order to contribute to the action. Further, Homer never evokes them for more than a single line in the same passage. In this, says Lessing, Homer recognizes the impossibility for poetic language to represent anything other than a succession of fragmentary images that could never lay claim to the simultaneity of a material tableau.

If one wants to graphically record the component gestures of a theatrical action, the correct procedure can be logically deduced from this analysis: it is a matter of constructing a chain of schematic images, where each link isolates a "word"—an elementary feature—of the figurative discourse.

Gilbert Austin's *Chironomia*, a didactic work published in England in 1806, works in exactly this way. Copiously illustrated with diagrammatic plates, the book sets out to find a "rich and simple language, apt to express with brevity and perspicacity the different modifications" of the gestures of an actor or an orator (Austin 1966).

In describing his own notation system, Austin cites this premonitory reflection, taken from Hogarth's *Analysis of Beauty*: "Action is a sort of language which perhaps one time or other, may come to be taught by a kind of grammar-rules; but at present is only got by rote and imitation" (Austin 1966, 271n; Hogarth 1997, 104).

According to Austin, it was high time to create this dynamic "grammar." The portraits of actors, their static postures evoked by isolated figures, was, in effect, not enough "to give an idea of their manner, connected with the whole of the scene. . . . Some art, or some invention is wanting, that may keep pace with the public speaker, and represent with fidelity his manner of delivery and his gestures, accompanying his words in all their various transitions and mutual relations" (Austin 1966, 280).

Thus, at the start of the nineteenth century, the pedagogical terrain was ripe for the invention of a visual language capable of representing the actions of an actor throughout an entire drama, and to record them for posterity, "towards repeti-

Figure 3.5 **Rodolphe Töpffer,**
Histoire de M. Crépin, **1837.**

Figure 3.6 **Rodolphe Töpffer,**
Histoire de M. Jabot, **1833.**

By their repetitive aspect, Töpffer's
strips that take up this rhetori-
cal vein clearly recall the didactic
plates that circulated in the theatri-
cal circles of the era. (Six decades
later, cartoonists would find in
chronophotography another typi-
cally repetitive model to parody.)

tive and practical ends," writing them as easily as common language in abbreviated notations.

The first sequences drawn by Töpffer—whose thoughts had followed a path similar to Austin's—perfectly perform this function: the postures of Mr. Vieux Bois are linked like discreet units in order to articulate a visual record of the action. As Töpffer would explain much later in his *Essai de physiognomonie* (1845), their very sketchiness finds, in this context, its own justification:

> If I want to draw a head showing bewildered fright, a foul and cutting mood, stupor, an inane and indiscrete curiosity, I confine myself to the graphic signs that express these emotions excluding everything else that would be associated with them or that would distract from them in a fuller

imitation. This, more than anything else, will allow clumsy artists to depict sentiments and passions with reasonable success, because it is helpful for their weakness to have only one thing to express at a time through a means that is all the more powerful because it is isolated. (Groensteen and Peeters 1994, 192)

Leaving to painters the task of producing "more complete imitations," Töpffer clearly approaches the question in conformity with Lessing's teaching: in his stories, objects and bodies participate in progressive action by presenting a succession of single traits "disengaged from all of the others." The visual chain that results from this process resembles a phrase, where gestures, expressions, attitudes, and postures have taken the place of words.

Figure 3.7 **Rodolphe Töpffer, *Histoire de M. Crépin*, 1837.**

"Egyptian" stylization. In his essays on art, as in his novels in prints, Töpffer identifies the stereotyped language of academicism (from Egyptian paintings to books on social etiquette) with the mechanical processes of industrial fabrication.

Nevertheless, an attentive reading of Töpffer's complete works—his picture stories as well as his serious novels and his essays on art—shows that he couldn't possibly vouch for Lessing's theoretical conceptions on progressive action without a deadly dose of irony. The arguments exposed in *Laocoon* suggest a rigid set of prescriptions for the poet to follow if that poet wants to properly represent a scene; yet, we know that Töpffer mistrusted any system posing as an authority on the question of imitation (*mimesis*) in art. For Töpffer, representation is never a goal in itself (which one can approach by slowly perfecting technique or theory) but always a means to an end: "The artist sees, he feels, and wants to express what he feels; imitation offers a means for that goal: that is art" (Töpffer 1998, 160–163).

In other words, no reason in the world should stop a poet from expressing his deepest sentiment within a descriptive poem if he feels like it. To declare, like Lessing did, that the imitation of a *progressive action* is the only mode worthy of poetry because action represents the most rational use of the imitative possibilities of language was, in Töpffer's view, tantamount to cutting the wings of poetry.

For Töpffer, systematization—*l'esprit de système*—whatever its justification, was intolerable in art: for him, rational rules inevitably lead to uniformity and academicism. Lessing's opinions on the subject of acting underline the differences between the two men: "The stage requires an expression that is so accomplished that it is impossible to add to its perfection. To achieve this, I cannot see any means other than to study all the particular nuances in the outward characteristics of the simple and composed passions.... The talent that leads to this clever imitation, *by a mechanical process established on invariable rules* [italics added], is the only true method to study the art of the comedian; otherwise the spectator and the actor will speak of warmth, feelings, depth, truth, nature, grace without agreement and without having any firm and positive ideas" (Lessing 1754, 209, 256; Anonymous 1820, 238).

Intellectually, Töpffer was absolutely at odds with this conception. In his texts on art, he contested the legitimacy of any work that pretended to be the result of the mechanical application of a process or a system, whatever it may be, and he virulently denounced the impoverishment of the expressive language, which never fails to follow.

On this question, Töpffer always reasoned with the subtle and fastidious vigilance of an author sensitive to the ideological stakes that the choice of a (graphic and verbal) language brings into play:

Academic language, the language of elegant yet cold formulas, pure yet unchanging, the favored language under the Empire, is the very image of academic drawing that I was talking about. It shows the same faults from the same causes. It substitutes, in some way, stereotype for individuality, methods consecrated by the great usage to expressions that were born of common usage. That language is, entirely and for everyone's use, in the dictionary; it has no more movement, life, and variety than academic drawing; it has isolated itself from nature by which I mean the spoken language, alive, energetic, ceaselessly growing, modified by everybody, and to which, like the art of drawing, it must ceaselessly come back if it want to preserve these qualities. (Töpffer 1998, 125)

We know that, deep down, Töpffer's little actors are grounded in the lively spirit of graffiti; but his pantomimes are clearly meant to enact, on paper, a language entirely contained in artificial "dictionaries" (starting with the stereotypical postures of Engel's *Mimik*). In other words, we must read his picture stories as perversely enacting his own definition of academicism.

Here, we begin to grasp the degree of skepticism with which we must approach Töpffer's invention of a new kind of sequential art. The stories that he drew expressed the ironic side of a perfectly coherent anti-academic view on art. In fact, not only academicism but progress, materialism, and the industrialization of society were all within Töpffer's crosshairs. These trends were typical of the modern world in that they attempted to standardize everything they touched, and to see everything in terms of mechanical processes. They were all connected by their use of the same rhetoric, that of progressive action, and they all spoke various sequential idioms of the same domineering language, that of progress in action.

Today, what was the clever work of man's hand has become the mechanical work of a crucible, a cast, which will give you a thousand, twenty

thousands cups, all identical in shape, style, and price: indeed, this is made by [mass] fabrication. Progress is not so much Industry creating more beautiful objects, as it is fabrication endlessly multiplying less beautiful objects. It does for things what civilization does for men; it puts them all in the same crucible. Thus it is against manufacturing that we hold a grudge. (Töpffer 1998, 77)

Through the language of progressive action, Töpffer's picture stories really explored the idioms of progress. To do so, they fell back upon the cartoonist's favorite weapons: the sketchiness of caricature, the mixing of genres, and the collision of tones and styles. All of these can be found in the stunning scene from *Mr. Crépin* in which Mr. Fadet, the etiquette teacher, instructs the hero's eleven children in the rules of French urbanity. Literally "programmed" by this formal instruction, the junior Crépins are conditioned to react like synchronous automatons, a situation that Töpffer amusingly treated in the "Egyptian" manner (fig. 3.8).

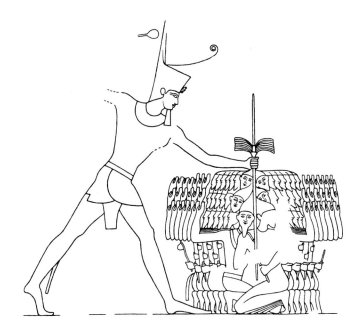

Figure 3.8 **Heinrich Schäfer, *Principles of Egyptian Art* (Oxford: Oxford University Press, 1974), 226.**

"There remains, of Egyptian painting . . . a load of perfectly conserved pieces. Out of all these pieces, a salient trait dominates: it is the same tendency to reduce faces to general types; divinities, heroes, warriors, priests, slaves, they are all types; in no way do they have any individual character. A thousand slaves are represented in a thousand different scenes, and it is always the same slave" (Töpffer 1998, 106).

With his comic concatenations of drawings, created to closely resemble a verbal sentence, Töpffer wishes to show the point to which the foolishness and automatization of industrial civilization threaten to blunt the mind of modern man. There is no doubt that in his comic strips the rhetoric of progressive action plays the role of comic foil opposite the "living, energetic, unbound" language that the author claims elsewhere. In a text that could have been dedicated to Töpffer, Henri Bergson marvelously describes how laughter gushes forth from such a contrast:

> In a public speaker, for instance, we find that gesture vies with speech. Jealous of the latter, gesture closely dogs the speaker's thought, demanding also to act as interpreter. Well and good; but then it must pledge itself to follow thought through all the phases of its development. An idea is something that grows, buds, blossoms and ripens from the beginning to the end of a speech. It never halts, never repeats itself. It must be changing every moment, for to cease to change would be to cease to live. Then let gesture display a like animation! Let it accept the fundamental law of life, which is the complete negation of repetition! But I find that a certain movement of head or arm, a movement always the same, seems to return at regular intervals. If I notice it and it succeeds in diverting my attention, if I wait for it to occur and it occurs when I expect it, then involuntarily I laugh. Why? Because I now have before me a machine that works automatically. This is no longer life, it is automatism established in life and imitating it. It belongs to the comic. (Bergson 1900)

Figure 3.10 **Rodolphe Töpffer, *Les amours de M. Vieux Bois*, 1839.**

Displayed in the style of direct representation, Töpffer's burlesque sequences recall the visual syntax of mechanical alphabets: they mock the triumphant reductionism heralded by most technical manuals. Paradoxically, the world of industrial progress would thus find itself enriched by a new graphic language perfectly adapted to its needs. The kinesthetic/mechanical brand of slapstick that Töpffer invented was to return to comic strips in full force during the era of Edison and the Lumière brothers, giving rise to the very first cinematographic fictions (in the vein of the Lumières' *Sprinkler Sprinkled*).

This rhetoric undermined by automatisms, which periodically returns to the same gestures and the same postures, marvelously defines the comedy in Töpffer's novels in prints. With seventy years' lead on the French philosopher, his paper pantomimes already demonstrated the Bergsonian orator "in action."

The industrial world was awash in "visual idioms" that cried to be expressed through the medium of progressive action. One of them, undoubtedly the most important for the future of the comic-strip form, would give birth to the modern meaning of the word *action* (in the sense of a dynamic sequence in an action film).

This is the language of visual slapstick—in which each phase of a corporeal or mechanical action is analytically depicted—and it appears very early in the story of Mr. Vieux Bois. After a second failed suicide attempt, the hero launches himself in pursuit of his beloved, but the rope around his neck is still attached to the beam, which prevents him from passing between two trees, and later through the door of his own house. The drawings function here, as they do in early cinematographic slapstick, as actual technical diagrams that completely define the physical parameters of the situation that is depicted. The caption that concludes the sequence confirms this link: "Mr. Vieux Bois *invents a new process* to enter his house."

At the time when Töpffer drew *Les aventures de Mr. Vieux Bois*, the distribution of cheap manuals helped to popularize technical illustration, which was one of the principal vehicles of the then-ongoing Industrial Revolution (Ivins 1996). The purely visual syntax of mechanical alphabets, which were capable of describing any mechanical work through a combination of diagrammatic elements, was in the spirit of the times: "If the combination of twenty-four letters of the alphabet is infinite in literature, what could we not do with fifteen hundred elements or letters of the mechanical alphabet that we already possess and that grow with each day of new work? What industrial poems could we not compose with this new lexicon?" (Jobard 1857), the zealots of the era gushed about this new language. Töpffer's corporeal and mechanical slapstick ironically exploits the overriding sense of causality generated by this new syntax.

Figure 3.11 **Rodolphe Töpffer, *Histoire de M. Pencil*, 1840.**

Progress, which Töpffer liked to describe as a phantasmagoria, is represented in Mr. Pencil as a malicious zephyr whose disastrous effects are relayed by blind, and therefore infinitely stupid, mechanisms. The telegraph becomes an emblem of these chain-reaction phenomena (also assimilated to contagious diseases and rumors) that constitute, to his eyes, the true syntax of progress (and of progressive action).

For all that, the author of *Mr. Vieux Bois* never lost sight of the formidable coherence of the system that he denounced. The syntax of "industrial poems" was not a "technical" epiphenomenon: it was at the very heart of the semiotic system promoted by Lessing, and at the heart of the new rhetoric of progressive action—as witnessed by this key passage from *Laocoon*:

Homer does not describe the shield [of Achilles] as finished and complete, but, as it is being wrought. Thus he here also makes use of that knack of art, which I have already commended; by which he changes that, which, in his subject, is coexistent, into what is consecutive, and thereby converts a tedious painting of a body into a vivid picture of an action. We see not the shield itself, but the divine craftsman who executes it. He steps with hammer and tongs before his anvil, and, after he has forged the plates out of the raw material, the figures, which he destines for the ornament of the shield, grow, one after another, out of the bronze, under our eyes, beneath the finer strokes of his hammer. (Lessing 1853, 126)

Imagine the application of this "knack of art" during Töpffer's era, at the height of the Industrial Revolution. Imagine if the poets adopted the same "knack of art" to describe the world surrounding them. This absurd proposition is exactly what Töpffer intended to ridicule in his novels in prints. And it stands to reason that, in his eyes, "industrial poems" such as these could only depict a terrifyingly empty landscape:

Progress is the wind that comes from every direction at once, blowing on the plains, shaking the large trees, bending the reeds, exhausting the herbs, whirling the sands, whistling in the caves, and upsetting the traveler right up to the refuge where he counted on finding some peace. (Töpffer 1983)

The metaphors of the virulent essay from which this passage is taken are stretched to absurd lengths in *L'histoire de Mr. Pencil* (1840). Progress? A whirlwind of causes and effects that twirls the planet like a windmill abandoned in a storm, a contagious condition that penetrates

Cependant les gardiens du Télégraphe, s'étant aperçus de quelque chose, secouent ferme pour nettoyer l'instrument

Et toutes les lignes télégraphiques secouent aussitôt

56 Le Ministre étant averti que le Télégraphe est dans un état de crise, se rend lui-même sur les hauteurs et s'assure que c'est le Choléra qui s'avance sur la Capitale

Figure 3.12 **Rodolphe Töpffer, *Histoire de M. Pencil*, 1840.**

the mind and drives it toward chaos. Such is the case in this memorable passage from *Mr. Pencil* in which a dog, walking along the arm of a telegraph machine, "lightly" presses down on it, provoking with every movement a telegraphic chain reaction that plunges Europe into chaos.

What is most striking when reading Töpffer's slapstick sequences is that they themselves seem like a mechanism that flies off the handle, as if the eye were engaged in a combination of improbable mechanical operators, drawn forward by an irresistible current akin to a chain reaction.

This powerful psychological phenomenon is one of Töpffer's great strokes of rhetorical inspiration: an original way to captivate the reader/spectator that will resurface fifty years later in the first fiction film scenarios (such as *L'arroseur arrosé* [The sprinkler sprinkled]) and in the wordless picture stories that inspired them. In the mischief perpetrated by the young rascals of comics and the early cinematograph, the diagrammatic depiction of the setting of a pratfall leads to a similar kind of expectant fascination. The twentieth century never tired of the type of mechanical causality that propels the reader/

spectator toward the comical paroxysm of the story—as if the film and the comic-strip page constituted, in themselves, an infernal machine.

But the euphoria of cinematographic slapstick (typical of the Thomas Edison era) is still far in the future for the reader in 1830. In Töpffer's albums, the rhetoric of progress in action is not so much jubilant as grating and strange. It drifts toward a disturbing *grotesque* that could be found in German picture stories of the second half of the century, following the presentation of Töpffer's albums in this language.

For Friedrich Theodor Vischer, who wrote the preface for these translations, this vein of the grotesque represents humanity plagued by the incessant persecutions of the inanimate sphere and suggests an actual demonology of familiar objects (Vischer 1845; Kayser 1957, 113). Wilhelm Busch, the creator of *Max and Moritz* and the leading auteur of the humoristic journal *Fliegende Blätter* in the 1860s and 1870s, frequently adopted this outlook, which, Vischer argued, proceeded with the "turbulent accumulation of incidents . . . that, once released, would tumultuously deploy themselves right up to the point of completely disintegrating a segment of reality."

Figure 3.13 **Rodolphe Töpffer, *M. Cryptogame*, 1845.**

This episode of Mr. Cryptogame hides an ironic allusion to the most famous passage of Baron d'Holbach's *Système de la Nature* (1770). Using the image of a whirlwind (in which the smallest molecule will obey the rational laws of mechanics), the encyclopedist maintains that science can explain even the most chaotic elements of nature—including social turbulence. Töpffer ridicules the rigid linking of causes to effects on which this materialistic and deterministic conception is founded. Here again, the language of progressive action reveals itself as the most apt to represent the thought and rhetoric of progress in all their absurdity.

Vischer attributed to Töpffer the invention of the most characteristic image in this diabolic chain reaction: the "spinning wheel of an insane world." The emblematic figure of the whirlwind appears in an episode of *Mr. Cryptogame*, about which, incidentally, Goethe had already expressed his admiration (Töpffer 2004, 413). Although there was nothing truly fantastic or supernatural about the phenomena, it was an important signpost in the development of Töpffer's satirical discourse. After his attacks against academicism and the rhetoric of progress, the whirlwind figure marked the transition to an ultimate level of denunciation. Through this image Töpffer expressed his detestation of materialist philosophy by ridiculing a well-known passage from Baron d'Holbach's *The System of Nature*:

> *In a whirlwind of dust, raised by the elemental force . . . there is not a single particle of dust . . . that has been placed by CHANCE, that has not had a sufficient cause for occupying the place where it is found, that does not, in the most rigorous sense of the word, act after the manner in which it ought to act.*
>
> *In those terrible convulsions that sometimes agitate political societies, shake their foundations and frequently produce the overthrow of an empire—there is not a single action, a single word, a single thought, a single will, a single passion in its agents, whether they act as destroyers or as victims . . . that does not act as of necessity it must act from the peculiar situation these agents occupy*

in the moral whirlwind. This could be evidently proved by an understanding capacitated to seize and to rate all the actions and reactions of the mind and bodies of those who contributed to the Revolution. (Holbach 1770, 44)

In the famous episode of *Mr. Cryptogame*, human beings and objects, swept away like Baron d'Holbach's molecules by purely mechanical chain reactions, finish by forming a sort of maelstrom, an aqueous meteor.

This whirlwind represents the ultimate face of the world of progressive action described by Töpffer. But it also constitutes a real test for readers of his albums, since those who could not (instinctively or consciously) decode this emblem of the materialistic view of the world were condemned to swirl around the empty center of the adventure without understanding the true nature of the voyage.

Propelled from image to image like a locomotive on rails—or like an orator mechanically delivering his speech—the modern reader who forgets the fundamental law of life, which is never to repeat itself, the traveler who loses the secret of traveling in zigzag, and the amateur who loses the pleasurable art of exploring an intricate tableau, will have no luck deciphering this allegory of the void thought of the modern world—and there will be no laughter.

"Go, little book," Töpffer wrote as a preface in all of his albums, "and choose your world, for at crazy things, those who do not laugh, yawn; and those who do not yield, resist; and those who

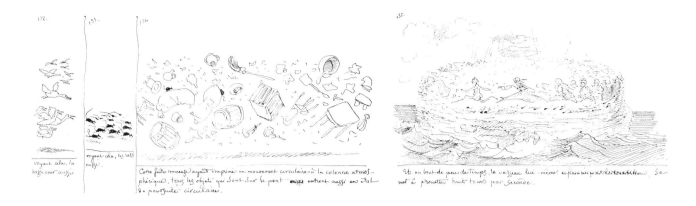

reason, are mistaken; and those who would keep a straight face, can please themselves."

It might seem to be a curious fact that a theoretician as prolific as Töpffer never produced an explicit theory of comics (or of sequential art). In truth, when his oeuvre is considered in its totality, we can see that he actually did present this theory, but implicitly. If this has escaped specialists of the Ninth Art up to today, it is because they have been waiting for a defense of sequential art, a positive theory of the comic-strip form (in line with our own cultural claims). But if one reads the serious and the comical sides of the Töpfferian oeuvre concurrently, what transpires is exactly the opposite: it becomes clear that the visual language of progressive action that he put together combined all the systems, all the injunctions, and all the models that characterized, to his eyes, the stupidity of the industrial world.

There are, of course, good reasons for the twentieth-century reader to miss the intrinsically ironic nature of Töpffer's invention, but what clues, if any, did he leave to help his contemporary reader avoid a similar misinterpretation?

In this respect, the extreme care with which he organized the printing and distribution of his albums was pivotal. Töpffer opted for an autographic technique that made each edition an original edition, produced in small print runs whose distribution he could personally control. These entirely hand-drawn books, produced on a very small scale, were often distributed from hand to hand (or accompanied by friendly correspondence). The irony of his illuminated novels lay entirely in the tension between the emerging mass culture they denounced and the archaistic and small-scale form they adopted for production and distribution. The person-to-person contact, like the quivering hesitations of the pen,

witnessed the chuckling, living intelligence behind his parodies. They were meant to contrast with the systematic minds and impersonal stereotypes that his stories caricatured. The handwritten captions, the lively arabesques of the frames in which he enclosed his little doodled actors, were part of the same counterpoint: in a cursive, breathing imitation of spoken speech, they contrasted starkly with the academic postures, compulsive errands, and repetitive actions of his comical creatures.

In his first albums, these traits were reinforced by a plot structure that evoked the anti-academic—and altogether archaistic—register of the picaresque satire. In *Kinds of Literature*, Alastair Fowler, after Claudio Guillén, characterizes the picaresque genre as "a loosely episodic narrative structure using recurrent motifs, circular patterns, incremental processes, and embedded subnarrations" (Fowler 1982, 58). The tradition dates back to the origins of the modern comic novel, and lent itself to improvisation and to the most whimsical experimentations with the narrative form. To Töpffer it offered a free and open language, with an unlimited range of possible parodies. Töpffer's albums were undoubtedly strange objects for the public of his era. In them, the modern world was depicted as an impossible phantasmagoria with its telegraphs, revolutions, obsessed characters dashing down country roads with the speed of locomotives, steam engine explosions, and flying telescopes. But this pulsating magic lantern show mysteriously took the form of an illuminated parchment; consigned to small oblong books, the adventures evoked the naïve manner of a tale from a bygone era.

In the 1830s, the public was becoming highly receptive to archaistic references of this kind. Carried along by the romantic wave, the reader

was fascinated by the Middle Ages, or at least by the imaginary version of the Gothic world that the novelists, poets, and publishers of illustrated books promoted at the time. Even if readers did not understand all the ins and outs of Töpffer's albums, they could still find a superficial pleasure in their bizarre and archaistic tone.

But some astute readers might also be tempted to place this atypical oeuvre in a more specific region of the literary landscape. At the onset of the romantic movement, there did exist an appropriate category for these strange picture stories: the eccentric, or arabesque, novel. When Cham (Charles Amédée de Noé) and Gustave Doré took up the genre, following Töpffer, it was clear that they understood his novels in prints as part of that tradition. Goethe, the man who had elevated German literature to the world stage at the end of the eighteenth century and opened up

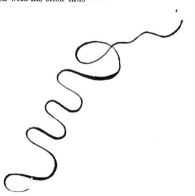

TRISTRAM SHANDY

Nothing, continued the corporal, can be so sad as confinement for life—or so sweet, an' please your honour, as liberty.
Nothing, *Trim*——said my uncle *Toby*, musing——
Whilst a man is free,—cried the corporal, giving a flourish with his stick thus——

A thousand of my father's most subtle syllogisms could not have said more for celibacy.
My uncle *Toby* look'd earnestly towards his cottage and his bowling-green.
The corporal had unwarily conjured up the Spirit of calculation with his wand ; and he had nothing to do, but to conjure him down again with his story, and in this form of Exorcism, most un-ecclesiastically did the corporal do it.

584

Figure 3.14 **Laurence Sterne, *Tristram Shandy* (London, 1759–1767).**

Illustration included in the text of Sterne's novel: with the end of his stick, one of the characters in the book draws the diagram for "liberty" in the air.

the way to romanticism, was very likely the first to carry out this rapprochement.

Comic-strip historians have never explained satisfactorily the enthusiasm of the giant of German letters for the adventures of *Festus, Cryptogame*, and *Jabot*, passed to him in manuscript (by a friend of Töpffer) during the winter of 1830–1831. Indeed, how can we understand the enthusiasm of an octogenarian poet for a genre that would still require two centuries to fully outgrow its contemptible image?

The actual reason for Goethe's enthusiasm was that Töpffer's picture stories brought together all the qualities that the author of *Faust* had himself helped to define for a generation of poets and novelists—those of a novelistic creation imbued with a spirit that the first romantics called the *Witz* (Menninghaus 1999; Muzelle 2006).

For the early romantics, one could only find the Witz in its pure form in certain singular and infinitely personal novels that were able to renew the genre at each attempt—novels such as Goethe's own *Wilhelm Meister* and Laurence Sterne's *Tristram Shandy*. In these books, which eluded definition and categorization, the first romantics detected the imprint of a poetic spirit that was universal, capricious, and fantastic, animated by a divine irony.

And here, three specimens of this rare species had reached the hands of Goethe, three diamonds of *Witz* from the purest water. Apparently the old master even had a little trouble separating himself from one of these precious manuscripts, guarding it jealously. The form of the incunabulum itself, the mixture of drawings and writing, its unusual origin—the manuscript was the work of an unknown author who had neither the intention nor the technical means to publish it at the time—contributed to making it a unique example of *Witz* incarnate. More than Goethe himself believed possible, Töpffer's eccentric little novels came close to embodying the form of the arabesque novel that, thirty years before, an entire generation had agreed to elevate to the rank of literary ideal.

By according the arabesque the status of a literary concept, the first romantics sought to evoke the spirit of play that haunted certain works conceived outside all canon and all systems. More than anyone else, Laurence Sterne brilliantly illustrated the art of the literary arabesque in his

Figure 3.15 **Rodolphe Töpffer, *Les amours de M. Vieux Bois*, 1839.**

Mr. Vieux Bois, racing in a straight line (at the speed of a locomotive), emphasizes the rigidity of the horizontal "railroad" of panels, which, in Töpffer's books, embodies the rhetoric of progress.

Tristram Shandy: however much one tried to find the idea that constituted the spine, the central panel of this strange book, it was never found. The poetics of the empty center was the very signature of the true arabesque at work, as a free and capricious way of creating things out of thin air and in an almost weightless state.

Cryptogame, *Festus*, and *Jabot* clearly belong to this fascinating literary constellation. The three stories sent by Töpffer were all improvised works; growing rhapsodically from one sequence to another, they conquered the blank pages of his small oblong books in the typical way of the graphic arabesque. Indeed, Töpffer's narratives deliberately spiraled around the empty hub of a missing central panel.

Festus, for instance, recounts the adventures of a man who leaves his home to see the world. Invariably locked inside a crate or a sack, however, the good Doctor Festus is forced to admit, after each leg of his journey, *that he has seen nothing*. At the end, the very point of the story is literally annihilated: Festus awakes in his bed, persuaded that the entire journey has been nothing more than a dream.

The materialist romance of Monsieur Cryptogame and Elvira describes an insoluble equation, a sterile loop of attraction and repulsion. Often taking the form of a carousel or a tornado, the trajectories of the two "lovers" are arabesques of "bachelor desires"; Cryptogame and Elvira are nothing but human molecules orbiting around a nonexistent sun.

All of Töpffer's monomaniacal heroes are invariably absorbed by sterile obsessions and delusions; incapable of producing a narrative subject in the traditional sense of the word, they are clearly related to the protagonists of *Tristram Shandy* and their trivial manias.

By connecting these Sternian themes to the industrial and materialistic view of the world, Töpffer introduced a corrosive hypothesis that would still haunt, decades later, the works of a Buster Keaton or a Samuel Beckett: *the soul is a tic*. This axiom, coined by Alfred Jarry (a great fan of Töpffer's comic strips, not incidentally), marvelously sums up the ruthless diagnosis that the small professor from Geneva pronounced on modern man.

By creating a new hybridization of literature and drawing, Töpffer came closer to the romantic ideal of the arabesque than had any of his predecessors. *Festus* and *Cryptogame* even returned to the graphic sources of the romantic concept by taking up the most important characteristic of the whimsical decorative frescoes in the ruins of Rome and Herculaneum, from which Raphael and his students took inspiration in decorating the papal loggias of the Vatican. As in these frescoes, the characters in *Festus* and *Cryptogame* float in a world where "the reality given to the impossible by the means of direct representation" (Töpffer 1837) plays with the laws of nature in general, and those of gravity in particular. In Töpffer's albums, bodies often fly through the air; given the slightest pretext, they take flight, madly swirling at the speed of the wind.

Töpffer's satire of an industrial, materialistic world in which the unthinkable hypothesis of spiritless matter reigns over every incident thus provided a new raison d'être for the phantasmagoria of the grotesque (the word, at the time, was synonymous with "arabesque"). Incidentally, this also makes Töpffer the key nexus in a surprising cultural genealogy: his work truly represents the missing link between the weightless world of

I have been very good,——the precise line I have de-
scribed in it being this :

By which it appears, that except at the curve, marked A,
where I took a trip to *Navarre*,—and the indented curve
B, which is the short airing when I was there with the
Lady *Baussiere* and her page,—I have not taken the least
frisk of a digression, till *John de la Casse's* devils led me
the round you see marked D.—for as for *c c c c* they are
nothing but parentheses, and the common *ins* and *outs*
incident to the lives of the greatest ministers of state ; and
when compared with what men have done,—or with my
ówn transgressions at the letters A B D—they vanish into
nothing.

In this last volume I have done better still—for from
the end of *Le Fever's* episode, to the beginning of my uncle
Toby's campaigns,—I have scarce stepped a yard out of
my way.

If I mend at this rate, it is not impossible——by the
good leave of his grace of *Benevento's* devils——but I
may arrive hereafter at the excellency of going on even
thus :

which is a line drawn as straight as I could draw it,
by a writing-master's ruler (borrowed for that purpose),
turning neither to the right hand or to the left.

This *right line*,—the path-way for Christians to walk
in ! say divines——

——The emblem of moral rectitude ! says *Cicero*——

CHAPTER XL

I AM now beginning to get fairly into my work ; and by
the help of a vegetable diet, with a few of the cold seeds,
I make no doubt but I shall be able to go on with my
uncle *Toby's* story, and my own, in a tolerable strait line.
Now,

These were the four lines I moved in through my first,
second, third, and fourth volumes.*—In the fifth volume

* Alluding to the first edition.

456 457

Figure 3.16 Laurence Sterne, *Tristram Shandy* (London, 1759–1767).

In book 6 of *Tristram Shandy*, the author expresses a wish to continue telling the story following "a tolerable straight line," acknowl-
edging that books 1 to 5 had strayed into numerous digressions. Making a transparent allusion to Hogarth's theory of beauty, Sterne
illustrated the (typically nonlinear) structure of his previous books with a series of supposedly explanatory diagrams.

In the majority of his albums, Töpffer used similar motifs around his vignettes (as detailed in this chapter), discreetly asserting
his affiliation with the romantic genre of the literary arabesque.

antique grotesques and the outrageous physics of
twentieth century "toons."

One of the principal theoreticians of the early
romantic movement, Friedrich Schlegel, once
declared that he wanted to write an essay that
he would title *Arabesken*, in which he meant to
present an explicit theory of stupidity (Menning-
haus 1999, 125). We see that Töpffer realized a
very similar project when he drew and wrote his
comic albums. Read in the light of the literary ar-
abesque, it is clear that his novels in pictures de-
nounce the language of progressive action as the
natural medium for displaying the void thought
of progress in all its avatars and idioms. Töpffer's
invention was, thus, very different from what we
tend to make of it. He was not the *benevolent*
"father of the comic strip" but rather the author

of a most extraordinary and ingenious broadside
launched *against* Lessing's original sequential art
concept. What we see, in hindsight, as a prom-
ising new form of expression was really meant
to be the perfect showcase for a comprehensive
theory of stupidity.

As this book hopes to demonstrate, how-
ever, the sequential form in itself is not the only
pertinent feature in the historical lineage of the
modern comic strip. From Hogarth on, illustra-
tors like Cruikshank, Töpffer, Thackeray, Doré,
and their peers, who sometimes experimented
with the picture story form, were also strongly
involved in the history of the comic (and the ec-
centric) novel. Moreover, they participated in the
birth and rapid growth of the illustrated press
and cultivated productive exchanges with practi-

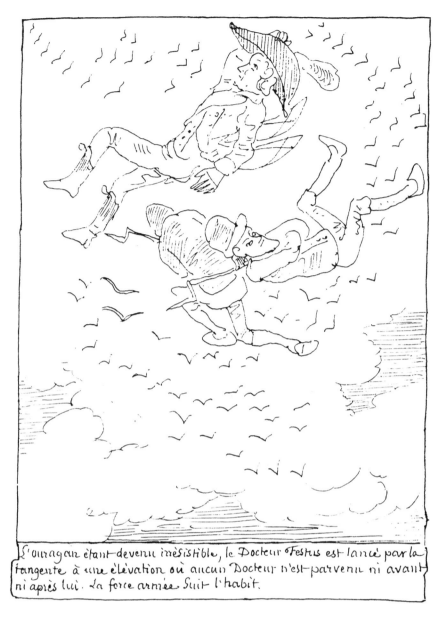

Figure 3.17 **Rodolphe Töpffer, *Dr. Faustus*, 1840.**

"The grotesques are a category of unruly and comical painting invented in Antiquity to decorate walls in which only forms suspended in mid-air can occur" wrote Giorgio Vasari (Muzelle 2006) in his classic description of the genre of the grotesque (at the end of the eighteenth century, the word "arabesque" was quasi-synonymous with "grotesque"). Taking advantage of the "reality given to the impossible by the means of direct representation" that his comic albums fostered, Töpffer invented novel reasons for such extravagances. His albums attest to a surprising affiliation between the antique tradition of the arabesque and the frenzied "physics of the toons" in the twentieth century.

cally all the emerging medias of the nineteenth century (photography, chronophotography, the cinema, etc.). Polygraphic humor was the prominent feature of their art; as we shall see, the twentieth-century brand of comic strip that appeared around 1900 directly proceeded from their ironic take on the nascent audiovisual technologies.

Half a century earlier, but very much working within the same tradition, Töpffer had the genius

to prepare the ground for this revolution by engaging a satirical debate with the modern idioms of progressive action. This debate is still going on today. One only has to open *Jimmy Corrigan, Krazy Kat*, or any book by Saul Steinberg to be reassured that the spirit of the arabesque is alive and well, and that the *Witz* continues to breathe in contemporary comics.

Figure 4.1 **Gustave Doré, *L'histoire dramatique, pittoresque et caricaturale de la sainte Russie* (Paris: J. Bry aîné, 1854). Wood engraving. (Collection Gérald Gorridge)**

Rabelaisian in tone, Gustave Doré's outrageous chronicle cultivates polygraphic contrasts: archaic, graffiti-like cartoons clash with elaborate illustrations drawn in the lavish romantic manner.

4

"Go, Little Book!"

The Novel in Prints after Töpffer

A survey of novelistic genres in Europe between 1740 and 1900 shows that the average lifespan of a literary genre is about twenty-five years (Moretti 2005); Töpffer started circulating *Mr. Jabot*, his first published album, in 1835,

and the genre of small oblong albums seemed to have quietly faded out in France and England by the end of the 1850s—neatly corresponding to the twenty-five year model. The actual extent of the genre's success in England is unknown, however, and more examples will probably be discovered in the future. Nevertheless, a number of milestones can be established, thereby highlighting the continuity of the literary and graphic traditions to which Töpffer belonged, and that his work renewed.

In France, it is clear that comic illustrators received the genre that Töpffer launched as a form of eccentric comic novel related to Laurence Sterne's *Tristram Shandy*. Around 1850, Töpffer also embodied a certain ideal for English and French illustrators whose horizons he had opened up by showing how it was possible to exist as a complete author outside the classic relationship between illustrator and writer (Kunzle 1992; Kaenel 2005). In England, the diffusion of the genre was tied to a small group that orbited around the two principal comic novelists of the period, Charles Dickens and William Makepeace Thackeray. One century after

Hogarth, humoristic illustrators still worked in unison with their literary counterparts, their polygraphic approach echoing what Mikhail Bakhtin calls the "hybrid linguistic structures" of the English comic novel (Bakhtin 1982).

The history of the novel in prints after Töpffer, however, got off on the wrong foot with the immediate bootlegging of the Genevan author's first three albums. Beginning in 1837, the pirated editions of *Jabot*, *Crépin*, and *Mr. Vieux Bois* met with great success at Aubert, the famous Parisian bookshop. Discovering the existence of these bootlegs, Töpffer published a note on the subject in 1839:

> *A handwritten book, that is to say one composed of original sketches whose charm resides in the spontaneity of making them, in the expressive freedom of the line, in a sort of mad negligence or comical impropriety, this very book, once it has been laboriously copied by the salaried employee of a publisher [no longer says] the same things in the same way, appearing inane where it seemed funny, stupid where it looked amusing. It is him, and it is not him. (Töpffer 1839)*

Figure 4.2 **Cham (Amédée de Noé),** *Deux vieilles filles à marier* **(Paris: Aubert and Cie, [1841?]). (Collection Juan d'Oultremont)**

Cover (private binding) of one of the books in the Collection des Jabots, published by Aubert and Cie.

In other words, if one erases the living arabesques of the graphic, cursive form (image and text included), all reference to the actual language of the author is suppressed in favor of the language the parody was supposed to ridicule. In the Aubert bootlegs, Töpffer's anti-industrial satire collapses like a house of cards, surrendering to the very same process that it denounces: the discourse of the three albums becomes flat, transforming itself into a monotonous display of silliness and stupidity.

Aubert went on to publish nine original albums in a special collection known as "les *Jabots*." On a formal plane, the series instituted a certain number of constants that would reappear in its Victorian counterparts: the oblong form is preserved but the panels are traced using a ruler, and the captions are typefaced. The publisher's employees thus erased the malicious chuckling presence that haunted the borders of the vignettes. In Töpffer's original books, the visual phrase lived and breathed under the mask of the rhetoric of progress; Aubert's *Jabots* expressed themselves in a mechanical fashion. Of the Töpfferian model, they kept only the automatisms.

In this collection, however, the seven albums produced by a young illustrator with the pseudonym Cham (Amédée de Noé) are not without interest. *Jabot, Crépin,* and *Mr. Vieux Bois* serve as prototypes here for a new format, and the process helps us understand the prism through which the young man read them.

The evidence suggests that Cham situated Töpffer's little novels in the wake of the French wave of eccentric novels by Xavier de Maistre, Charles Nodier, and others, based on the Sternian prototype (Sangsue 1987; Mainardi 2011). In every page of *Tristram Shandy*, Sterne asserted his authorial presence and resistance to the conventions of print culture (Keymer 2009, 130): examples of typographical idiosyncrasies abound (ubiquitous asterisks, dashes of varying lengths, unusual insertions of white space on the page) as well as striking metatextual gestures that violate the conventional boundaries of the text. Among the best-known examples of these Sternian transgressions are the black page dedicated to Yorik's memorial, the marbled page arbitrarily inserted in middle of volume 3, the blank page provided for the reader to imagine widow Wadman's portrait, a "torn out" chapter represented by a

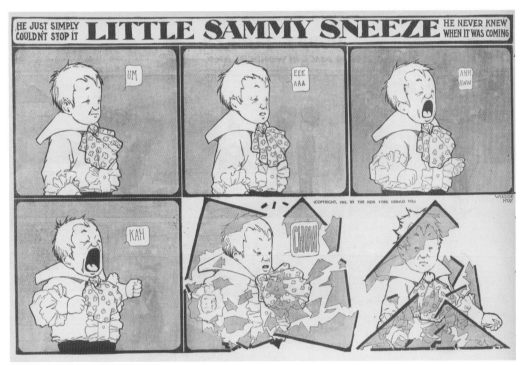

Figure 4.3 **Cham, *Deux vieilles filles à marier* (Paris: Aubert and Cie, [1841?]). Lithographic pen. (Collection Juan d'Oultremont).**

Figure 4.4 **Winsor McCay, *Little Sammy Sneeze*, September 24, 1905. (Collection Peter Maresca)**

Since its origins, the Töpfferian novel in prints ironically revealed its rhetorical structure, marking its relation with the English humorous novel of the eighteenth century. Töpffer, Cham, and Doré affirmed the primacy of the author's ironic presence on realistic representation: these images should be read, and not simply just seen. Winsor McCay, and many cartoonists after him, continued to recall this principle to the twentieth-century reader.

"chasm of ten pages," and, of course, the famous diagrams that comically illustrate the serpentine deviances that Sterne's digressive style imposed on linear expectation. Cham and other contemporary readers must have instantly recognized, in Töpffer's little books—in the strip-like shape of the story, the floating borders of the panels, the handwritten captions—a typically Sternian awareness of form and resistance to convention.

Following the lead of Sterne and Töpffer, Cham playfully exposed the devices he used (fig. 4.3); his most accomplished work, in this spirit, is the brilliant *Impressions de voyage de Monsieur Boniface* (1844). Although his humor never achieved the brilliance of Sterne's (to say the least!), the influence was indisputable.

The Sternian affirmation of the author's presence at the expense of realistic representation became typical of the post-Töpfferian novel in prints. The genre had only just begun its autonomous career in the publishing world, and the works of Cham, Gustave Doré, and others were already violating its boundaries, playing self-reflexive and provocative pranks as if to claim their right to the most capricious kind of wit.

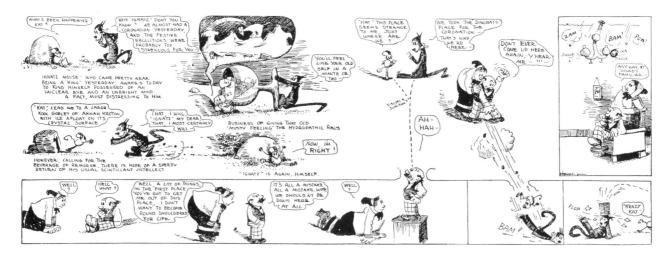

Figure 4.5 **George Herriman, *The Family Upstairs*, 1913. (John Fawcett, Maine Antique Toy and Art Museum)**

The creation of Herriman's *Krazy Kat* at the start of the 1910s offers a striking example of marginal transgression. The anthropomorphic pantomime debuted "at the feet" of the characters of a series entitled *The Dingbat Family*, soon to be renamed *The Family Upstairs* (in August 1910). The Dingbats, whose name provided the title of the preceding series, in turn became marginal as they continually questioned the (invisible) tenants on the floor above them. The *Krazy Kat* ministrip thus acquires a certain autonomy, but on a lower level—as a "margin of a margin."

The novel in prints was not supposed to take itself seriously, to believe in its own power of imitation. It seemed to assert that a margin can always generate another margin, and that the process can renew itself indefinitely. The credo still appears to be second nature to many cartoonists in the twentieth century. It shows up in animated cartoons (from Otto Messmer's *Felix the Cat* to the delirious works of Tex Avery) and has given rise to countless hilarious *mises en abymes* from Winsor McCay to *Krazy Kat* and *Mad Magazine.*

The spirit of ironic violation of the boundaries, the spreading of the action into the margins, has survived to this day, still an integral part of the comic and polygraphic tradition. Illustrators who belong to this artistic family jealously reserve the right to add a double layer of irony every time their language runs the risk of stiffening or becoming established.

The process that consists of exposing the "grammatical" framework of the medium, then transgressing the frame thus re-created, is typically baroque, as is comic authors' eagerness to exploit *all* of the machinery, *all* of the stages of creation, to slip into the smallest crack of the editorial apparatus by playing with the "seams" that assemble the elements of a book. Illustrator George Cruikshank provided a minor but striking early example of this attitude in the codas of the first issues of his periodical (*George Cruikshank's Omnibus*, 1842) when he inserted a small gag showing the disappointment of a "lady

in the bonnet" who had "missed the omnibus"; a typical inhabitant of the margins, the little lady became the source for illustrations and developments (such as fake letters to the editor) that grew more and more effusive with each issue.

Whenever the institutional context or the balance of power is favorable, cartoonists instinctively turn to the spirit of ironic transgression: they perforate their own framework to create margins beyond margins. The early issues of *Mad Magazine* give many examples of this attitude.

In the same spirit of irony and *mise en abyme*, a young illustrator who had also made his debut at the Maison Aubert embraced the genre with great enthusiasm: Gustave Doré published his first novel in prints at Aubert at the age of fifteen, *Travaux d'Hercule* (Labors of Hercules) (1847), which the publisher presented as a (late) addition to the *Jabots* collection.

Doré's third album, *Des-agréments d'un voyage d'agrément* (Unpleasant pleasure trip) (1851), took inspiration (as did Cham's *Impressions de voyage de Monsieur Boniface*; see above) from the French episodes of Sterne's *Tristram Shandy.* These tribulations, which focused on the inconveniences and minor incidents of a trip, suggest that every journey from point A to point B is essentially an empty form and a source of endless tedium for the modern traveler. As satires of one-dimensional "tourism" and its mindless automatisms, these albums should be contrasted, like those of Töpffer, with the positive models of

CHAPITRE X.

Tityre, tu patula.
ÉGLOGUE.

Nos voyageurs en sont quittes pour la peur et M. Boniface pour quelques cheveux. Les voilà hors de Beauvais. La compagne prend un aspect vif et riant.

CHAPITRE XI.

Six de l'un, une demi-douzaine de l'autre.
ALCIDE TOUSEY.

Trouvant le paysage monotone, M. Boniface tourne ses regards du côté opposé

CHAPITRE XII.

Dans les bras de Morphée.
UN CLASSIQUE.

Le Dieu gratifie M. Boniface de ses pavots !

CHAPITRE XIII.

C'est la merveille la plus rare.
JEAN DE PARIS.

Les pavots l'abandonnent, M. Boniface se réveille en apercevant le paysage du chapitre XIV.

CHAPITRE XIV.

Toujours la nature embellit la beauté.
PONCHARD.

Nature morte adroitement combinée avec la nature vivante.

Figure 4.6 **Cham, *Impressions de voyage de Monsieur Boniface* (Paris: Paulin, 1844). Woodcut.**

Cham's Monsieur Boniface ridicules the "rhetoric" of travel during the age of the railroad, a theme that evidently intersects with Töpffer's anti-industrial ideas. By eliminating panel borders and by inviting the reader to flit around the page, Cham once again openly marks the much sought-after contrast between progressive action (alienating, repetitive, purely sequential) and the capricious movements of the author's imagination.

travel narratives produced during the romantic era: traditional picaresque adventures, picturesque trips, rambling and digressive loitering, travels in zigzag. *Mises en abymes* and ironic excess abound in these works by Cham and Doré, and give them their bite.

The most significant change in these two albums touches upon the Töpfferian strip-like layout of the story. In switching publishers, Cham seized the chance to abandon the horizontal "railroad track" of the *Jabots*. These pages, and those from the Doré album, regroup several vignettes of variable dimensions, simply arranged in the blank space of the paper. They evoke the "macédoines" of humorous images that were Cruikshank's specialty in the 1820s and 1830s. The zigzagging journey of the gaze across the page, here, is preferred to the strictly linear kind

of tunnel vision Töpffer chose to express his satirical vision of the modern world.

If the two young caricaturists moved beyond the Töpfferian format, it was to freely explore the idea of the novel in prints that had, over the course of the 1840s, begun to interest almost every important cartoonist on both sides of the Channel. Encouraged by the popularity that their work enjoyed during the golden age of the illustrated book, comic illustrators dreamed of an alternate world in which the relationship between illustrator and writer would be inverted (Kaenel 2005). For Cham, Doré, and J. J. Grandville, the example of Töpffer crystallized this dream. Artists of this stature, however, were not content to slavishly imitate Töpffer's (ironic) strip-like grammar of progressive action. The challenge they took up consisted of inventing—as Töpffer

Figure 4.7 **Gustave Doré, *Des-agréments d'un voyage d'agrément* (Paris: Aubert and Cie, 1851). Lithographic pencil.**

The footprint of a Savoyard is inadvertently imprinted on the album of Doré's Parisian traveler. This is one of the most spectacular excesses in a novel in prints that is crammed with them. By multiplying such obviously fake "effects of the real," the author underlines the artificiality of the editorial enterprise. This typically Sternian strategy, which encompasses everything right up to the paratextual system of the book—including the editor's note—is found again in his *Histoire de la sainte Russie* (fig. 4.8).

himself had done—singular comic novels, deploying all the polygraphic resources, all the eccentricities, transgressions, and *mises en abymes* that these great cartoonists were capable of.

L'histoire de la sainte Russie (History of holy Russia) (1854), Gustave Doré's last and most ambitious novel in prints, perfectly fits this program. In this delirious chronicle of the history of Russia, graphic registers clash on each page, from the most minimalistic drawings to the most grandiose battle scenes. A page memorably adorned with one large red spot, again, affirms the book's kinship with Sterne's *Tristram Shandy*. The album draws upon one of the most ancient sources of the European comic novel by imitating the tone of Rabelais. Ever since Hogarth, the varied palette of comic cartooning had evolved in tight symbiosis with literary fashion. Professionally involved in the contemporary editions of comic master works (Cervantes, Rabelais, Shakespeare), the illustrators of the romantic age also knew the deep tradition of the comic novel much better than many of their contemporaries.

1542-1580. — Suite du règne d'Ivan-le-Terrible. Devant tant de crimes, el'gneu- l'œil pour n'en rien voir
que l'aspect général.

12

Figure 4.8 **Gustave Doré, *L'histoire dramatique, pittoresque et caricaturale de la sainte Russie* (Paris: J. Bry aîné, 1854). (Collection Gérald Gorridge)**

Laurence Sterne's *Tristram Shandy* contained a blotched page and various blank pages, to which Doré responded with a terrible red stain (marked with a rag) in his own (black and white) album.

"GO, LITTLE BOOK!"

GALERIE DES BEAUX-ARTS

Musée rétrospectif : débris curieux des vieilles industries humaines et de l'art personnel antérieurs à l'ère du grand art unique, mécanique, solidarique et pneumatique.

Figure 4.9 **J. J. Grandville, "Le louvre des marionettes,"** *Un autre monde* **(Paris: H. Fournier, 1844). Wood engraving.**

Like *L'histoire de la sainte Russie, Un autre monde* (Another world) (1844) by J. J. Grandville offers its readers a crystal ball in which every imaginable form of graphic stylization sparkles: bird's-eye views (taken from the carriage of a hot-air balloon), neoclassical ("Flaxmanized") views, perspectives ranging from the microscopic to the botanical, astronomical, fabulous, allegorical, emblematic, and so on. The deliberately heterogeneous entries of this immense potential workshop of contemporary polygraphy even include several typically Töpfferian idioms: the Grandville steam orchestras echo the "auto-mated" children of Monsieur Crépin; the section dedicated to the "Zig Zag trips" pays witty homage to Töpffer's *Travels in ZigZag.*

Today, one would not naturally place *Un autre monde* within the category of the Töpfferian comic novel in prints, but the fact that the book directly alludes to Töpffer and is entirely driven by his images (the text by Taxile Delord was written after the drawings, on Grandville's instructions) indicates otherwise. *Un autre monde* fully belongs to that eccentric genre in its early era of intense exploration.

Figure 4.10 **Caran d'Ache (Emmanuel Poiré),** *Carnet de* *chèques* **(Paris: Plon, Nourrit and Cie, 1892).**

Published in 1892, at the time the Panama Canal corruption scandal exploded in France, Caran d'Ache's *Carnet de chèques* can undoubtedly be considered a late resurgence of the Sternian vein, almost forty years after Gustave Doré's *Histoire de la sainte Russie*. Unfortunately, it also reflects the author's anti-Semitism; Cham was still drawing in this register even as the Dreyfus Affair unfolded.

Adopting the form of an actual checkbook, this little book uses different *effets de réel* (signatures, annotations, fingerprints) to denounce the manipulative personality of a corrupt Jewish banker (who annotates his check stubs with a strong Germanic "accent") and the pitiful excuses of corrupt deputies (of whom one is expressed in the first person in the initial sequence).

Confirming his own interest in the form of the novel in prints, Caran d'Ache would become, two years later, the creator of a new genre of textless "illustrated novels" with *Maestro*, a book that remained unpublished until its recent rediscovery in several original sketchbooks and its partial publication by the Centre National de la Bande Dessinée Internationale (CNBDI) in 1999. This imaginary biography of a virtuoso musician would have comprised about 360 pages of wordless panels had it been published in full.

In England, as in France, Töpffer's little books captured the interest of the best cartoonists in the 1840s and 1850s. The story of Mr. Vieux Bois was translated into English in 1841 as *Obadiah Oldbuck* and published without the name of the author by the London publisher Tilt and Bogue, using Aubert's bootleg editions. The same version would be reprinted in the United States a year later (Beerbohm, De Sa, and Wheeler 2003). George Cruikshank, the celebrated illustrator of *Oliver Twist*, possibly sponsored this first album (released by his publisher), whose frontispiece was drawn by Cruikshank's brother.

Cruikshank probably discovered *Mr. Vieux Bois* at the end of the 1830s by way of his friend Thackeray. By an extraordinary coincidence, Thackeray had spent the winter of 1830–1831 with the entourage of Goethe, in Weimar, at the very moment when Töpffer's picture stories (still in their manuscript form) were submitted to the aging master of German letters for his appreciation (Smolderen 2005; Kunzle 2007). Thackeray, who was only nineteen years old at the time, immediately began to sketch stories modeled on Töpffer's. With *Jabot*, *Vieux Bois*, and *Crépin* having just appeared in bookstores, the future author of *Vanity Fair* and *Barry Lyndon* found himself in the position of "smuggling" the Parisian albums back to his friend Cruikshank.

Soon after their release, Töpffer's novels in prints were then adopted by the nineteenth-century heirs of Fielding, Smollett, and Sterne. Cruikshank, who had made a brilliant contribution to the success of *Oliver Twist* during this period, was the Hogarthian illustrator par excellence; he had illustrated all the masterpieces of humorous literature of the eighteenth century, and his renown in Europe was immense. More than anyone else, he had helped to establish the sphere of activity of the modern cartoonist (from political caricature to advertisements, book and magazine illustrations, almanacs, and comic anthologies). The heart of this activity was the polygraphic kind of wit invented by Hogarth; in his long career, Cruikshank considerably enlarged the spectrum of conceivable graphic hybridizations.

The tumultuous relationship between Dickens and Cruikshank during the period when *Oliver Twist* was being published, however,

showed that a prestigious career was not sufficient to make a seasoned illustrator the equal of a young novelist (Patten 1992). French illustrators were not the only ones to suffer from their relationships with writers during this period, and Töpffer's example opened up the same perspectives to Cruikshank as it did to his Parisian colleagues: that of taking on the role of author by embracing this new form of comic novel, "driven" by the drawings.

Cruikshank's first attempt in this direction was undoubtedly his most successful and spontaneous. *The Loving Ballad of Lord Bateman* (1839) is based on a traditional song that the whimsical Cruikshank liked to sing whenever he had had a drink too many (or had children to entertain). However, the story was accompanied by fanciful explanatory notes (probably from Dickens's pen), and Thackeray polished the verses. The small book did not present itself as a pure novel in prints, and this probably explains why it has not been recognized as one until now. The pseudocritical apparel with which it was adorned is nonetheless representative of the movement toward the margins, evoked above—another example of the spirit of ironic transgression of the frame that characterized the Töpfferian form of novels in prints.

The graphic style adopted by Cruikshank for *Lord Bateman* used the contour line (shaded on only one side) that had been introduced in Europe at the end of the eighteenth century by the English sculptor John Flaxman and that aimed for the classical simplicity of Greek decorated vases. During the nineteenth century, cartoonists often took up this style; whenever they wanted to evoke an antique or archaistic tone, they turned to pure contour drawing or the Flaxman formula.

Cruikshank's second attempt at a novel in prints, however, was something of a failure. *Mr. Lambkin* (1844) transposes Töpffer's *Jabot* into a style that deliberately evokes Hogarth's. American historian David Kunzle sees this effort as a step on the road that would later bring Cruikshank to abandon the comic genre altogether, in order to denounce the dangers of alcohol in two picture story books that recalled Hogarth's morality series, *The Bottle* (1847) and *The Drunkard's Children* (1848) (Kunzle 1992).

Lord Bateman as he appeared previous
his embarkation.

The Turk's only daughter approaches to
mitigate the sufferings of Lord Bateman.

The Turk's daughter expresses a wish
as Lord Bateman was hers.

The "Wow."

The Turk's daughter, bidding his Lordship farewell, is impressed with
a foreboding that she will see him no more.

The young bride's Mother is heard
(for the first time) to speak freely.

And goes home in a coach
and three.

Lord Bateman, his other bride, and his favorite
domestic, with all their hearts so full of glee.

Figure 4.11 **George Cruikshank,** *The Loving Ballad of Lord Bateman* **(London: Charles Tilt, 1839). Etching.**

Published at the time George Cruikshank discovered Töpffer's novels in prints, this illustrated ballad already bears witness to the influence of the creator of Mr. Vieux Bois on the group of English illustrators who gravitated around Dickens and Thackeray. *Lord Bateman* foreshadowed the polygraphic spirit with which a number of cartoonists (such as Wilhelm Busch in Germany) responded to the genre initiated by Töpffer by pastiching old forms of picture stories.

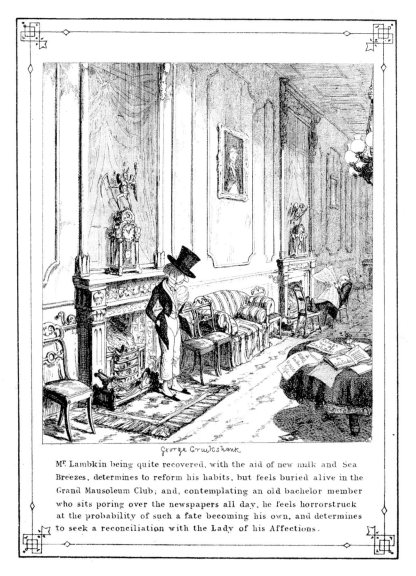

Mr. Lambkin being quite recovered, with the aid of new milk and Sea
Breezes, determines to reform his habits, but feels buried alive in the
Grand Mausoleum Club; and, contemplating an old bachelor member
who sits poring over the newspapers all day, he feels horrorstruck
at the probability of such a fate becoming his own, and determines
to seek a reconciliation with the Lady of his Affections.

Figure 4.12 **George Cruikshank,** *The Bachelor's Own Book; or, The Progress of Mr. Lambkin (Gent)* **(London, 1844). Etching.**

Lambkin could also be a (quite typical) instance of a polygraphic take on the derisory story of a modern snob, seen through the prism of Hogarth's series. In both cases, the operation fell flat.

Today's reader might be perplexed to see an artist as versatile and productive as Cruikshank toying with the so-called sequential form proposed by Töpffer, rather than simply adopting it. In this, Cruikshank was no different from other illustrators in England who published an indeterminable number of small books and leaflets around 1850. The formula used by Aubert for the *Jabot* collection was faithfully reproduced, and yet these ministories in etching demonstrate the variability of the genre, when interpreted by cartoonists of the era. Alfred Crowquill and Thomas Onwhyn, two illustrators who were younger than

Cruikshank but who moved in the same circles, made a specialty of short publications of this kind. These little books resemble what we would call *novelties*—the typical products of a feverishly commercial period, marked by the opening of the International Grand Exposition in 1851.

A brief look at twenty-five years of novels in prints shows that the production of Töpffer's direct heirs in France and England actually moves more often *away* from our notion of comics than toward it. This paradox requires explanation: Töpffer's albums, at least when they are read superficially, correspond more closely to the concept of comics that we hold today than do their immediate successors. This is mainly a distortion caused by hindsight. The landscape of humorous images of the nineteenth century has lost many of

M.ʳ & M.ʳˢ John Brown arrive at the Exhibition. M.ʳˢ B. had no idea they could have carried it to such a length. She despairs of ever getting through it.

Figure 4.13 **Thomas Onwhyn, *Mr. & Mrs. Brown's Visit to London to See the Grand Exhibition of All Nations* (London: Ackerman, 1851). Wood engraving.**

A number of English and French illustrators (such as Gustave Doré and Bertall [Charles Albert d'Arnoux], particularly in *Journal pour rire*) dealt with the theme of visiting the Grand Exhibition at the Crystal Palace. The subject combined extremely significant elements for the coming of comics in the newspapers. Here, we are already much closer to *La Famille Fenouillard* by Christophe (Georges Colomb) and *The Adventures of Tintin* than to the experimental and ironic novels in prints of Töpffer, Cham, and Doré.

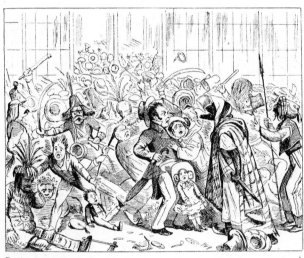

In the terrific rush to get in, a desperate row ensues. Grand melee of all Nations. The Browns barely escape with their lives.

They are carried in by the crowd

M.ʳˢ B. gets her bonnet dreadfully out of shape. M.ʳ B. looses his hat and coat tail. The little B.s escape wonderfully.

They soon set themselves to rights and begin to look about them. M.ʳ B. purchases a Catalogue.!

A Chinese explains; only they cant understand some of the wonderful productions of the Celestial Empire

"GO, LITTLE BOOK!"

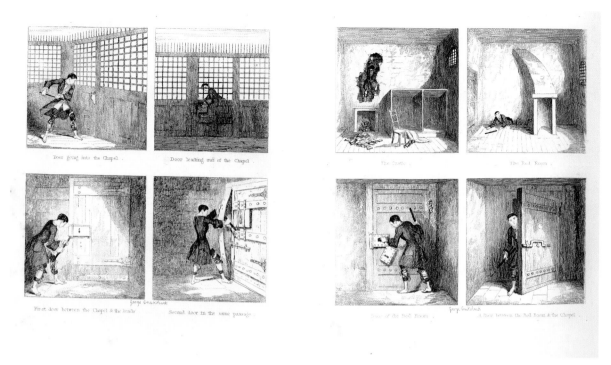

Figure 4.14 **George Cruikshank (illustrations),** *Jack Sheppard* **(London: Richard Bentley, 1839). Etching.**

Just after his work on *Oliver Twist*, and just as he was becoming conscious of Töpffer's stories, Cruikshank commissioned a historical novel from the writer William Harrison Ainsworth. His illustrations included two action sequences that illustrated the way romantic cartoonists started playing with older picture-story forms at the time.

its dimensions for us. A century of symbiosis between comics and the cinema separates us from this era, a period during which the audiovisual steamroller has radically simplified the model of progressive action by shifting it from the rhetorical domain to the cutting room. To look at the novels in prints of the era, including those of Töpffer, exclusively from the point of view of narrative sequence drastically blunts the complexities of a culture penetrated by many other dimensions of the readable image. The sophisticated forms of deciphering cultivated by the satiric/emblematic tradition played with simple picture stories like a cat with a mouse, but the comic illustrators of the nineteenth century, as a general rule, continued to favor the traditional (nonnarrative) tools of their craft. Cruikshank's collections of humorous drawings, for example, which did much to refresh the landscape of the decipherable image in the 1820s–1830s, were seasoned with all kind of puns and rebuses, free associations of ideas, playful contrasts and comparisons, and so on. These humorous devices called for the same kind of deciphering that had applied to the richly textured world of "hiero-

glyphic" (allegorical and emblematic) images since the Renaissance.

At the end of the nineteenth century, the satirical works of Frederick Burr Opper, Richard Fenton Outcault, and many other representatives of the comic tradition were still rooted in the culture of the satirical image. The pervasive nature of this model, at least in the humorous press, goes a long way toward explaining the relatively marginal status of the (much simpler) picture-story form in comic art during the nineteenth century. However, it is important to recognize the deeper stylistic continuity that allowed the comic artist of the nineteenth century to switch so easily between the narrative and the deciphering ways of reading an image.

When humoristic illustrators turned to the picture-story genre, they generally used all kinds of old templates from popular culture—illustrated ballads, crude chapbook woodcuts, atrocity prints, and so on—as vehicles for their anti-academic attraction to the archaic and the naïve. This romantic "preference for the primitive" (Gombrich 2006) accounts for much of the perplexing variety of nineteenth-century

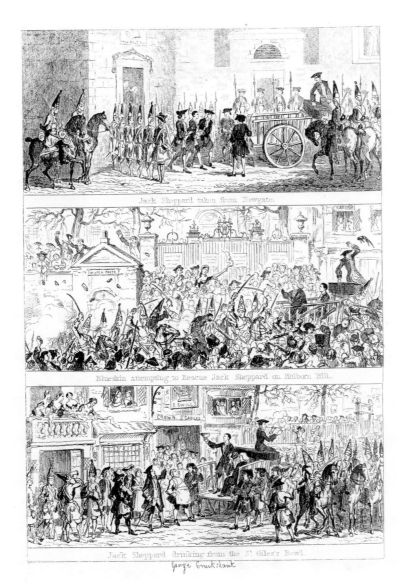

Figure 4.15 **George Cruikshank (illustrations), *Jack Sheppard* (London: Richard Bentley, 1839). Etching.**

The escape sequence of the novel's eponymous bandit takes inspiration from contemporary depictions (1724) of the criminal's heroic exploits (Kunzle 1973, 191), describing the different phases of the operation in a series of explanatory diagrams. Here, Cruikshank globally adopts the same austere, purely descriptive tone, only adding the stealthy silhouette of the bandit. If the hyperanalytic treatment of the episode bears some resemblance to Mr. Vieux Bois's escapes, it is no accident: Töpffer's slapstick also made reference—but ironically—to the model of the technical diagram.v

picture stories and for many of the ambiguous forms that are difficult to classify as "proper" comic strips.

This whole field was rooted in Hogarth's satirical works. To read a humoristic picture story or decipher a humoristic image, one had to navigate through a "polygraphic space" where the artist ironically stylized and compounded different systems of representation. In the nineteenth century, as in the eighteenth, visual humor was, above all, an exercise in flexibility for the modern visual polyglot. By vocation, polygraphic humor is, generally speaking, a prolific generator of hybrid forms, and that generator was kept very busy by the success of the romantic illustrated novel, by the late Gothic/early Renaissance revivalism that inspired many illustrators after the 1840s, and by the frenetic ecology of the illustrated press in general. George Cruikshank's

The Loving Ballad of Lord Bateman (1839) and his sequential illustrations for *Jack Sheppard: A Romance* (1840) are typical of the polygraphic reframing and compounding of older sequential formulas (Kunzle 1973, 191). In fact, except for the direct influence of Töpffer, most of the sequential material produced by the comic tradition in the nineteenth century playfully referred to the popular picture stories of yesteryear and was deliberately archaic in tone and design.

By the end of the 1850s, the original form of the Töpfferian novel in prints (the format popularized by Aubert's *Jabots* collection) had disappeared, but the genre had already overcome a capital barrier: in 1844, it had entered into the world of newspapers with Cham's adaptation of Töpffer's *Monsieur Cryptogame* for *L'Illustration* (see the following chapter). There is, however, one important exception to this general move-

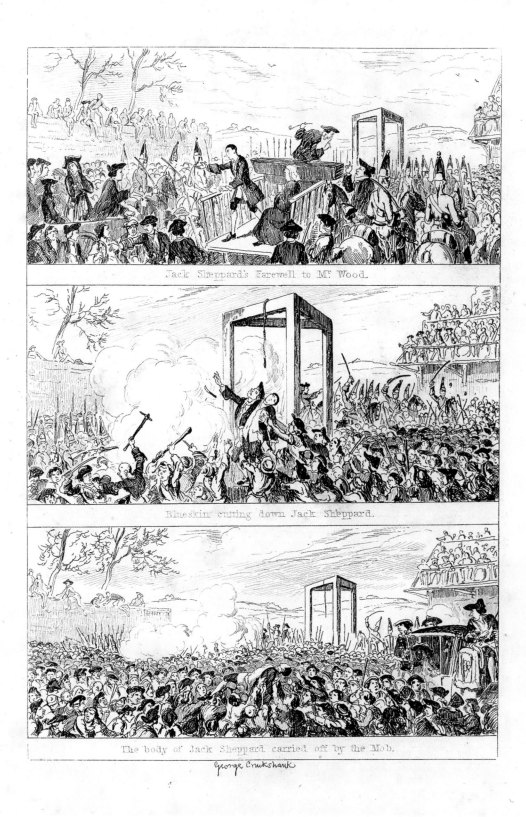

Figure 4.16 **George Cruikshank (illustrations),** *Jack Sheppard* **(London: Richard Bentley, 1839). Etching.**

The images of the execution in themselves recall the end of the bad apprentice in Hogarth's series *Industry and Idleness*, evoking the tradition of the atrocity prints of the sixteenth and seventeenth centuries, which described in detail to all of Europe the progression of the most sensational executions (Kunzle 1973).

Figure 4.17–Figure 4.21 **Alfred Crowquill (Alfred Henry Forrester),** *Pantomime: To Be Played As It Was, Is, and Will Be, at Home* **(London: J. Harwood, 1849). Wood engraving.**

Fascinated with pantomime shows since the start of his career, Crowquill here interprets a magical spectacle "to be played at home," in a narrative that adopts the general form of Aubert's *Jabot* collection—thus translating this archaic (but extremely popular) theatrical genre into Töpfferian language. In order to better highlight the charming improprieties that characterize progressive action in the pantomime shows (the passing from one plane of reality to another, the arrested postures, the transformations, etc.), the author resorts to typically Töpfferian devices like empty frames and visual metonymies.

ment away from the form of the novel in prints. Wilhelm Busch (author of *Max and Moritz* and *Pious Helen*) represents an important deviation from this trend. In the last third of the century, Busch drew and wrote a number of novels in prints that were a major influence on the international community of humoristic illustrators of the period (Kunzle 1990, 1998). His picture stories are typical of the stylized evocation of the old tradition of popular imagery, which he combined with the tone of nursery rhymes, legend, and folktales. Quite different from the Töpfferian canon, his mix of rustic and contemporary themes became extremely popular during this period. His well-known work should probably be seen as another genre, altogether a third form of the novel in prints, as distinctive, in its own right, as the Hogarthian and Töpfferian forms.

The Curtain rises to slow music | And discovers a pair of legs | The Fairy who owns the legs summons her sisters | Who like other Ducks, stand upon one leg

The Queen of the Fairies appears on a soft cloud, and tells a love tale. | Upon which her Court put their heads together and dance | The Lover (on earth) explains his feelings, but is discreet enough not to say a word | The desired young Lady puts out the desired hand

She descends and brings down three rounds of applause | Her parent comes home from somewhere and interferes with a horsewhip | The Lover escapes to the delight of all the Lovers in the Theatre | She sulks in a very pretty attitude

"GO, LITTLE BOOK!"

A prince, out a hunting sees her, thinks her the prettiest dear that he has seen all day.

The father, like a man of the world, thinks it a good hit

He drags her forward She wishes her father, farther

The prince kneels and offers her the proceeds of the last half hours taxes!!

The Lover rushes in, knocks him down, and absconds!

Everybody pursues the rash youth — therefore there is no one on the stage.

The prince goes to the devil, who springs from the earth at his summons. — after this feat he comes down on his own !

He promises to stand his friend and bids him use force

She is very much _moved_ but wont go on

The good Fairy appears!

The Devil is in a devil of a stew

The Prince is stupid and penitent

The Lover offers up his hat and a thanksgiving

The Maid does the same thing in her own way

The Father feels (as a pantomime father) that he has done very wrong

The Lover is changed to Harlequin As he never had any change about him before, he is delighted

The Maid is changed to Columbine, and keeps doing this sort of thing, which does not astonish her parent

The Prince tumbles and flies all to pieces

The father is changed to Clown and a fool, both of which he was before

The Prince turns into Pantaloon

The good ones float away upon Clouds and the bad ones sink into the cellar, and the fun begins —

He courts a lovely (pantomime) female and steals her shawl Police

He is alarmed by the bat of Harlequin

He burns himself with a red hot poker, this is positively necessary

He treats Pantaloon in the most undignified manner

The Clown makes a desperate Leap to catch the Harlequin and fails of course

He shows a great contempt for constituted authorities and receives much applause

This kind of pantomime storm is remembered by all the youngest Inhabitants

He robs the innocent

Clown catches the Lovers tripping

He seizes the magic Bat

Harlequin loses his power

Last Scene _ Blue Fire! Happy Lovers _ Everybody gets upon everybodies shoulders Curtain falls

"GO, LITTLE BOOK!"

Figure 5.1 **Cham (Amédée de Noé), after** *Töpffer, Histoire de M. Cryptogame, L'Illustration,* **January 25–April 19, 1845. Wood engraving.**

5

The Evolution of the Press

Between Institution and Attraction

The publication of *Histoire de Monsieur Cryptogame* in *L'Illustration* in 1845 marked a decisive turning point for Töpfferian picture stories. Adapted by Cham from Töpffer's drawings, *Cryptogame* introduced the genre to the periodical press,

a transplantation that would shape the future of the form for more than a century.

In moving to another medium, Töpffer's invention also changed its raison d'être. Its artistic goals could no longer remain the same: the aim was not to produce an autonomous work—a novel in prints—but to share in the life and rhythms of a periodical and its readers. The periodical press offered rich evolutionary possibilities; it also suffered from an obvious flaw: authors could not control this complex environment in the same way that they were able to control the publication of a novel.

The physical dimensions of *L'Illustration*, for a start, imposed a radical shift of format from the oblong shape of Töpffer's books. To the eyes of the twentieth-century reader, the grid solution adopted by Cham (fig. 5.1) seems modern, but we will see (in the following chapter) that this layout only came into its own in the period between 1880 and 1900 in the United States through the playful evocation of chronophotography and cinema.

In 1845, a layout of this kind represented nothing more than a default solution: strictly practi-

cal and neutral in terms of tone, Cham's grid was simply the easiest way of organizing a series of engraved blocks on a single page. The artist used the same method to juxtapose humorous drawings with no narrative connection (a ready-made solution that would likely never have occurred to a twentieth-century designer, for whom this type of arrangement inevitably suggests a dynamic—and cinematic—reading associated with comics).

When he permitted *L'Illustration* to publish *Cryptogame*, Töpffer knew that the strip-like format of his picture stories would not survive the operation. What was most important for him was that the ironic *tone* of his satire would not be lost. It was imperative to choose an artist who was capable of adequately interpreting his drawings in woodcuts.

In 1844, Töpffer wrote to his cousin Jacques-Julien Dubochet (the editor of *L'Illustration*): "It is necessary [that this adaptation] be entrusted not to a skillful designer—because God forbid that, due to some unwarranted sense of propriety one should serve cold what must be served hot and spicy—but to a pencil that is droll, yet docile and capable of respecting the zaniness of

Figure 5.2 **J. F. Sullivan, *On Expression* (continued) (detail), *Fun*, July 28, 1880. Wood engraving.**

In England, the picture story form followed parallel paths in the serious and the comic illustrated press. In the latter, artists like J. F. Sullivan continued using the traditional toolbox of the comic illustrator, playing self-reflexive pranks about the comic artist's profession—as in this series about expression—and frequently using allegorical devices to represent abstract ideas.

my drawings, my hyperboles of expression and movement, so as not to chain them to the chilling processes of the tracing paper and only to the cold and slavish variety of copying" (Gautier 1974, 133).

Beyond the stylistic *faute de goût*, Töpffer really feared a deeper kind of contradiction. The coldness of academic propriety and the mechanical application of industrial processes (like the tracing paper or any other form of slavish copying) were not only tasteless; they directly contradicted his true agenda. He had good reasons to be wary about a move that involved so many changes in technique and medium. He had drawn his stories in order to ridicule the rhetoric of progress, and here he was, offering to the illustrated periodicals of Paris, London, Munich, and New York—and, by extension, to the modern and industrialized world that he loathed—a visual language of progressive action that perfectly suited their needs.

From the end of the 1840s onward, stories derived from Töpffer's original model started evolving in the international press, in France, Germany, the United States, and Great Britain. The case of Britain is particularly interesting because it presented two quite distinct environments in which the form could develop: the seri-

ous illustrated weekly magazines and the humoristic press. These contexts imposed very different constraints on the ways the evolving form related to the social world, graphic tradition, and the periodicals in which it was published.

The artists who drew for the refined holiday supplements of the *Illustrated London News* and the *Graphic* clearly distanced themselves from the chaotic culture of graphic satire and from comicalities in the Cruikshank vein. Puns, emblematic political innuendos, the old phylactery (see chapter 7), and other hieroglyphic devices were completely eschewed from their vocabulary; the artists of *Judy*, *Fun*, and *Ally Sloper's Half-Holiday*, however, still used them every week in the popular humoristic press.

This contrast in tone reflected the fact that the picture stories of the *Illustrated London News* and the *Graphic* operated within a defined set of editorial values, while the humoristic press generally presented a chaotic and opportunistic environment in which the artists tried everything that worked (*Punch*, a very institutionalized periodical, was a notable exception). Hence this paradox: in the second half of the century, the British serious press gradually evolved state-of-the-art picture stories—including a purely journalistic kind—that were perfectly attuned

Figure 5.3 **Randolph Caldecott, *A Lover's Quarrel*, *Graphic*, Summer 1884.**

Serious British publications like the *Graphic* and the *Illustrated London News* completely discarded the old-fashioned tricks of the trade from the Cruikshank tradition, favoring straightforward storylines and an elegant brand of realism that Randolph Caldecott's picture stories epitomized particularly well.

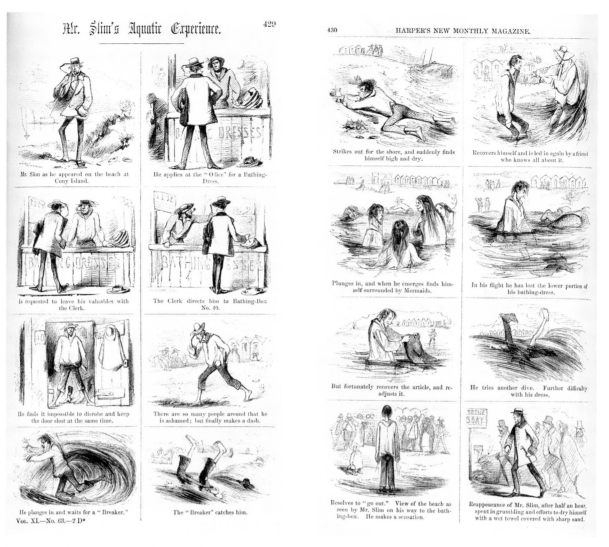

Figure 5.4 John McLenan, *Mr. Slim's Aquatic Adventures*, *Harper's New Monthly*, August 1855. Wood engraving.

A typical example of a social script developed in the burlesque fashion. It is worth noting that, thanks to picture stories of this kind, the breaking down of social scripts into distinct visual phases had already become second nature for readers of the press at the beginning of the twentieth century when silent films took on similar subjects and started to build their own system of editing action on a very similar basis.

to the late-Victorian modern environment; but in the end, it was the deep cultural memory and quick opportunism of the artists working in the international *humoristic* press that led to the creation of the modern comic strip at the very start of the audiovisual age.

Early in the 1850s, picture stories started appearing episodically in the Christmas supplements of the *Illustrated London News*, where they competed with artistic illustrations, musical partitions, puzzles, rebuses, and the inevitable illustrated report on the Christmas panto-mime shows in London theaters (which Alfred Crowquill initiated in the first year of the pa-

per's existence, in 1842). During the 1860s and 1870s, interest in the picture-story form seems to have grown slowly—or, perhaps, editors were slow to recognize public taste for pictorial narratives proper, as opposed to the other forms of thematic comic pages often produced by the same authors in the Christmas supplements. (It is worth noting that the contours of the picture-story genre were quite fuzzy at the time: authors would often draw pages of interconnected pictures that played on generic situations and were neither strictly thematic nor strictly narrative.)

By the 1880s, however, picture stories (often in color) had become a steady feature of the win-

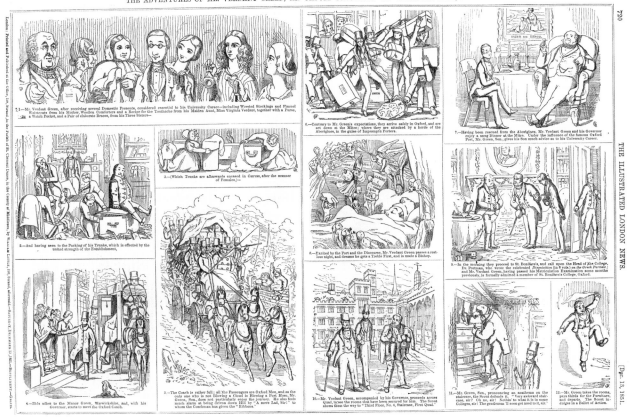

Figure 5.5 **Cuthbert Bede (Edward Bradley),** *The Adventures of Mr. Verdant Green, an Oxford Freshman*, *Illustrated London News*, **December 13, 1851. Wood engraving.**

ter and summer supplements, particularly in the *Illustrated London News'* great rival, the *Graphic* (launched in 1869). Moreover, a completely new genre of *journalistic* picture stories had also emerged in the two weeklies. For the last two decades of the century in these two periodicals, the form enjoyed a kind of golden age that for some reason has, until recently, completely escaped the scrutiny of historians.

The earliest picture story to appear in the *Illustrated London News* was *The Adventures of Mr. Verdant Green*, written and drawn by Cuthbert Bede (Edward Bradley) and published in two installments during the winter of 1851–1852 (Bede would later develop the idea in a novel). It was an uninspired story of an Oxford undergraduate moving from his family manor to the university and organizing his new life.

Bede's *Verdant Green* follows a basic trend that had already been asserted by stories in *Le journal pour rire* and the *Brown, Jones, and Rob-*

inson adventures drawn for *Punch* by Richard Doyle. In this early period, comic stories published by the press often appear to content themselves with documenting generic activities—a Christmas dinner, a hunting party, a boring visit to a friend in the countryside, a trip to the horse races—without offering any real "story point." The reader of today might be puzzled by their blandness but would likely miss the real nature of the enjoyment they procured to the public at the time. Sequences like *Brown, Jones, and Robinson: The Visit to Ascot*; *Mr. Verdant Green in Oxford*; and *Mr. Slim at Coney Island* (fig. 5.5) offered a new kind of experience to the reader by breaking down into visual stages the stereotyped social scripts they described. They were constructing those scripts pictorially for the first time. This was a new language, and as such it was probably fascinating to watch it build up, with diagrammatical precision, a picture of modern society in action.

Psychologists describe social scripts as the generic subconscious schemata that allow us to navigate smoothly within the complex mechanisms of social life (Schank and Abelson 1977). Such material perfectly suited the periodical nature of the serious and comic illustrated press, which closely followed the cyclical habits and behaviors of its readership. In the nineteenth-century illustrated press, the traditional ephemera of the old almanacs were replaced with a careful monitoring of theatrical seasons, annual horse races, feminine fashion, international expositions, weekends in the country or by the sea, and so on. Picture stories played a complementary role by documenting the same generic activities visually, with minimal variations and incidental anecdotes.

In short, Töpffer's pictorial language had quickly become the perfect vehicle for synchronizing the rhythms of the press and the habits of its readers. This key function goes a long way to explaining the successful symbiosis that the comic-strip form was to enjoy with the press for more than a century. In the serious press, editors would generally come to view comics as an *institutional* feature par excellence—the feature that most directly reflected the interests of the press as a *periodical* institution.

This status would later be expressed in unequivocal terms by the American trade magazine *Circulation* in the 1920s. In articles contributed by psychologists, sociologists, and press professionals at the highest level, *Circulation* goaded its clients into valuing the funnies as quintessential habit builders—the tool that could best strengthen the psychological automatisms that set off the buying impulse. By that time, of course, the serialization of the funnies had become, in itself, an institution, and the mirroring of everyday actions and routines by comic characters had been an integral part of the symbiosis of picture stories and the illustrated press for seven decades. In the heyday of behaviorism, the daily rendezvous with these funny creatures of habit was seen as the most important cog in a commercial machine that overtly enlisted the psychological characteristics of human nature in the service of the newspaper: "Novelty attracts readily but does not hold," writes Arthur Irving Gates, former professor of psychology at Columbia University, continuing:

A stronger, more reliable, more permanent source of satisfaction is the familiar—the attraction of the things to which we are adjusted by habit. . . . Once the habit gets under way, it takes care of the separate acts of the future. . . . It requires but little ingenuity to enlist these fundamental characteristics of human nature in the service of the newspaper. The question simply is: "How can the reading of this paper be made a habit, irresistible as other habits?" The answer is, it must have a continuity of familiar features; a constancy of general characteristics with, of course, the novelty of detail and content. Man's habits become adjusted to certain types, certain arrangements, certain features, certain locations. . . . Every evening a certain reader looks first for "Krazy Kat." If it is missing, he betrays his disgust in no mild terms—it is nearly as bad as finding his cigar box empty. . . . As we become drunkards by a drink a day, or saints by daily acts of charity, so we become devotees to a newspaper by a feast a day on the particular features which strike our fancy. Nothing holds like Habit. (Gates 1921, 18)

That the form invented by Töpffer would be cynically used to harness the automatisms of human nature in the interest of the press industry is deeply ironic but, in a way, perfectly logical. Remember that Töpffer's invention was tailor made to denounce the mindless, mechanical routines imposed on man by the industrial world (see chapter 3). His analysis was farsighted and penetrating; in hindsight, its graphic implementation was, perhaps, a bit *too* successful.

It appears, however, that the most interesting and lucid creators in the history of the genre were generally aware, at some level at least, of the inner tension on which the form was built originally. After all, the strip-like format that Töpffer had invented was, in itself, a commentary on the tunnel vision that the rhetoric of progress inflicted on modern thought. His satirical take on the industrial world was woven into the very fabric of the form he had created.

In the 1920s, George Herriman, Frank King, and Cliff Sterrett built their greatest works on that tension by playing the repetitive behavioral automatisms of everyday life (if we count the throwing of a brick as routine in the world of cartoons) against the *bigger picture*, permeating their work with wit brilliantly conveyed in the

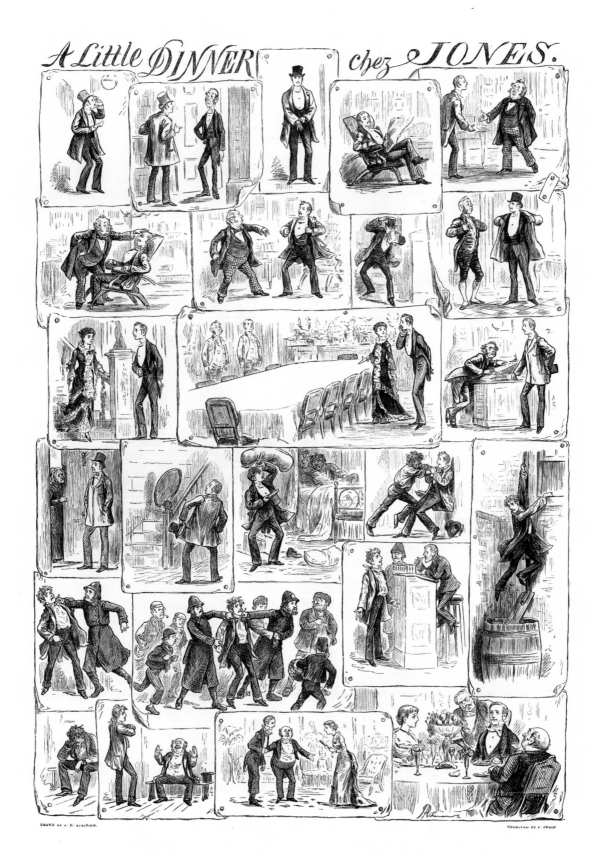

Figure 5.6 **J. P. Atkinson,** *A Little Dinner chez Jones,* *Illustrated London News,* **Christmas supplement, 1881. Wood engraving.**

The description of social scripts in picture story form perfectly suited the periodical nature of the press, and serious and humoristic artists constantly returned to the subject. The journalistic picture stories published by the *Graphic* were often based on original sketches sent in by correspondents, and the technique of the storyboard (as a narrative tool) was probably invented for the job. In a telling reversal of influence, comic picture stories like this one also began simulating the storyboard system as a tongue-in-cheek *effet de réel.*

THE EVOLUTION OF THE PRESS

layout of their pages. The most interesting thing about the artists published by the *Illustrated London News* and, fifty years earlier, the *Graphic* is that they seemed to have recognized the same fundamental tension at the core of the new medium. In fact, some of their most striking work can be seen as the missing link between Töpffer's witty theory of "sequential stupidity" and the meaningful inventions of Herriman, King, and Sterrett.

A page published in the *Illustrated London News* in 1856 (fig. 5.7) gives an early example of a social script presented in a truly Töpfferian spirit. In this foggy tale of "returning home after a Christmas party," a drunk man and his friend, going their separate ways and well prepared for a possible mugging, meet again and start battling in the dark before recognizing each other. The rather pointless story, the frenetic action, and the use of fragmented metonymic images are of course typically Töpfferian, but even more characteristic is the way the chain of events underlines the protagonists' misinterpretation of the scene. Like Töpffer's Doctor Festus, the two characters are suffering from an acute case of tunnel vision (their idée fixe about being mugged); they cannot see the big picture and are led blindly into sequential action.

The large format of the pages published by the British weekly magazines offered Töpffer's heirs an obvious battlefield for playing out these opposing forces by contrasting the layout of the page (which suggested the ironic point of view of the author) against the purely sequential action it displayed. The authors working for the *Illustrated London News* and the *Graphic* found many creative ways to exploit this inner tension between *big picture* and *tunnel vision*. The influential pages that Frederick Barnard started publishing in the late 1860s show that the problem was at the heart of the rich range of design solutions that were developed in these magazines.

Before the end of the 1860s, picture stories had only occasionally appeared in the seasonal supplements of the *Illustrated London News*. For artists like Charles H. Bennett and Alfred Crowquill, the Töpfferian form was one tool among many others, which they usually alternated with rebuses and puzzles, humorous variations on some theme, swarming full-page illustrations, and other comic devices. But a brilliant

page drawn by Barnard for the 1868 Christmas supplement seems to mark the point at which the genre, at last, started enjoying a significant revival in the serious press—first in the *Illustrated London News*, then in the *Graphic*, its main competitor (where radically new journalistic directions were to develop in the 1870s and 1880s).

Precocious Pete, or What Became of the Naughty Little Boy Who Would Go Behind the Scenes (fig. 5.8) tells the story of a precocious rogue who infiltrates the wings of a pantomime show and gets more than he bargained for. Once Pete enters the artificial (and adult) realm of the theater, the story becomes pure action. Pete is attacked by a phalanx of amazons and is defended by fairies; he is angrily kicked into the basement by the director; and so on. On several occasions, Pete is plunged into complete obscurity. In the end, a theatrical elevator propels him onto the stage, where he is finally fired off like a human cannonball.

This wacky chain of action and reaction reminds us of Töpffer's best slapstick episodes, but with a different underlying theme. In Töpffer's stories, the characters were usually swept along by the blind forces of materialism and industrialization. Here, it is the adult world that reacts in machine-like automatic defense against the foreign body of the boy, propelling him through the sequence in typical tunnel vision mode.

Like Töpffer, however, Barnard doesn't want to leave the presentation of the story to the purely rectilinear rhetoric of progressive action. His composition balances the strip-like, rigid tunnel through which Pete is propelled against a very peculiar arabesque device that seems to invite the gaze of the reader to follow its own free-roaming serpentine path on the surface of the page.

Quite independently from Töpffer (one presumes), Barnard thus comes up with a very similar solution. The contrapuntal arabesque makes it clear that the rhetoric of progressive action must be seen from the point of view of simultaneity and totality. Unlike Pete, the reader is not taken hostage by the train of action: the reader is free to explore the landscape of the page at leisure.

As for the obvious Hogarthian overtones of this solution (see chapter 1), the following remark by a contemporary author strongly suggests that they were not lost on Barnard either:

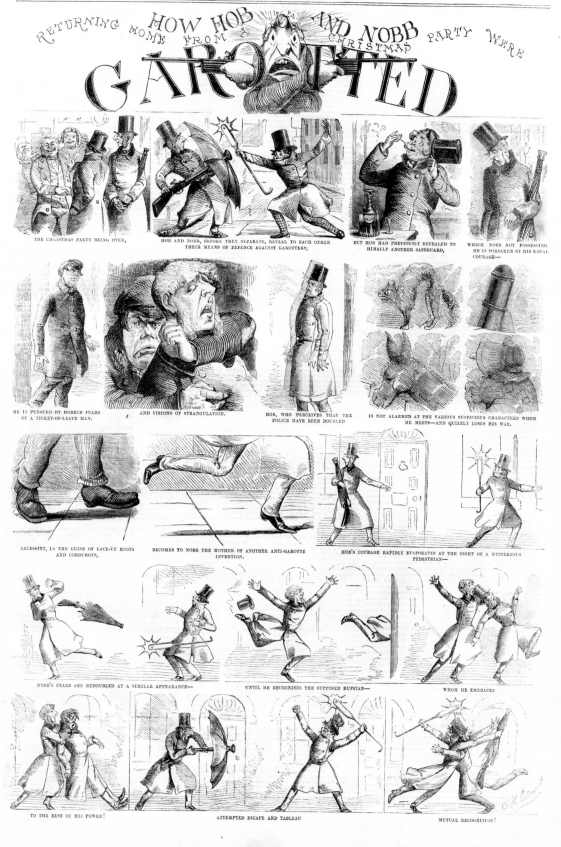

Figure 5.7 **Charles H. Bennett, *How Hob and Nobb, Returning Home from a Christmas Party Were Garroted*, *Illustrated London News*, December 20, 1856. Wood engraving.**

Mr. Barnard is little or nothing of a theorist, but if he may be said to have any theory at all, it is that of curved lines in nature and necessarily in drawing. Almost everything, he says, in nature, shews the truth of this. The very latest fashion in drawing and execution, that of rigid parallel lines, is artless and contemptible. His adopted theory of the curved lines will be found practised in all his work . . . and, upon investigation, somewhat of a revelation even to one long familiar with it. (Harper 1892, 43)

Barnard's use of the arabesque device is relevant to much of the compositional experimentation carried out by the next generation in the *Illustrated London News* and the *Graphic*. During the 1870s, 1880s, and 1890s, the artists of the two magazines would progressively drive the picture-story form toward new ground, and the rococo arabesques appear again and again in their designs. The drawings would be connected by serpentine lines of text or integrated by some curious structure of broken curves; in other cases they would be loosely arranged on the white page like islands in a slowly meandering stream. There are striking exceptions to this preference for the curvilinear, but there is no doubt that the contrast between simultaneous presentation (serpentine and intricate) and sequential content (straightforward action and/or rigid social scripts) was a constant preoccupation of the artists in these magazines.

It should be clear by now that their sustained interest in the form of the page cannot be reduced to purely decorative intention. In one way or another, these artists were all dealing with the same problem that Barnard and Töpffer had addressed before them and that authors like Herriman, King, and Sterrett would address in the future: they didn't want the rhetoric of progressive action to take control of their readers' thought processes and aesthetic enjoyment. It was their job, as refined comic artists, to frame this rhetoric in irony. The layout and design of the page was the natural instrument for the job: it was through this medium that the artist could both convey a certain tone to the storytelling and assert the totality and simultaneity of their vision.

During the 1870s, the *Graphic* began publishing a new kind of journalistic picture story in which the form took a new turn and became a vehicle for reporting events and true incidents. (The *Illustrated London News* was also, but to a lesser degree, involved in this development.) The *Graphic* was published every Saturday; distributed all over the British Empire, it was known for its network of professional "artists-correspondents." Its editors, however, were always pleased to "receive from the general public Sketches, Photographs and Portraits in connection with any interesting incidents of which they may happen to have been witnesses." The bulk of the journalistic picture stories published by the *Graphic* were based on such contributions (which were thoroughly reworked in London, before publication).

In their address "To Artists, Amateurs and all who are fond of sketching," the editors also gave some practical recommendations: "It must always be remembered that the Sketch should form the raw material which our artists at headquarters can understand and develop. Thus, in many instances, a good diagram, drawn with intelligence by someone with no artistic pretensions is a far better groundwork for an artist that a showy sketch with all the important details conspicuously absent" (*The Graphic*, December 28, 1889).

The reader of the *Graphic* had a pretty good idea of the kind of "interesting incidents" the editors had in mind: the drawings sent by amateur correspondents were meant to give an accurate (indeed, diagrammatic) image of everyday life across the British Empire. Most of the captions were written in the first person, and it was generally understood that the original eyewitnesses drew the sketches on which a story was based. This direct and explicit connection between the *incident vécu* and its pictorial report in the magazine was the whole point of the genre. For that reason, spectacular narratives were not welcome. In the hundreds of such pages published between the mid-1870s and the end of the century, nothing overtly dramatic, exotic, or sensational was ever presented in the form of a picture story. To be believable, the stories *had* to be quite unremarkable.

The new genre thus held a mirror to the routines and habits of the public. It was a logical extension of the role already played by Töpfferian comics in the periodical press, and the continuity between the two forms must have been obvi-

PRECOCIOUS PETER; OR, WHAT BECAME OF THE NAUGHTY LITTLE BOY WHO WOULD GO BEHIND THE SCENES.—SEE PAGE 638.

Figure 5.8 **Frederick Barnard, *Precocious Pete*, *Illustrated London News*, Christmas supplement, December 26, 1868. Wood engraving.**

Figure 5.9 **Harry Furniss, *The March of Science: Electricity at Christmas, Illustrated London News*, Christmas supplement, December 1879. Wood engraving.**

Following Barnard's example, Harry Furniss, like J. F. Sullivan, Alfred Chantrey Corbould, and many other comic artists of the period, frequently used serpentine lines to link the scenes of their picture stories. Here, the effect is put to good use by the artist to reveal the hidden connection between a series of electrical pranks played by the host of a Christmas party.

Figure 5.10 **Frank King, et al.,** *Crazy Quilt,* **part 4,** *Chicago Tribune,* **May 3, 1914.**

Known for the innovative layouts of *Gasoline Alley*, Frank King was, significantly, part of the gang of cartoonists who produced a series of extraordinary jam pages for the *Chicago Tribune* in 1914. The *Crazy Quilt* Sundays typically echo the earlier interest (shown by British artists like Frederick Barnard, Harry Furniss, William Ralston, and others) in contrasting the simultaneous whole of the page with some sequential action developing in tunnel vision mode. *Crazy Quilt's* individual strips intersect and interact in ways that spectacularly emphasize the same contrast between the point of view of the reader (who gets the whole picture) and that of the "funny creatures" worming through their tangled space.

Figure 5.11 **William Ralston and C. W. Cole,** *Dripping from a Water Picnic, Tsu-Sima Island, Japan,* **Graphic, May 18, 1889. Wood engraving.**

ous at the time because the artists who adapted the amateur's sketches for publication were typically involved in both kinds of work. Indeed, it was at this crucial stage of the process (when the raw material was developed by the "artists at headquarters") that journalistic picture stories regained some crucial characteristics from the original comic form.

William Ralston adapted an impressive number of such anecdotes for the *Graphic* between the 1870s and the late 1900s. He also drew many comic picture stories for the seasonal supplements. In *Drippings from a Water Picnic* (fig. 5.11), Ralston makes use of various humoristic devices to organize a report sent by C. W. Cole (a frequent contributor). The kettle painted on the Japanese fan is an emblem of the incident (a British domestic ritual held in foreign waters). The scenes are loosely connected by the flow of a stream or by vegetation, except for two drawings that are simulated to be roughly cut and are pasted on the right side of the page. Artists at that time often arranged their pictures on the page as if they were loose leaves pinned on a board—thus reminding the reader of the original sketches on which the reports were based. The technique of the storyboard (as a narrative tool) was probably invented to take care of this job, and it was typical of the humoristic approach to stylize this new visual language in the finished product, as a slightly ironic *effet de réel*. In a telling reversal of influence, many *comic* picture stories, at the time, also started simulating the storyboard system (see fig. 5.6, *A Little Dinner chez Jones*, for a striking example).

Alfred Chantrey Corbould was another frequent contributor of the journalistic genre. His picture stories were usually composed in the rococo style derived from that of Frederick Barnard and Harry Furniss (with serpentine lines connecting the different scenes), but in a brilliant report of a trip from London to Brighton (fig. 5.13), Corbould changed his approach to embrace the purely sequential experience of traveling at full speed, at midnight, on a new postal van.

There's no softening the edges of the frenetic action here, no flowing curves to integrate the different episodes in an elegant, ironic composition. The storyboard composition becomes a marquetry of fragmented images and chaotic sensations—until we come to the last scene, which shows the artist daydreaming on the train that brings him back to London. Taken as a whole, this landscape of fleeting impressions can be read as the reliving of the trip in the voyager's mind as afterimages pop erratically before his harassed eyes: the solitary cyclist flying like a demon on his arcane machine; the fracas of the first change of horses; the drunkard nearly caught by the wheels of the van; the rabbit frozen in the ray of the vehicle's lamp.

This curious assemblage of minor incidents (including the riddle of a strange light seen at a distance, followed by its "solution") is not the work of a serious, objective reporter. The page is characteristic of the peculiar slant the journalistic genre took in the hands of comic illustrators during the 1880s. At many levels, artists like Corbould and Ralston led the way in the art of pictorial reportage by introducing humoristic tropes that were deeply rooted in the Hogarthian tradition. The serious pictorial reporters of the time were still working under the ethos of the historical painter, trying to get to the heart of their subject with the one, *essential* image that would sum it up. Their humoristic colleagues were only interested in showing the lively, multifaceted *diffraction* of the events they reported. They looked at the world with the eye of an alert, humoristic observer. It was all about the amusing peripheral observation, the telling detail, the incongruous point of view, the unintended comic emblem, the odd visual riddle, the crazy-quilt grammar of contrasting attitudes and situations. The ethos, here, was more akin to that of a novelist in the comic tradition. It was the verve with which the story was told—not the subject itself—that conveyed the essence of the thing.

Another characteristic of the humoristic observer was a heightened sense of self-awareness. The comic artist-correspondent was always eager to highlight the limitations of an embedded viewpoint, subjected to all kinds of comical mistakes and frustrations. For the comic illustrator (fig. 5.14), the topic traditionally leads to some allegory of subjective misinterpretations in the Quixotic vein, where windmills are taken for giants—or, in this case, colleagues are taken for picturesque windmills. But transposed in the much more realistic context of seriocomic

Figure 5.12 **William Ralston and W. H. Deakin, *Leaves from the Diary of an Officer in India* (detail), *Graphic*, December 1, 1900.**

Pictorial reportage often borrowed from the humoristic tradition. Like many picture stories revolving around social scripts, this journalistic account of an uncomfortable journey by train descends, ultimately, from Töpffer's anti-industrial satires. As in Töpffer's stories, the actor's body, subjected to purely mechanical forces, can only express its frustration by working its way through a series of exaggerated, comical postures.

1. Loading at the Depôt, London
2. Picking up a Special Edition at Kennington
3. Good Night—Streatham
4. The Demon of the Road
5. The First Change of Horses—Croydon

6. A Narrow Escape
7. The Last Lamp
8. Too Astonished to Run
9. One Way of Getting Home
10. A Riddle

11. The Solution
12. Ware Trees
13. "The Chequers," Horley
14. The Meeting of the Vans at Horley
15. "Ten Minutes for Refreshment"—Horley

16. The Last Change of Horses
17. A Nap
18. Nearing Brighton—Dawn
19. Our Artist's Morning Toilette—Brighton
20. Our Artist On the Way Home Again

A MIDNIGHT TRIP BY ROAD TO BRIGHTON
WITH THE NEW PARCEL POST VAN

Figure 5.13 **Alfred Chantrey Corbould, *A Midnight Trip by Road to Brighton*, *Graphic*, December 31, 1887. Wood engraving.**

THE EVOLUTION OF THE PRESS

A BEAUTIFUL SPOT.

Our Artist has been sketching in quite a favourite part for artists. He says the place was full of artists, and yet they never seemed to be in his way at all when he was sketching. He is not so long-sighted as he used to be, but he jotted down some most beautiful effects of pure landscape.

Here is lovely effect—Trees (or something of the kind) against an evening sky.

Here is a peculiar bit—Pollard willow—(more or less) on a windy evening. (Our Artist says this is a most difficult subject, and he has known sketchers to get so disheartened at their failure to render it as to wildly destroy their canvas on the spot.)

Figure 5.14 **J. F. Sullivan, *A Beautiful Spot* (detail), *Fun*, September 23, 1880. Wood engraving.**

reportage (fig. 5.15), this sense of self-awareness becomes an integral part of the reporter's experience. The visual hazards encountered on the field by the artist and the photographer form the basis of a new vocabulary of embedded, ironic subjectivity that is probably one of the missing links between the visual idioms of the twentieth century and the prephotographic culture of comic illustration (Crary 1992).

Because of the inevitable interplay between comic and serious illustrations, the journalistic picture-story genre evolved swiftly during the 1870s and 1880s. Academically trained artists like W. B. Murray and Henri Lanos generally adapted the layouts of their pages of pictorial reportages to their own more sober taste, but they definitively retained something of the immersive, insider's gaze that characterized the comic reporter. These serious artists, however, were generally less interested in *people* than in unusual locations, innovative vantage points, and spectacular lighting.

During the short period when electric lighting coexisted with wood-engraved illustrations, a new grammar of light and shadow appeared in the pages of the *Graphic* and the *Illustrated London News*. To the reader of today, the solid rays of white light, the shadowy silhouettes, the sudden blinding flashes irresistibly evoke the language of film noir. But take note of the historical precedence: the shadow play, the strange industrial locations, the innovative points of view here ex-

ist only for their own sake. No drama is involved. It is only a generation or two later that film noir directors and cinematographers would think of combining such graphic visions with lethal plotting and dangerous actions.

The same goes for the true-life stories sent to the *Graphic* by amateur correspondents. In the hands of realistic artists like Joseph Nash Jr., Reginald Cleaver, Robert Barnes, and A. S. Boyd, some of these anecdotal reports appear incongruous because they are given a dramatic treatment sometimes worthy of Harold Foster (figs. 5.17, 5.18, and 5.19). The same historical caveat applies, however: for these artists, the reportorial picture story is, above all, an exercise in heightened realistic sensation. No other visual medium existed at the time that could transport the reader so efficiently, so *graphically*, onto a foreign sea or into a jungle at the edge of the empire. Fiction was quite dispensable when a few pictures in a magazine could help you share the direct experience of someone who was actually *out there*. That was, after all, the whole point of the illustrated press.

The picture stories of the *Graphic* and the *Illustrated London News* reflected the way of life of their upper-middle-class readership. In the Christmas and summer supplements, the tales always revolved around the same seasonal themes (the pantomime show, the Christmas party, the old Gothic ballad, the amusing romance, the hunting incident). Journalistic sto-

The Officer who has left his sketch book in his frock coat sacrifices the white lining of his cocked hat. (Interrupted by the sharp command " On Hats !")

(Playfully) " I'm really very sorry, but your loose little sketches all blew away—but you shall dance with me to-night" " O——h, A——h ! Thank you"

'Twas not a dream. " The shirt I wore yesterday gone to the wash"—" Yes, Sir !" " Oh ! all my notes were on the wristbands—250,000 people robbed of a laugh"

Photographing under difficulties

An Officer, apparently with a dessert plate under his coat, twirls a black stud at his button-hole with a very audible click

The playful and vigorous Ferguson wrenches open the door of Newton's temporary dark room. A flood of electric light enters

The result of one of the sailors moving while the detective camera was in operation

SKETCHING AND PHOTOGRAPHING ON BOARD SHIP

Figure 5.15 **Unsigned.** *Sketching and Photographing On Board Ship*, *Graphic*, **February 8, 1890. Wood engraving.**

Comic or seriocomic illustrators often showed a perverse interest in displaying images marred by technical problems, thus emphasizing the mediated, partial nature of the artist's viewpoint when working in situ—or more generally, the resistance opposed by the world to any ideal form of representation. In the fifth panel, an officer stealthily takes a photograph of the scene, but a sailor moves his head at the same moment. The resulting half-masked picture, taken by the "detective camera," is presented below (seventh image).

BEHIND THE SCENES AT THE FOUNTAINS.

Figure 5.16 **W. B. Murray, *The International Health Exhibition: Behind the Scenes at the Fountains*, *Illustrated London News*, August 2, 1884. Wood engraving.**

1. Just before dark, when the chief steward went ashore to the post, the sea was not so smooth as it had been, but I was told it was customary weather for Jaffa
2. At dinner I was helped to soup in a manner that I believe is also customary at Jaffa
3. So that later on I was not suprised to find myself slipping about on the shiny leather cushions of the Smoking Room
4. At 10 P.M. I had serious thoughts about retiring for a night's rest
5. But soon before midnight I abandoned the idea
6. And hearing some of our passengers had returned from Jerusalem, I went on deck to see them get on board. (Mem.—It was a fine night overhead)
7. Feeling more composed after the diversion I again courted slumber, this time on the floor of the music room, casting myself upon a heap of rugs that littered a corner
8. But the heap of rugs (otherwise an indignant dragoman) objected to the proceeding; and rest was denied me

A PLEASURE CRUISE TO THE MEDITERRANEAN ON BOARD THE STEAM YACHT "VICTORIA"—VI, A NIGHT AT ANCHOR OFF JAFFA

FROM SKETCHES BY MR. A. M. HORWOOD

Figure 5.17 **Joseph Nash, from sketches by Arthur M. Horwood, *A Pleasure Cruise to the Mediterranean*, 6: *A Night at Anchor in Jaffa*, *Graphic*, November 5, 1888. Wood engraving.**

Figure 5.18 **Reginald Cleaver, *An Unfortunate Huntress*, *Graphic*, Christmas supplement, December 1899.**

Figure 5.19 **A. S. Boyd, from sketches by Arthur M. Horwood,** *An Eastern Imbroglio: A Tale of Two Stockings*, *Graphic*, **Christmas supplement, December 1896.**

Through the lens of a clumsy amateur photographer, a summer afternoon on the Thames becomes a hallucinatory experience; through the eyes of a Japanese painter, the Christmas dinner party turns into a weird, unfathomable ceremony (fig. 5.22).

WE TRY A PORTRAIT OF AN EMINENT A.R.A. SOMEHOW HIS HEAD COMES OUT LIKE A RISING SUN

FIRST ATTEMPT AT AN INSTANTANEOUS PHOTOGRAPH

ries, because they avoided any form of sensationalism, were almost as predictable. The genre was solidly anchored in the class values and journalistic practices of these prestigious magazines; to the comic artists who worked in the popular press, they probably appeared to belong to an entirely different sphere.

Across these social (and institutional) differences, however, all comic picture stories of the period were part of a larger tradition dominated by Hogarth's stylistic legacy, which permeated comic illustrations, satires, and humorous images in the age of the illustrated press. The overarching characteristic of Hogarth's heritage was polygraphic humor. In a world that was already saturated with various systems of representation, Hogarth had invented the humorous art of seeing reality diffracted by myriad ways of seeing, as if through an infinite range of lenses.

The polygraphic approach to style embraced the whole spectrum of line-drawing illustrations; it drew on all graphic sources, old and new. Frequently, it did both at the same time. In the illustrated press of the nineteenth century, comic illustrators camped on the semiotic borders of the rapidly expanding industrial and colonial world. They were on every battlefront, taking note of the emerging technologies brought about by the Industrial Revolution (photographic and microscopic images, X rays, chronophotography, the Kinetoscope) and addressing every significant emerging style (the various artistic trends and revivals and the most exotic forms of representation). Their work was central to the visual culture of the period because, in their stylized shorthand, comic illustrators always found some way to make humorous sense of the *new* by hybridizing it with some familiar idiom.

AN ENGLISH CHRISTMAS AS DEPICTED BY A JAPANESE ARTIST. DRAWN BY KRU-SHAN-KI.—SEE PRECEDING PAGE.

Figure 5.22 **George Cruikshank Jr.,** *An English Christmas Dinner as Depicted by a Japanese Artist,* *Illustrated London News,* **December 25, 1880. Drawn by Kru-Shan-Ki. Wood engraving.**

Figure 5.23 **Unsigned, *The Water of the Serpentine, in Hyde Park* (detail), *Illustrated London News*, July 18, 1857. Wood engraving.**

Figure 5.24 **Sir William Schwenck Gilbert, *A Drop of Pantomime Water*, *Graphic*, Christmas supplement, 1870. Wood engraving.**

A comic artist translates into a pantomime show the image of a drop of water seen through a microscope (note the similarity of composition: the second image was clearly based on the first, published thirteen years earlier). Cartoons such as these played an important semiotic role in the thriving visual culture of the nineteenth century. Presenting scientific and artistic innovations as "lenses" through which familiar scenes could be seen in a different light, comic artists established humorous links between the familiar and the foreign. They allowed the public to appropriate new visual idioms while bypassing the much more rigid (and often vested) scientific and artistic discourses that generally accompanied their presentation in the press.

Figure 5.25 **Frank Bellew, *The Aesthetic Craze as Seen from a Chinese Point of View*, *Harper's Bazar* 15, no. 3, January 21, 1882.**

THE POSSIBILITIES OF THE RONTGEN METHOD.

We have much pleasure in giving here one of Mr. Edison's latest results obtained by means of his perfected opera-glasses embodying a special device, by means of which the X rays are brought into use by the simple pressing of a button. It is expressly intended for chaperons who are anxious to keep an eye on their charges in time of war, as the present case fully explains. An officer in full dress (which, of course, in the result is invisible) lays siege to the fortress of love (also in full dress — that by Worth); although in this case (and that *en passant*) its worth is reduced to a minimum. The lady's expression is full of ethereal bliss, whilst that of her beloved lacks nothing in firmness of outline. Our hero is in not an altogether unfamiliar attitude, whilst the lady, overcome with emotion, is trying to seat herself — wherefore she gropes for a chair with her left arm extended. The chaperon has unhappily left her *Röntgen-Edison opera-glass* behind her, so that our officer's rival has used it and made a sketch on the spot, which, through Mr. Edison's kind permission, we are enabled to reproduce here. As for the rival, there is no *ray* of hope left, which in this case, of course, is quite ex-cusable.

Figure 5.26 **Schreiber, *The Possibilities of the Roentgen Method*, *Picture Magazine*, May 1896.**

Figure 5.27 **J. J. Calahan, *Ye Telephonists of 1877, Lightning Flashes and Electric Dashes: A Volume of Choice Telegraphic Literature, Humor, Fun, Wit, and Wisdom*** (New York: W. J. Johnston, 1877). Wood engraving.

The picture stories published by the *Graphic* generally adopted a much more realistic stance than the cartoons and stories published in the popular comic press. Rationality and objectivity marked the resistance of the serious press toward popular sensationalism. A serious British illustrated weekly had no business dealing with an uneasy mixture of hieroglyphic devices such as talking emblems, abstract allegories, figurative puns, and talking scrolls—a lexicon that dated back to the religious wars of the seventeenth century and had already been condemned as barbaric and Gothic in the age of enlightenment (Freeman 1948). In the popular comic press, however, the old idioms of graphic satire were allowed to adapt and perform their semiotic job without restraint.

In that respect, major American magazines like *Harper's Weekly* were closer to comical magazines than were their British equivalents:

they still published cartoons and picture stories based on the old grammar of hieroglyphics, emblems, and allegories, to which they constantly added new features in response to the modern industrial world. It was from this broth of popular culture that the modern form of the comic strip would bubble out around 1900.

We find a good example of the kinds of creative processes that were involved in the birth of the modern comic strip (and that of the modern speech balloon) in a cartoon that reacts to the foundation of the Bell Telephone Company in 1877. Foreseeing the havoc a shouting telephone operator would create in a telegraph office, the artist represents the aggressive reaction of the telegraphers with a curious code of jagged lines and electrical expletives. The telegraphic technology, which transforms the written word into short repetitive bursts of electrical energy, clearly informed this description of the operators'

Figure 5.28 **N. (?),** *A Valentine Romance of Ye Olden Times*, *Harper's Weekly*, **February 16, 1861. Wood engraving.**

This page (signed only by a monogram in the fourth image) is typical of the pseudomedieval tone often affected by comic artists in the second half of the nineteenth century. Captioned in phony "Olde Englyshe," the panels are drawn and engraved in a mock approximation of rustic woodcuts. Note the explanatory diagram for the Valentine emblem (second strip, last panel). Hieroglyphic conceits such as these were an integral part of the popular graphic culture, and humorous artists still used them frequently at the end of the nineteenth century. From its deep, baroque lineage, the modern comic strip thus inherited a taste for abstract graphic tricks such as speed lines, gaze arrows, shock stars, expressive lettering, floating exclamation marks, speech balloons, and so on. Adding this playful "hieroglyphic layer" to the purely representational level considerably enhanced the capacity of the comic strip to respond to various technological and cultural changes in the twentieth century.

wrath. The exclamation marks and stars are an extension of a commonplace analogy—that of the telegraph as a "nervous system" buzzing with energetic bursts of information. The standard vocabulary for representing shock, surprise, and other violent emotions in the modern comic strip appeared a decade or two later but was probably modeled on the same telegraphic metaphor, as an expressive hieroglyphic of the messages sent to the brain by the character's nervous system. The modern form of the speech balloon (see chapter 7) would follow a somewhat similar process of cooptation.

In the last decades of the nineteenth century, popular comic illustration was in an ebullient, dynamic state in which even the oldest trick of the trade could suddenly give relevant insight into modernity or turn a tired joke into a powerful metaphor. It was also a chaotic jumble in which the hieroglyphic props of the ingenious emblematist conflated with those of the modern inventor, constantly running the risk of sliding into barbaric incoherence—as it often did during the Christmas period, when archaic nonsense was generally given a free rein (fig. 5.31).

The great Western experimental Money-Doctor, after infinite pains and study, succeeds in making a Rag-Baby. He breathes into it the breath of life.

"Bless its dear little heart, it is as good as Gold!"

But the little pet grows rapidly, and becomes too heavy to carry;

So he drops it at a neighbor's door, and flies.

But the creature he has created arises and pursues its parent, and—

Finis.

THE DEMOCRATIC FRANKENSTEIN.

Figure 5.29 **Frank Bellew, *A Democratic Frankenstein*, *Harper's Weekly*, 1876. Wood engraving.**

Professional comic illustrators like the American Frank Bellew or the Englishman J. F. Sullivan (who produced a great number of picture stories for *Fun*) often drew allegorical narratives that kept the old language of political satire alive in the pages of the popular press. The deep historical roots and the versatility of the abstract hieroglyphic devices with which they played were an important part of the ebullient tradition from which the modern form of the comic strip emerged at the end of the 1890s.

In images such as these, the craft of the comic illustrator definitely revealed its kinship with that of a fairground performer. Both professions thrived on the grotesque and cultivated sensationalism by tradition. When American newspapers began publishing humoristic cartoons in the 1890s, that attitude became a major factor in ruthless circulation wars between rival papers and fueled the rapid evolution of the genre. From then on, comic artists began to work according to the most basic principles of the fairground—by following the blind Darwinian rules of attraction.

What defines the concept of attraction in this context is less the effect in itself—the nature of the comic idea, the content of the sensational journalistic subject—than the empirical method that underlies its production. Institutional discourse has practically no role to play in a process that evaluates success and failure in strictly mercantile terms (hence the distaste of the "re-sponsible editor" for the whole approach). The editor working for the yellow press, like the fairground barker, has no qualms. He does not have to defend a coherent view of the world. He combines competing attractions, innovates when opportunity arises, or recycles old tricks. Like the newsboy who shouts the headlines in a busy street, he works with a quickly changing public, which, by its reactions, selects the most promising variants. The editor learns his lesson and improves his product. In other words, the mechanism that drives this cultural process is as blind as Darwinian evolution and completely oblivious to any institutional discourse. If the usher at the dime museum or the editor of the popular press frequently wraps himself in florid Barnumesque rhetoric, it is to hide the fact that the products he throws at the world are knocked together without any intention other than to attract. An attraction doesn't need to say anything meaningful; it merely needs to *attract*.

CHRISTMAS JUMBLE.—[DRAWN BY FRANK BELLEW.]

A CHRISTMAS JUMBLE.

THIS picture contains from one hundred and fifty to one hundred and seventy smaller pictures. The exact number it is almost impossible to ascertain by counting. The following is a list of the principal objects represented: one church; one doll's house; one Noah's ark; one ship; one row-boat; one cornucopia; one pen; fifty-six grotesque heads and faces; seventeen figures; nineteen animals from Noah's ark; seven emblems on head of Christmas; nineteen objects—globe, turkeys, sheep, etc.; eleven scenes—circus, skating, etc.; cards, coins, etc., etc., etc.

The central face represents the head of Christmas. The nose of this face is formed of an American eagle perched on the horns of John Bull. On the fur cap of Christmas hangs a string of beads. These beads contain each a picture appropriate to the advent of the new year. The central bead represents the face of a clock, with both hands at twelve, indicative of the birth of a new year. To the right is a pyramid, the symbol of all that is enduring; to the left is a butterfly, the symbol of all that is ephemeral. To the right of the pyramid is the grave; to the left of the butterfly is the cradle. On the extreme right is a scythe, the weapon of the destroyer; on the extreme left, a heart pierced by an arrow, to typify love, which precedes the cradle. Above all hovers a fairy figure, the good genius of the new year. On the right-hand side, lower down, is the globe, with its (Christmas) satellite plum-pudding, revolving round the centre of our solar system, the mighty dollar. Close by are goblets, turkeys, roast beef, fish, sausages, and abundance of coin, to indicate festivity and plenty, with a cornucopia on the left pouring out money and the fruits of the earth.

The application of the other pictures will be apparent to the reader.

Figure 5.30 **Frank Bellew, *Christmas Jumble*, *Harper's Bazar*, January 13, 1877. Wood engraving.**

According to a contemporary witness, Morrill Goddard, the city editor of the *New York World* who introduced the Sunday comic supplement in 1894, was a man who "went in for the weird and wonderful in every-day life, and if things were not weird and wonderful enough for him, . . . [he] made them so" (McCardell 1905). That was the practical philosophy under which comic artists would work in the yellow press at the end of the century.

In the ruthless commercial war between the Pulitzer and Hearst papers, victories and defeats were recorded in sales figures only. No other requisite was necessary—even writing was dispensable: "the three papers with comic supplements realized that their patrons were spectators rather than readers—that is, that they cared little or nothing for humorous writing, however good it might be, but did care for pictures; so the jokes, verses, and sketches were stricken out, and the comic supplements became what they now are, merely collections of pictures" (McCardell 1905). How did comic series originate in this context? According to the same witness, "they just grew": "Every Sunday comic colored supplement is edited by a special man, highly paid, and responsible in proportion to his pay. He and his immediate assistants are constantly planning, weighing, eliminating. To them suggestions are made by both 'insiders' and 'outsiders'; readers send suggestions: other schemes are conceived in the office; the artists themselves make good suggestions. . . . Once received, the suggestions are considered and tried. If they please the public, they are carried on until the people weary of them; if they fall flat, they are dropped at once, like a hot potato."

It's likely that the artists who came from traditional comic magazines like *Puck* and *Truth* did not fit comfortably into a new industry whose ethos consisted in following the taste of the crowd without any other concern. A strong feeling of the author's presence was a necessary condition for irony. Comic artists, as we have seen, usually projected a point of view into the images that they created. Their interest in the "weird" and "wonderful" was always tempered by a sense of self-awareness and amusement. Yet the profession quickly adapted to the practical Darwinism of the yellow press, and the cartoonists became the kings of the new ecosystem. This

astonishing conversion took on another remarkable characteristic of their graphic lineage: it was almost as old as that of the fairground gypsies themselves. The power of a blind empirical process to adapt and invent solutions depends of the depth and variety of its accumulated experience. In the jungle of the popular press, the deep cultural memory of the comic artist (whose vocabulary extended back to the baroque period) would prove to be one of his main weapons.

One artist in particular possessed exactly the qualities required to exploit this heritage. Richard Fenton Outcault, the creator of *The Yellow Kid* (Blackbeard 1995), had a solid graphic culture, but, unlike many of his peers, he did not feel he had to build a coherent visual discourse to produce a cartoon. Like many of Cruikshank's and Hogarth's satires, Outcault's *Hogan's Alley* was teeming with a great variety of features and characters, but there was a crucial difference: whereas his predecessors had felt an implicit obligation to exploit the overall theme of their satires down to the tiniest details, Outcault was willing to involve completely extraneous elements (provided that they struck him as amusing or unusual). By breaking the first rule of the genre, he left the field open to the type of quasi-Darwinian mechanism on which the yellow press rested its faith.

The large, swarming images that Outcault published each week allowed him to freely test the impact of his visual and verbal innovations and to serialize them as soon as the reaction of the public indicated that he had hit the bull's-eye. This is how he came up with such features as the bald child in a yellow nightshirt, the little boy falling from the top floor, the parrot and its word balloon, the goat on the roof, the little girl with the distinctive hat, and so on. Outcault's ability to create successful "attractions" and serialize them instantly showed the path to his colleagues. His method of running with any successful idea (however singular or odd it might be) gave birth to most of the major series in the early years of the comic strip.

In hindsight, it is obvious that the weekly rendezvous with recurring comic characters must have played a major part in the success of the Sunday comic supplement. Comics scholars generally don't feel the need to explain the success of a formula that was robust enough to persist for

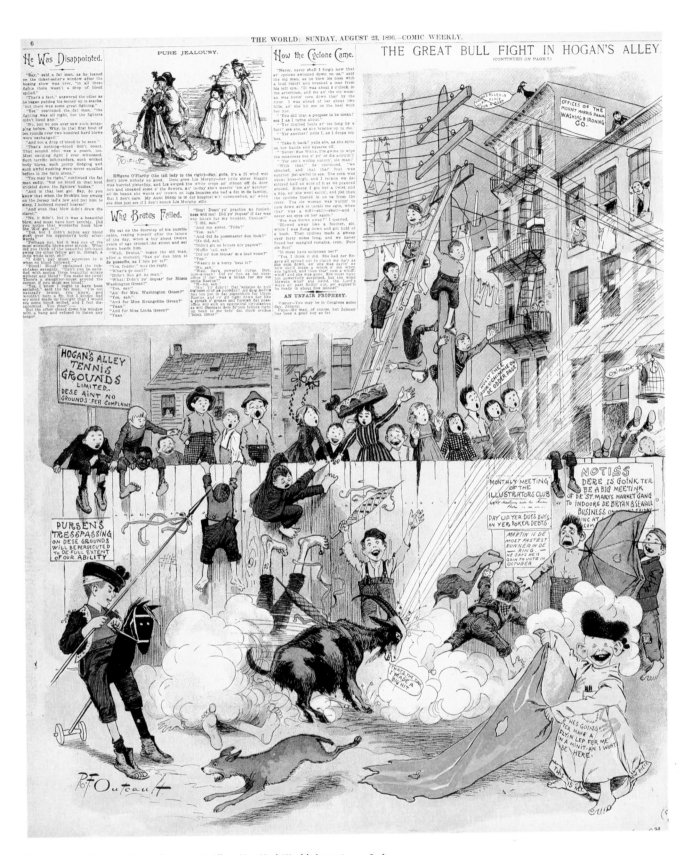

Figure 5.31 **Richard F. Outcault, *Hogan's Alley*, *New York World*, August 24, 1896.**

Outcault's large, cacophonous pages offer a landscape from which the reader cannot infer any distinct tone or overall message. In fact, Outcault's urban collages were as much the product of an advertiser as that of a satirist (his drawings were peppered with extraneous inscriptions of all kinds, in which he often slipped in a self-promoting message). His heterogeneous images reflect and embrace the commercial dimension of the modern urban environment in ways that could possibly be compared to certain Pop Art paintings of the 1960s.

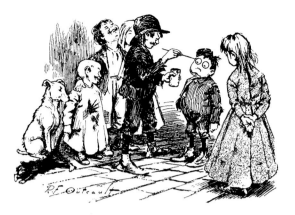

FOURTH WARD BROWNIES.
MICKEY, THE ARTIST (*adding a finishing touch*)—
Dere, Chimmy! If Palmer Cox wuz t' see yer, he'd
git yer copyrighted in a minute.

Figure 5.32 **Richard F. Outcault, *Fourth Ward Brownies*, *Truth*,
February 9, 1895.**

The question of copyright, which Outcault frequently raised in
his cartoons, encapsulates his attitude toward his profession.
Having begun his career as an illustrator in Edison's laboratory,
he took on all promising comic ideas as worthy of patenting,
serializing, and commercializing. His homage to the "big-eyed"
style of Palmer Cox (fig. 5.33) summarizes his whole ap-
proach. He treats (graphic) hybridization exactly as a pragmatic
inventor would do today in the R&D department of a genetic
engineering firm.

decades. But hindsight is not necessarily the best
way to understand the sudden emergence of a
new editorial practice in a chaotic situation like
the newspaper wars of the 1890s. At the time,
unconnected ideas and stylistic elements shifted
rapidly into unusual combinations. In such a
situation, a winning formula generally emerges
from the unprecedented conjunction of various
elements. Probably crucial in the success of the
"funny folks" as "habit-builders" (to use the be-
haviorist language of the 1920s) was the (appar-
ently) unrelated fact that they were *cute*.

By paying homage to the huge eyes of Palm-
er Cox's Brownies (fig. 5.32), Outcault puts us
on the trail of one of the strangest mutations
brought about by the competitive jungle of the
newspapers: a drift toward *cuteness*. This partic-
ular genetic trait was to become one of the most
salient features of comic strips' funny folks in the
twentieth century (the eyes would grow to even
more monstrous proportions in Disney cartoons
and Japanese manga).

The Brownies' saucer-like eyes were only the
most visible part of a general move in that direc-
tion in comic characters around 1900, a trend
whose underlying mechanism was truly Darwin-

ian if one believes German ethnologist Konrad
Lorenz. In a well-known paper (Lorenz 1950),
Lorenz explains that neotenic features such as
disproportionately large eyes, a rounded fore-
head, a receding chin, dimpled cheeks, and rub-
bery limbs are universally deemed *cute* (*kawaï*
in Japanese) because they are typical of human
babies. They trigger in us an instinctive feeling
of tenderness and attraction. All creatures, real
pets or even artificial toys, sharing these traits
benefit from an innate mechanism of protection
toward human infants. In their interactions with
kittens, for example, humans have instinctively
bred these cute traits into the furry critters.

Hence the strange, unpredictable connection
between cuteness, habit building, and serializa-
tion in the emerging form. When the gene for
saucer-like eyes jumped into the Sunday comic
supplements, the cuteness of the funny critters
drawn by the like of James Swinnerton and Fred-
erick Burr Opper considerably reinforced the at-
tachment that the public felt toward them. They
became household pets—and, inevitably, strong
habit builders.

For the Töpfferian form, cuteness represented
quite a revolution. The comic picture stories that
belonged to the Töpfferian lineage had always
followed the opposite prototype, which prob-
ably went back to Cervantes's *Don Quixote*. Like
Töpffer's own *Mr. Vieux Bois*, characters drawn
in that tradition were generally of the emaciated,
geriatric kind, their elongated adult features a
systematic inversion of the neotenic formula de-
scribed by Lorenz. Only a thorough shuffling of
the stylistic cards at the end of the century can
explain such a massive conversion.

The "graphic gene" for cuteness can be traced
back, once again, to an archaic trait in the popu-
lar comic press. In nineteenth-century illustra-
tion, the "cute" formula (minus the "patentable"
saucer eyes later invented by Palmer Cox) had
flourished in a tradition that, originally, had no
connection to the genre created by Töpffer—
that of the pseudo-Gothic "illuminated" picture
book, of which the German illustrator Ludwig
Richter was one of the main exponents (Bu-
chanan-Brown 2005). First seen in Germany in
various collections of illustrated ballads, then
quickly exported to the English-speaking world,
Richter's "cute" version of the Gothic revival
had dominated children's illustrated books and

That should they turn, as turn they might,
They 'd keep the downward course aright;
They fashioned some for three or four,
And some to carry eight or more,
While some were made to take a crowd
And room for half the band allowed.

Before the middle watch of night,
The Brownies sought the mountain height,
And down the steepest grade it showed
The band in wild procession rode;
Some lay at length, some found a seat:
Some bravely stood on bracing feet;
But trouble, as we understand,
Oft moves with pleasure, hand in hand,
And even Brownies were not free
From evil snag or stubborn tree
That split toboggans like a quill,
And scattered riders down the hill.
With pitch and toss and plunge they
 flew;
Some skimmed the drifts, some tunneled
 through
Then out across the frozen plain
At dizzy speed they shot amain,
Through splintered rails and flying gates
Of half a dozen large estates;
Until it seemed that ocean wide
Alone could check the fearful ride.

And thus until the stars had waned,
The sport of coasting was maintained.
Then, while they sought with lively race,
In deeper woods a hiding-place,
" How strange," said one, "we never tried
Till now the wild toboggan ride!
But since we 've proved the pleasure fine
That 's found upon the steep incline,

We 'll often muster on the height,
And make the most of every night,
Until the rains of spring descend
And bring such pleasures to an end."

Figure 5.33 **Palmer Cox, *The Brownies*, *St. Nicholas Magazine*, 1883. Wood engraving.**

The pseudo-Gothic style initiated by German illustrators during the romantic period was dominant in American children's magazines like *St. Nicholas* until the end of the century. In his famous Brownies series, the Canadian artist Palmer Cox skillfully exploited the same trend while exaggerating cute and quaint traits like saucer-like eyes and reversed articulations. Presented in the (typically postromantic) manner of an illuminated manuscript, his page layouts favored playful interactions between text and image.

MASTER CHARLEY, having been much excited by the accounts of the great "International Prize-Fight," makes a match with Pat Dooly, "The Pet of the News-boys." He puts himself into a vigorous course of training, to get rid of superfluous flesh, improve his wind, and develop his muscles.—Fighting weight, 39 pounds.

VOL. XX.—No. 120.—3 H*

He becomes a diligent student of the *Clipper;* and on weighing day, being found by the Dutch groceryman's scales to be within weight, the "Affair" comes on. But before any of the "Events" are decided the Authorities interfere, and the fight is stopped.—Bets, payable in Pea-nuts and Taffy, are decided to be "off."

Figure 5.34 **Frank Bellew, *Master Charley's Prize Fight*, *Harper's New Monthly*, May 1860. Wood engraving.**

The influence of the sentimental, ornate style of Ludwig Richter is evident in these pages drawn for *Harper's New Monthly* by Frank Bellew (a British expatriate). The jagged stick borders used to frame and compartmentalize the page are typical of the pseudo-Gothic Germanic style (Buchanan-Brown 2005).

magazines since the 1840s. It was omnipresent in *St. Nicholas*, the magazine where Palmer Cox's Brownies began their career in the early 1880s.

The pseudo-Gothic style had been a formidable rival to the Töpfferian form of picture stories in the second half of the nineteenth century. It was a radically different register of storytelling that worked particularly well in conjunction with versification and folktales. In the "comicalities" section of magazines like *Harper's New Monthly*, Töpfferian picture stories and the Gothic form often alternated, and it was probably inevitable that some illustrators would try intermediate formulas, like Frank Bellew did in the early 1860s (fig. 5.34).

The most successful effort in this direction, however, was undeniably Wilhelm Busch's cel-

ebrated picture stories published by the German magazine *Fliegende Blätter* since the 1860s. As noted earlier, after Hogarth and Töpffer, Busch probably deserves to be considered the inventor of the third kind of novel in prints. His little books of illustrated verses definitively integrated some Töpfferian elements (possibly via Cham and Doré), but they were, before all, typical products of the German Gothic revival. Busch's stories introduced an authentic sense of the carnivalesque and the grotesque in the genre. His influence on the modern form of the comic strip is generally accepted as a fact, but, as we shall see, what was lost in the interim was probably much more significant than the part of his heritage that survived.

Figure 5.35 **Charles Bennett (illustrations), Francis Quarles, *Quarles' Emblems* (London: James Nisbet, 1861). Wood engraving.**

Illustrated anew by Charles Bennett, the Victorian edition of a seventeenth-century English emblem book shows the influence of the "cute Gothic" vein imported from Germany—and the concurrent revival of other archaizing trends in comic illustration. The surrealistic mix of hybrid creatures and swarms of winged cherubs that characterized baroque emblem books clearly followed the same blind rules of fairground attraction that inevitably provoke the ire of "responsible" institutional critiques. Indeed, at the end of the seventeenth century, some of the latter had already expressed their disgust toward such popular collections of visual enigmas, pronouncing them arbitrary, barbaric, and occult (Shaftesbury 1713); the form was banned from serious literature and treated as a childish toy (Freeman 1948, 35). Note that three fundamental graphic traits seem to resurface automatically when free rein is given to the production of graphic attractions: the cute, the strange, and the atrocious. Thus, it is no accident that some of these traits reappeared in new disguise in the comics of Outcault, Swinnerton, and Opper at the beginning of the twentieth century (or later in Japanese mangas and superhero comic books).

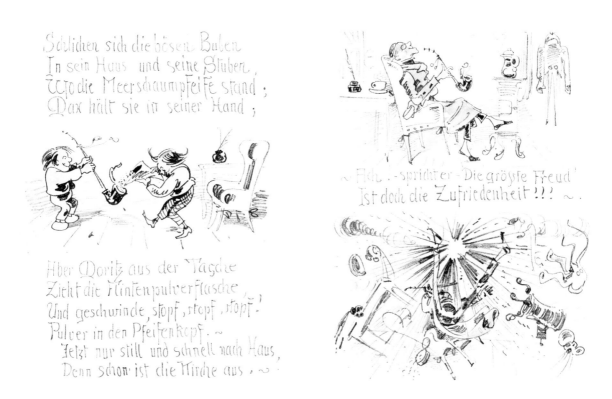

Figure 5.36 **Wilhelm Busch, *Max und Moritz*, 1865, original manuscript pages.**

The graphic and verbal tone of Wilhelm Busch is that of the nursery rhyme, the legend, and the fairy tale. Busch did not hesitate to push certain scenes toward the macabre and fantastical, charring his characters or transforming his heroes into baked bread. His tone is very different from the much more prosaic pantomimes of his German successors.

Figure 5.37 **Rudolph Dirks, *The Katzenjammer Kids*, 1898.**

Because Rudolph Dirks modeled *The Katzenjammer Kids* after Busch's *Max and Moritz*, it is generally assumed that Busch's stories constitute a direct link between the Töpfferian form and the American comic strip. The landscape of comic illustration, however, was too convoluted at that time to allow such a direct connection. While Töpffer's stories mocked the rigid logic of cause and effect that dominated the industrial world, Busch's picture stories gleefully paid homage to the poetic logic of the legend and the folktale. His deliberately rustic style referred to

Figure 5.38 / Figure 5.39 **Emil Reinicke, wordless cartoon, *Fliegende Blätter*, no. 2325, 1891.**

Like Lothar Meggendorfer, Hans Schliessmann, and several others, Emil Reinicke was a specialist in the burlesque pranks found in *Fliegende Blätter*. The deadpan, modern tone and strictly physical slapstick of their "stories without words" was the real model for Dirks's *Katzenjammer Kids*.

the popular prints of the preindustrial world, and even his wordless picture stories suggested, by their visual rhythm, the scansion and logic of the nursery rhyme. The virtual presence of an oral, folksy narrator was an integral part of the charm of his tales.

In Dirks's *Katzenjammer Kids*, that tone was completely lost. The *Max and Moritz* theme was treated in the new style of wordless stories developed by the generation that had followed Busch in *Fliegende Blätter*. In these stories, the German cartoonists of the 1880s and 1890s had cultivated a positivist form of mechanical burlesque that entirely rested on the visual logic of cause and effect. Their wordless gags, which often featured mechanical devices, were generally drawn in a clear, diagrammatic style that evoked that of technical schematics. Deliberately eschewing all "Gothic" reference to a verbal or oral tone of storytelling, the drawings presented a perfectly self-sufficient explanation of the chain of actions, and the fact that they didn't need (or entice) any paraphrase or commentary was probably their most salient feature: these purely visual "sentences" were clearly the self-propelled products of the modern industrial age. French cartoonists Caran d'Ache (Emmanuel Poiré) and Christophe (Georges Colomb) frequently adopted a similar mechanical tone, under the German influence, in the 1890s. This was the real model on which Rudolph Dirks had based *The Katzenjammer Kids*, whose first mischief was a variation of the hose gag, the prototypical example of the genre.

Figure 5.40 **Hans Schliessmann, *Ein Bubenstreich*, *Fliegende Blätter*, no. 2142, 1886.**

Possibly the first version of the "viral" gag of *The Sprinkler Sprinkled*. The celebrated adaptation of the gag by the Lumière brothers ten years later laid the groundwork for the genre of filmic mischief, typical of the "fairground" phase of the early cinema (Gunning 1995).

The hose gag had gone viral in its definitive form (where the sprayer is sprayed by the intervention of a mischievous kid) after its publication in the Munich-based *Fliegende Blätter* in 1886. It is worth noting at this point that the editors of *Fliegende Blätter* (the "flying pages" or "loose sheets") had developed a "fairground" methodology that was somewhat similar to that of the comic supplements in the late 1890s and relied heavily on contributions from their readers. According to a French commentator (Alexandre 1892), it was impossible at the time to utter a witticism or experience a funny situation in Germany without someone remarking: "Hey! That was great! We should send this to *Fliegende Blätter*!" The magazine received hundreds of suggestions each week and submitted them to a ferocious selection process before routing the best gags and witticisms to their illustrators. The modern version of the "mischief gag" became the most successful product of this policy.

According to Tom Gunning, a historian of the early cinema, the mischief gag was also the first genre to emerge in the nascent cinema industry (Gunning 1995). From 1896 to 1905, short films chronicling a gag or bit of mischief and frequently featuring a young rascal became one of the major genres of motion pictures. Consisting of one shot, these films went to great lengths to show, with the clarity of a technical sketch, the preparation of the prank (generally involving a trap made of flour or soot) and the catastrophic

Figure 5.41 **Hans Schliessmann, *Fliegende Blätter*, no. 2342, 1891.**

result that ensued. Gunning (after Donald Crafton [1995]) describes this form of exposition as proceeding from comic-strip logic and considers it an integral part of the operational aesthetic of the cinema of attractions, which "addresses the spectators directly with a visual display, rather than a developed narrative action" (Gunning 1995).

The original mischief gag on film was *L'arroseur arrosé*, made in 1895 by the Lumière brothers and generally heralded as the first true fictional narrative in the history of the cinema. Because of its striking simplicity, the Lumières' hose gag has often been claimed an elementary building block of narrative—the motion picture's "first step" on the journey to more complex storytelling. However, the history of the Töpfferian form in the nineteenth century tells us otherwise. If the gag looks simple, it is only because—like most ideas that go viral—it simultaneously resolves the terms of a complex cultural equation. The hose gag was really the streamlined product of a selective process that, after fifty years of convoluted evolution, was bringing back the Töpfferian picture story to its original questioning of

the rhetoric of progress—only to turn Töpffer's vision on its head.

A peculiarity of Töpffer's stories is that they involved a lot of mechanical props and a great deal of action but offered no true gags in the modern meaning of the term, no comical payoffs, no clever turns of events or surprising resolutions. Mischief gags celebrate ingenuity and cunning; Töpffer's hilarious stories are satires of stupidity—a direct and deliberate projection of his philosophical stance. The grammar of cause and effect, for him, was the fabric of a materialistic and finite world, thus essentially sterile. Its only potential was for a morose kind of one-track-mind stupidity that invariably led to improbably surrealistic consequences.

With the hose gag, the mischievous rascal magically opened the door to the kind of lively, meaningful burlesque that would soon characterize Buster Keaton's and Charlie Chaplin's comedies. Here was a new kind of trickster, the boy wizard of the "do-it-yourself" civilization. His appearance marked the point, near the end of the nineteenth century, where the technical props of everyday life, touched by the magic

Figure 5.42 **Frank Crane,** *Willie Westinghouse,* *Boston Sunday Post,* **ca. 1902.**

wand of progress, acquired a shining new aura of unlimited potential for serendipitous discovery, creative "misuses," and unforeseen (comic) applications. With the hose gag, Töpffer's saga of industrial stupidity morphed seamlessly into a playful, crystalline allegory of progress in the Edison age.

It is no coincidence, of course, if the lifespan of the "mischief gag" genre in the motion picture industry (1896–1905) exactly coincided with the early years of the modern comic strip. During these seminal years, the two attractions were engaged in a mirroring process of mutual definition that we will explore more thoroughly in the next chapter. In the wordless gag, the early cinema had found the reflection of its own rhetorical device; the public came to see a sequential machine

whose luminous software was, actually, a diagrammatic story without words: a self-propelled, comic stylization of progress in action. But the influence also went the other way around. Working hard to capture on paper the magic of moving pictures, comic-strip artists could only turn to the traditional tools of the comic illustrators. The style, the tone, the "shape" of the picture stories would try to capture and reflect the new way of seeing brought about by the motion picture technology. As it happens, their predecessors had already covered some of that ground in the last two decades of the nineteenth century, by closely following the advances in the connected fields of instant photography and chronophotography.

Figure 5.43 **Christophe (Georges Colomb),** *Un Arroseur Public*, *Le petit français illustré*, **no. 23, August 3, 1889.**

A story without words is, in principle, the closest thing to a story without a narrator—a story that "reads itself"; hence the coldly diagrammatic line often used in the 1880–1890 period by the likes of Schliessmann, Christophe, Caran d'Ache, and others for depicting purely visual gags in terms of a transparently readable syntax of mechanical causes and effects. The genre is not only typical of the period's fascination for new contraptions, it also jubilantly explores the new kind of "mechanical" mode of storytelling that comic illustrators could foresee in the emerging technology of the moving picture. It is no coincidence, then, that the early cinematographers immediately adopted gags of this type as natural content for the new medium.

Figure 6.1 **Arthur Burdett Frost, _Nature Study with a Camera_, _Ladies Home Journal_, 1915.**

6

A. B. Frost and the Photographic Revolution

The 1880s gave cartoonists many reasons to be interested in the evolution of photography. In the publishing world, photographic processes began disrupting the traditional connection between illustrators and the printed image.

Wood engraving, essential until then, would become obsolete by the beginning of the 1890s, and from then on images published in the mainstream press would almost always be reproduced photographically from pen drawings. The American Arthur Burdett Frost was one of the first (along with England's Phil May [Fougasse 1956, 26]) to develop a style based on the expressive possibilities offered by the new process. His strips display a freedom, a cursive vitality, that had not been seen since Töpffer's stories.

Yet the technical advances in photography were also felt in other areas: instant photography transformed the way people looked at the world in action. The inventions of Eadweard Muybridge and Étienne-Jules Marey, and later those of Thomas Edison and Louis and Auguste Lumière, would give new meaning to the idea of progressive action. In this domain, originally rooted in the rhetorical art of the actor and the speaker, chronophotographic and cinematographic models introduced—for the first time—a strong presumption of objectivity.

Cartoonists, however, were quick to make the point that the "objective" images produced or inspired by these new technologies could be stylized exactly in the same way as more traditional images. With a mixture of fascination and impertinence, they immediately started parodying the new models of action as recorded by technology (which we can term *sequential*, in contrast to the old rhetorical models of *progressive* action) and confronting them ironically with more familiar idioms.

The earliest comic stories A. B. Frost published in *Harper's New Monthly* in 1879 and 1880 and in *Harper's Bazar* during the mid-1880s provide a striking example of this approach. At the moment that comics were preparing to enter into a new era of exchange with audiovisual technologies, Frost was particularly well situated to make sense of the vast semiotic territory that was thus opening to designers of humorous picture stories.

In 1878, Frost, already a well-known illustrator, enrolled with his fiancée at the Pennsylvania Academy of Fine Arts in order to study with Thomas Eakins, one of the most interesting American painters of the period (Reed 1993, 19). This connection would have immediate consequences on the comics Frost would publish soon after.

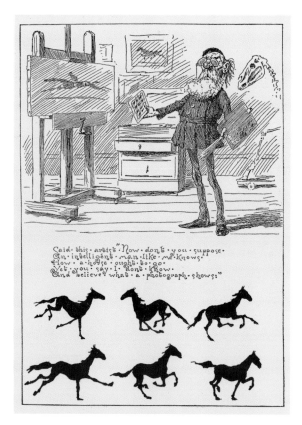

Said this artist "Now don't you suppose
An intelligent man like me knows
How a horse ought to go
Yet you say I don't know
And believe what a photograph shows!"

Figure 6.2 **Arthur Burdett Frost, *Stuff and Nonsense* (New York: Charles Scribner's Sons, 1884).**

At that time, Eakins was particularly interested in the technical progress of photography, which, he argued, was a source of information that artists could no longer ignore. The painter and his entourage vigorously debated the latest photographic innovations, particularly the experiments of Eadweard Muybridge, a photographer from California whose pioneering work offered a way of analyzing the motion of animals with precision for the first time.

When Frost published his first comics in *Harper's New Monthly* in 1879–1880, Eakins had already made contact with Muybridge (Mathews 2005; Sewell 2001), suggesting new avenues for research into the study of human movement. Through this direct connection, the new questions that were fluttering around chronophotography at the time also penetrated Frost's picture stories. In a certain way his comics engaged, within the realm of cartoons, a discussion that paralleled that which was unfolding in the world of art.

A cartoon published in Frost's first cartoons collection, *Stuff and Nonsense* (1883) (fig. 6.2), thrusts us into the heart of the debate by mocking a painter from the old school who is outraged by the revelations of instantaneous photography. The drawing alludes to the polemics (about the relevance of photography to representational art) that Eakins's circle was involved in at the time (Mathews 2005, 18–22). It also gives an early indication of the way Muybridge's work would lead to new kinds of naturalistic stylization in the next century, particularly in the field of animation.

In Frost's cartoon, the artist's conventional view of a horse in a flying gallop recalls the naïve images that Töpffer produced in his own picture stories and vigorously defended in his theoretical writing. Frost contrasts this solution with a series of stylized figures inspired by Muybridge's plates. On the surface, the cartoon only points out the inadequacy of the old models of artistic representation, but in a subtle way it also reinitiates, at the very place where Töpffer had left it fifty years earlier, the debate between image as *imitation* and image as *symbol*.

Contrary to the painter in Frost's cartoon, Töpffer did not naïvely claim to imitate reality with what he called his "symbols" (he willingly left that task to Louis Daguerre's plates). What he defended was the idea that the artist could produce a schematized figure that was immediately recognizable as a "thought intention" (une intention de pensée) (Töpffer 1998, 259, 288, 388, 392).

For Töpffer, naïve representations like the flying gallop were clumsy or incongruous in purely imitative terms, but as signs, as *ideas*, they had the immense advantage of being instantly legible. Indeed, the flying gallop is a kind of pictogram whose first quality is to suggest a specific interpretation: it can only mean "this is a horse in full flight." This type of rigid relationship was typical of comic art until Frost, inspired by Muybridge's plates, opened a varied repertoire of quasi synonyms that were much richer in terms of expressive and dynamic information.

Instant photography offered to cartoonists an almost unlimited source of new models that could be stylized, deformed, or redirected in empirical and intuitive manners to represent action and movement. This process, of course, didn't relieve the artist working on a picture story from having to select adequate signs. Like his predecessors, he had to suggest the key idea that made the chain of images legible. What Frost

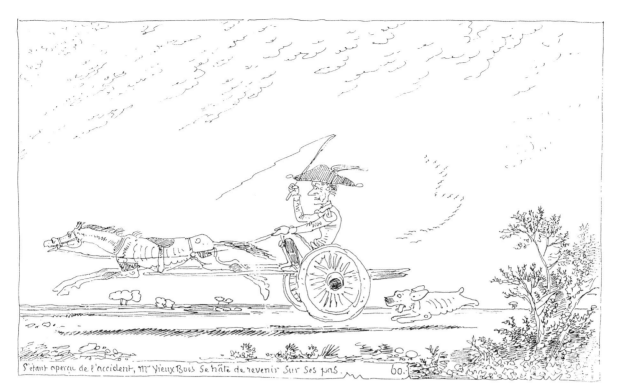

Figure 6.3 **Rodolphe Töpffer, *Histoire de M. Vieux Bois* (Geneva, 1839).**

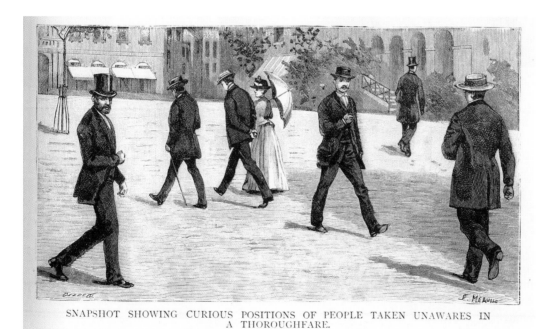

SNAPSHOT SHOWING CURIOUS POSITIONS OF PEOPLE TAKEN UNAWARES IN A THOROUGHFARE.

Figure 6.4 **Fortuné Louis Méaulle, *Picture Magazine*, January 1895.**

Thanks to Hogarth's deep interest in diagrammatizing arrested movement (see chapter 2), comic illustrators had quite a head start in dealing humorously with awkward accidental postures (an interest that was principally mediated by Thomas Rowlandson and Töpffer in the first part of the nineteenth century); in the 1880s–1900s, cartoonists were quick to exploit the reservoir of "curious positions" opened by snapshot photography.

showed was that one could substitute a whole spectrum of comical symbols, much busier and more varied in expressive and dynamic terms, for the conventional (and quite rigid) schematizations used by most cartoonists in the Töpffer and Cruikshank tradition.

Eakins's careful anatomical and photographical studies produced new kinds of diagrams (fig. 6.5) that Frost and a few other cartoonists of the naturalistic school (Edward W. Kemble, T. S. Sullivant, and Herbert Merrill Wilder come to mind) were quick to adapt to comical stylization. The observation of nature played an important role in their caricatures. In a world where the photographic image was slowly becoming the reference by which all graphic representation was instinctively measured, this new visual repertoire also suggested new comic possibilities that were somewhat at odds, stylistically, with mainstream comic tradition.

The Philadelphia School. A.B. Frost's studies under Eakins at the Pennsylvania Academy of Fine Arts marked the first naturalist "moment" in American cartooning. Many famous cartoonists including Edward W. Kemble, Herbert Merrill Wilder, and T. S. Sullivant displayed this influence (Sullivant actually studied under Eakins in the 1880s, and Kemble studied art in Philadelphia during the 1870s). In many ways, Eakins's instruction prefigured the realist approach adopted by Walt Disney Studios in the 1930s. Significantly, Disney's animators preserved a box full of drawings by T. S. Sullivant for inspiration (Marshall 1983; Beiman 1987).

Figure 6.6 **T. S. Sullivant, *Fables for the Times* (New York: R. H. Russell and Son, 1896).**

Figure 6.5 ***Thomas Eakins: un réaliste américain, 1844–1916* (Paris: Éditions de la réunion des musées nationaux, 2002).**

Figure 6.7 **Arthur Burdett Frost, *Stuff and Nonsense* (New York: Charles Scribner's Sons, 1884).**

Eakins required his students to develop volume and movement from the inside out, beginning with a linear diagram that roughly followed the shape of the spine. The anatomical exaggerations that Frost inflicted upon his comic characters originated from this subtle serpentine line. The same approach can be found in the work of other well-known cartoonists from this school.

Ever since Hogarth's *Analysis of Beauty,* the use of simple geometrical forms had been reserved for the domain of humor and derision; and natural, elegant, and varied forms for the pursuit of beauty. Most comic strips at the turn of the twentieth century respected this division. The series created by Richard Fenton Outcault, James Swinnerton, and Frederick Burr Opper, for instance, deliberately played with rudimentary geometrical figures. Their graphic style and their gags were definitively part of the long Hogarthian tradition that tied simple forms to repetitive, artificial (and thus comical) behavior.

Shaped by Eakins's naturalist school, however, A. B. Frost was more interested in the variety and spontaneity of natural behaviors than in purely mechanical slapstick. His scenarios—if we can call them that—were rarely predictable. They rarely came to a close but rather resembled an open suite of spontaneous gestures and disordered sensations. His best-known stories (*Our Cat Eats Rat Poison; Carlo* [Frost 2003]) are representative of his peculiar comedic vein. Above all, his stories are filled with a sustained energy and vitality rarely seen before. Frost's comics are all about acceleration, momentum, shock, and

brutal changes of rhythm. His sequences share an important trait with Muybridge's first chronophotographic plates: an interest in trying to capture on paper the dynamic curves of spontaneous, natural activity.

The first two stories Frost drew for *Harper's New Monthly* (December 1879 and January 1880)

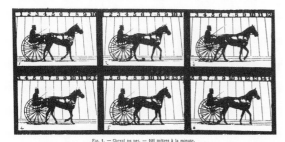

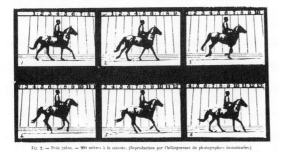

Figure 6.8a **Eadweard Muybridge, *La nature*, 1878.**

The first publication in a European magazine of Eadweard Muybridge's experiments.

(figs. 6.9 and 6.12) also adopted the repetitive grid that was the most salient visual feature of Muybridge's plates.

Muybridge's goal was to analyze the temporal and dynamic progression of the photographed action, and the layout of his plates had to highlight the signifying differences between each instant. It was thus necessary to record and display the phases of movement in the most uniform way possible. Eakins and his circle (which included Frost and Frost's future wife, Emily Louise Phillips) were acutely aware of this feature of Muybridge's experience: when Frost joined Eakins's drawing class at the Pennsylvania Academy of Fine Arts in September 1878, the painter had begun testing Muybridge's first motion photographs with a zoetrope; finding the intervals inconsistent, he then proceeded to redivide the sequence into equal segments and to reconstruct the appropriate poses from his knowledge of equine anatomy (Paschall 2001, 243). Later, when experimenting firsthand with chronophotography, Eakins would add a timepiece to his specially designed camera that could precisely record the lapses between exposures (Foster 1997, 111).

Frost had a penetrating intuition of what was actually involved in the emerging language he stylized for comical effect: he understood that Muybridge's regular grid, strictly identical framings, and precisely timed intervals gave temporal, dynamic meaning to the gaps between successive images.

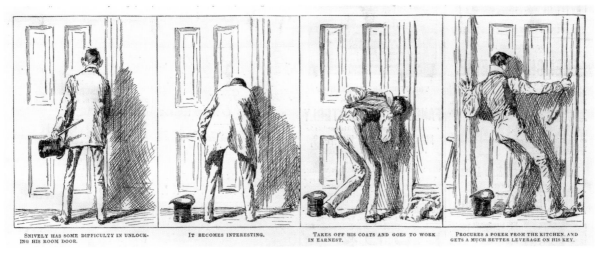

SNIVELY HAS SOME DIFFICULTY IN UNLOCKING HIS ROOM DOOR. IT BECOMES INTERESTING. TAKES OFF HIS COATS AND GOES TO WORK IN EARNEST. PROCURES A POKER FROM THE KITCHEN, AND GETS A MUCH BETTER LEVERAGE ON HIS KEY.

Figure 6.8b **Arthur Burdett Frost, untitled, *Harper's Bazar* 19, no. 14, April 3, 1886.**

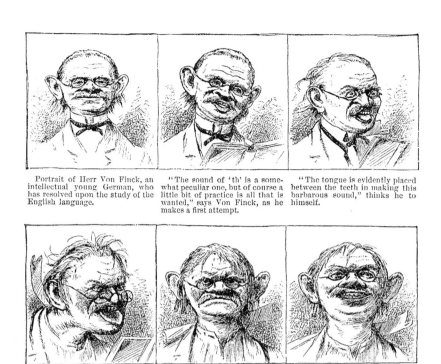

Portrait of Herr Von Finck, an intellectual young German, who has resolved upon the study of the English language.

"The sound of 'th' is a somewhat peculiar one, but of course a little bit of practice is all that is wanted," says Von Finck, as he makes a first attempt.

"The tongue is evidently placed between the teeth in making this barbarous sound," thinks he to himself.

"Donnerwetter! Is a German, and above all, a Von Finck, to be beaten by such a simple little thing

"The Devil take such a hideous combination as that! However, just let me once seriously devote

"Oho! I knew I should get it! How easy! Strange I should have had any trouble with it. 'De man,

Figure 6.9 **Arthur Burdett Frost, *Harper's New Monthly*, December 1879. Wood engraving.**

Published in December 1879, the first of these two stories is presented as a scientific experiment in fashionable phonological research (in this case, a study of the pronunciation of the "th" sound). The regular grid of panels evokes a steady temporal beat that allows the reader to reconstruct the activation curve of the subject in movement. Note the regular acceleration of the tempo of the action from image (1) to image (4), the sudden reconfiguration of the face in image (4) to image (5), and the more subtle change in tonality from image (5) to image (6).

In 1842, the French illustrator J. J. Grandville had drawn a similar series of images—a graphic variation on a pantomime number by the famous mime artist Baptiste (Jean-Gaspard Deburau). The difference between the two conceptual approaches is made quite clear by the comparison. In Frost's story—as in Muybridge's chronophotographic plates—the temporal and dynamic information is given in the *intervals* between contiguous images. In Grandville's pantomime, the transition between two contiguous images plays no role in the reconstruction of the action. Very logically for the era, the Frenchman represents the transitions in the images themselves, through a subtle mix of contradictory facial ex-

pressions. The whole point of Grandville's exercise is to make explicit the morphing from one expression to the other. Like words in a sentence, the different moments of Grandville's pantomime are actually separated by a neutral space with no particular significance.

The page Frost published a month after his little phonological experiment (*Harper's New Monthly*, January 1880) is based on the same Muybridgean "reading mode," in which the activation curve of the sequence is given by the forward jump from one image to the next. In fact, the intervals between the images here are even richer in information. Their six panels describe the relationship between a father (heavily preoccupied with his bills) and an obnoxious son who flits around him like an annoying housefly. While the dialogue explains the action, the visual comedy exploits the fact that, given equal transition time, the facial and postural shifts between two frames give rich kinesthetic and temporal information about the contrasting dynamism of the two characters. To appreciate this, it is sufficient to follow only the head and shoulders of the father (with the little boy flitting around in the reader's peripheral vision): there is barely a tremor between (1) and (2) and between (2) and

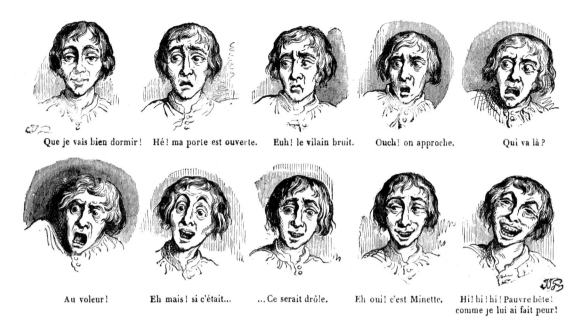

Que je vais bien dormir ! Hé ! ma porte est ouverte. Euh! le vilain bruit. Ouch! on approche. Qui va là ?

Au voleur ! Eh mais! si c'était... ...Ce serait drôle. Eh oui! c'est Minette. Hi! hi! hi! Pauvre bête! comme je lui ai fait peur!

A STUDY IN EXPRESSIONS.

It is said that Garrick one day, before entering a drawing-room, introduced his head through the partially opened door and, by the clever distortion of his features only, spread anxiety and terror over all those assembled, and not until he had reassured them, by reassuming his ordinary features, could the conversation be resumed. Hardly less striking examples of different expressions in one face are here shown by a number of heads, drawn by J. J. Grandville, and purporting to illustrate the following incident : John is turning in rather late, after a long babble with a neighbour. They had been talking of ghosts, but John does not believe in ghosts. The lights are out, he gropes for the door of his room, with the thought that he is going to enjoy a good night's rest. The sequel is told by the pictures above given.

Figure 6.10 **J. J. Grandville, *Le magasin pittoresque*, July 1842. Wood engraving.**

(3); an acceleration between (3) and (4), when the upper half of his body moves to an erect position; a brief jump forward between (4) and (5); and, concluding the story, a quick and unexpected movement between (5) and (6).

During his career as a cartoonist, Frost often drew stories whose only real point was to oppose characters with highly contrasting levels of vitality and energy. His animal and human creatures were driven by primal effects—fear, wrath, enthusiasm, hapless exuberance, or plain stubbornness—and he showed considerable verve in staging the arc of their emotions by skipping from one particularly well-chosen attitude to the next.

Not all of Frost's stories, however, can be read, strictly speaking, as Muybridgean plates. Under his pen, the interval between two images soon became pregnant with new expressive powers, and he often used the concept much more loosely and intuitively. In the tale of the two bicyclists (fig. 6.13), the "camera" pans from left to right in the first three images, and the temporal framework is uneven. The action, however, retains the spontaneous dynamism and propelling sensation of his first stories.

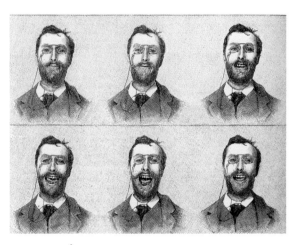

Figure 6.11 **Étienne-Jules Marey, *Portrait of Demeny Pronouncing the Phrase "Vive la France"* (detail), *La nature*, no. 988, 1892.**

Sometimes, comic illustrators appear to think ahead of the scientific community. More than ten years after Frost's phonological pastiche of chronophotography (fig. 6.9), Étienne-Jules Marey and his assistant, Georges Demeny, used the same technique to capture the human face and its shaping of sounds into words, thus producing sequences that were eerily similar to Frost's prophetic cartoon (Mathews 2005, 84).

This second story, published in
Harper's New Monthly a month after
the first, also makes reference to
Muybridge's repetitive chronophoto-
graphic compositions. It contrasts the
ponderous attitude of the father with
that of the intolerable son, who flits
about, asking incongruous questions
and demanding a plate of ice cream.

MR. VAN PURCELESS BEING FASHIONABLY SHORT OF FUNDS, HAS TO WRITE A CAREFULLY
WORDED LETTER, WITH A VIEW TO RAISING THE WIND, AND IS ASSISTED IN THE FOL-
LOWING MANNER BY HIS SON AND HEIR:

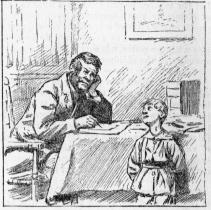

"Pa, will you buy me a plate of ice-cream next Fourth
of July?"

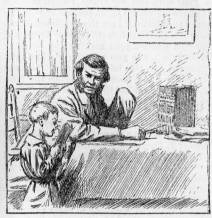

"Pa, what does inc-ompr-ehens-ib-le spell?"

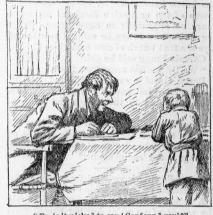

"Pa, is it wicked to say 'Confound you'?"
"Confound you—yes! Don't bother!"

"Pa, my nose itches."
"Then scra-a-atch it!"

"Pa, I think the ice-man is going to call for his bill
to-day."

This is more than flesh and blood can stand. Van
Purceless is on the war-path.

Looking at the world through a simplified,
schematized version of the Muybridgean model,
Frost found the germ of a stylized idiom of action
that he evidently linked to his theme of choice.
Muybridge's plates were about humans and
animals "in motion," and the visual information
they captured mechanically and chemically was
objective (this was, of course, what allowed the
Lumière brothers and Edison to reverse the ana-
lytical process in order to produce the illusion of
motion on the screen). In Frost's later stories, the
real metric of the action was not the temporal
or spatial metric of motion but the inner, elastic
metric of surging emotion.

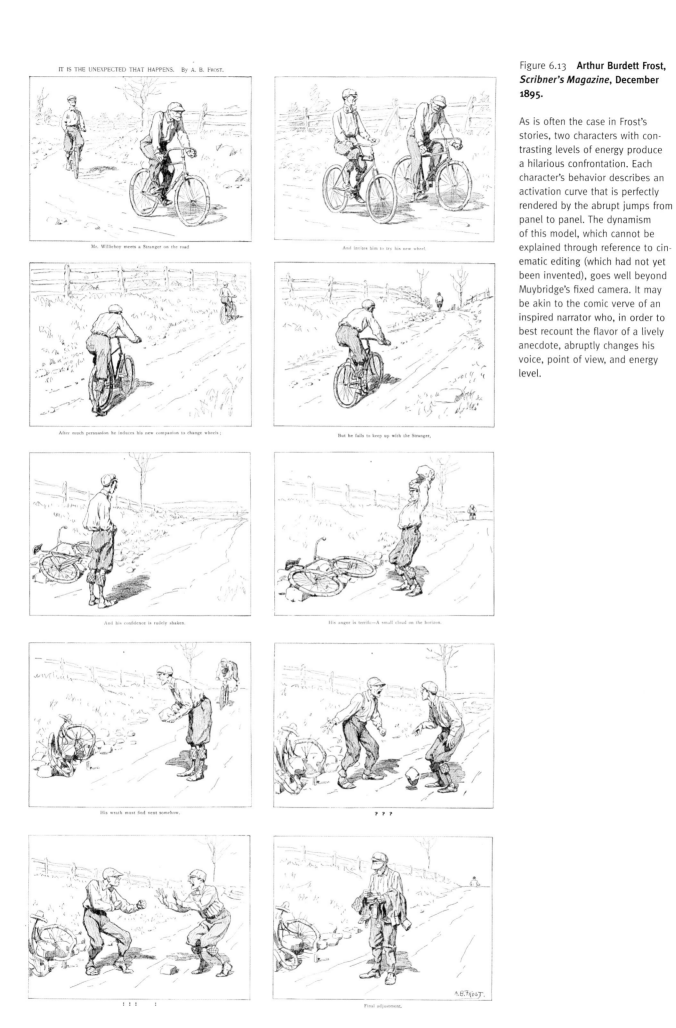

IT IS THE UNEXPECTED THAT HAPPENS. By A. B. Frost.

Mr. Willieboy meets a Stranger on the road.

And invites him to try his new wheel.

After much persuasion he induces his new companion to change wheels ;

But he fails to keep up with the Stranger,

And his confidence is rudely shaken.

His anger is terrific—A small cloud on the horizon.

His wrath must find vent somehow.

? ? ?

! ! ! !

Final adjustment.

Figure 6.13 **Arthur Burdett Frost,**
Scribner's Magazine, **December**
1895.

As is often the case in Frost's
stories, two characters with con-
trasting levels of energy produce
a hilarious confrontation. Each
character's behavior describes an
activation curve that is perfectly
rendered by the abrupt jumps from
panel to panel. The dynamism
of this model, which cannot be
explained through reference to cin-
ematic editing (which had not yet
been invented), goes well beyond
Muybridge's fixed camera. It may
be akin to the comic verve of an
inspired narrator who, in order to
best recount the flavor of a lively
anecdote, abruptly changes his
voice, point of view, and energy
level.

Figure 6.14 **Arthur Burdett Frost,** *Mr. Bites Goes Rail-Shooting,* *Harper's Bazar* 17, no. 48, October 24, 1884. Wood engraving.

Figure 6.15 **Caran d'Ache (Emmanuel Poiré),** *A Cow, Watching a Passing Train*, **Bric-à-Brac (Paris: Plon, Nourrit and Cie, 1893).**

In retrospect, it is difficult to appreciate the nuances between the different idioms of progressive action with which the cartoonists of the period played in the immediate precinematographic period. Today, the art of telling a comic-strip story is often taken as a seamless craft that integrates all the tactful, rational choices one has to make to accomplish the job in a realistic and convincing manner. This is the general perspective adopted by Will Eisner and Scott McCloud: in their books on the subject, sequential art is seen as an all-encompassing, unified medium.

Comic picture stories of the nineteenth century could be more fruitfully compared—if one wants to find a parallel in the twentieth century—to *Mad Magazine*'s brilliant parodies of TV commercials, newspaper comic strips, genre movies, 3-D comics, modern art, and more in the 1950s. For *Mad*'s Harvey Kurtzman and his colleagues, telling the story efficiently was not the issue; the important thing was to make comical points with the way the story was told, using the specific idioms lampooned by the authors. The laboratory of humoristic illustration in the second half of the nineteenth century worked in a similar way: it produced short, focused picture stories with a definite (and often ironic) tone. Its

core tools were the witty allusion to older visual forms of storytelling, the stylization (and hybridization) of existing visual languages, and the diagrammatic reference to the new "ways of seeing" brought about by technology.

In the 1880s and 1890s, especially in the German and American press, one can observe a growing interest in the last of these tropes—a tendency to gravitate toward the recording of action by technical means. From the point of view of an illustrator, the defining characteristic of photographic images was their cold neutrality of tone, which they shared with technical illustrations. In the previous chapter, we saw how visual humorists like Hans Schliessmann and Emil Reinicke in Germany, and Caran d'Ache and Christophe in France, promoted a "clear line" that mimicked that lack of expression in many of their wordless gags. Of course, the flat, pseudo-objective tone in which they delivered their "stories without words" about the props and inventions of the modern world was as much an affectation as the Gothic, flowery style used by the generation before. There was still much irony behind their drawings, to be sure—but it was a deadpan sort of irony.

PHOTOGRAPHS OF ANIMALS IN MOTION, TAKEN BY PROFESSOR ABRIDGE'S INSTANTANEOUS PROCESS.

1. The Mule.—The Animal which posed for this Series is of the breed known as "The Paragrapher's Extra," and is capable of anything possible to an individual of his Species.

3. The Boy—As he appears chopping Wood for his Mother. The Clock is included in this Series for Scientific Reasons, and not merely for the Picturesque Effect.

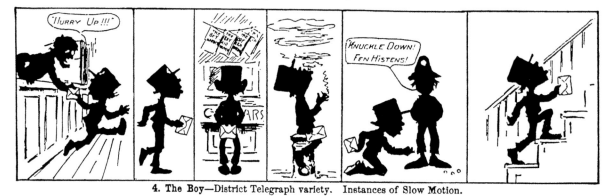

4. The Boy—District Telegraph variety.　Instances of Slow Motion.

Figure 6.16　**Henry Stull, *Photographs of Animals in Motion Taken by Professor Abridge's Instantaneous Process, Our Continent*, April 8, 1883. Wood engraving.**

Humor is a powerful semiotic and cognitive tool: European and American cartoonists near the end of the nineteenth century helped translate (ironically) the experience of the moving image in terms of existing systems of representation. In this evocation of Muybridge's Zoopraxiscope projections, a number of familiar "social scripts" are comically reinterpreted in light of the new technology.

It was only natural that the cold, diagrammatic style adopted by authors of the new generation would also be reflected in the layouts of their pages. The mechanical rhythm of the Muybridgean grid, with its strict repetition of background in each panel, was just the vehicle for making fun of the modern world, and the German and French adepts of the "clear line" started using it with increasing frequency in the 1880s and 1890s. The trend was also a symptom of the growing impact of chronophotography on the visual culture at large.

In the middle of the 1890s, Edison's Kinetoscope began to arouse even more interest, particularly in the United States, than had Muybridge's original invention. The culture of the moving image was entering its first decade of existence, an initial "fairground phase" during which Edison's and the Lumières' moving pictures would proudly display their power to at-

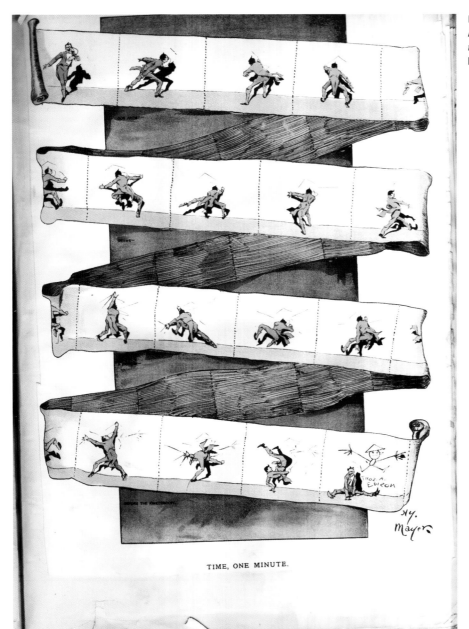

Figure 6.17 **Henry "Hy" Mayer, *Time, One Minute (Our Artist Draws a Picture Before the Kinetoscope)*, ca. 1896, from a scrapbook in the collection of Robert Beerbohm.**

tract large crowds with the magic of recorded action (see chapter 5). Comic illustrators clearly felt challenged by the novelty. They had held the precursor technology under close scrutiny since the 1880s, and its signature layout was now part of their vocabulary: the dialogue between comic illustrators and moving pictures could only be intense and involved.

Opper's *Kinetoscopic Study of Human Nature* (fig. 6.19), published early in 1900, is a good example of the way cartoonists at that time could still refer to the new technology while holding it at arm's length. Concentrating on the facial expressions and gestures of the actor, Opper's strip starts by presenting Edison's Kinetoscope in terms of the old culture of rhetorical gestures

and action (a tradition that English cartoonists like Harry Furniss firmly maintained in *Punch's Sketches in Parliament*, in which MPs are shown in oratorical action). The whole point of Opper's story, however, is to show the transition between the old and the new languages of progressive action: as the subject reads an offensive comic valentine, he loses his composure, and his rhetorical gestures become more and more agitated, emotional, and impulsive. The story that had begun as an exercise in self-control and decorum now finishes, quite chaotically, as a truly "Kinetoscopic study of human nature."

At the time Opper drew this page, however, a new factor had just appeared that was to profoundly affect the exchange between comics and

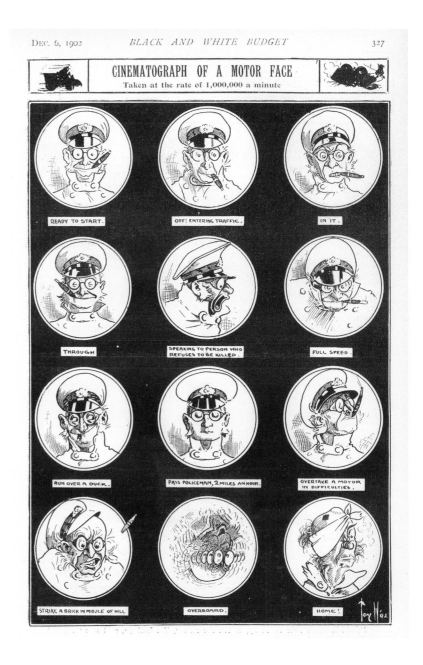

moving pictures. Around 1900, American cartoonists realized that an increasing proportion of the short films produced by Edison and his consorts were directly inspired by their stories. Before that point, the use of a chronographic layout had always implied a certain distance, a witty—if deadpan—reference to mechanically recorded (sequential) action. Now that the relationship with the new medium was becoming competitive, cartoonists probably recognized that they had to respond to the success of the concurrent medium and mark their territory. The most effective way to accomplish that was to adopt the Muybridgean grid as their default solution.

The Katzenjammer Kids gag shown in figure 6.21 is a good example of the spectacular new di-

mension the grid was given when used in combination with vibrant colors. The primary tones added a potent decorative value to the formula. The repetitive patterns (not unlike those of fancy wallpapers) now presented an eye-catching, attractive visual signature that made such layouts instantly recognizable as comic strips.

In the early years of the century, cartoonists massively adopted this solution in the Sunday color supplements. In a period enthralled by the magic of moving pictures, it was a strong, original statement of identity and priority. If cartoonists were to share a symbiotic relationship with the nascent cinematographic industry, this was the way to go: in flying colors, with a vivid reminder of the leading role they had played in opening this new territory.

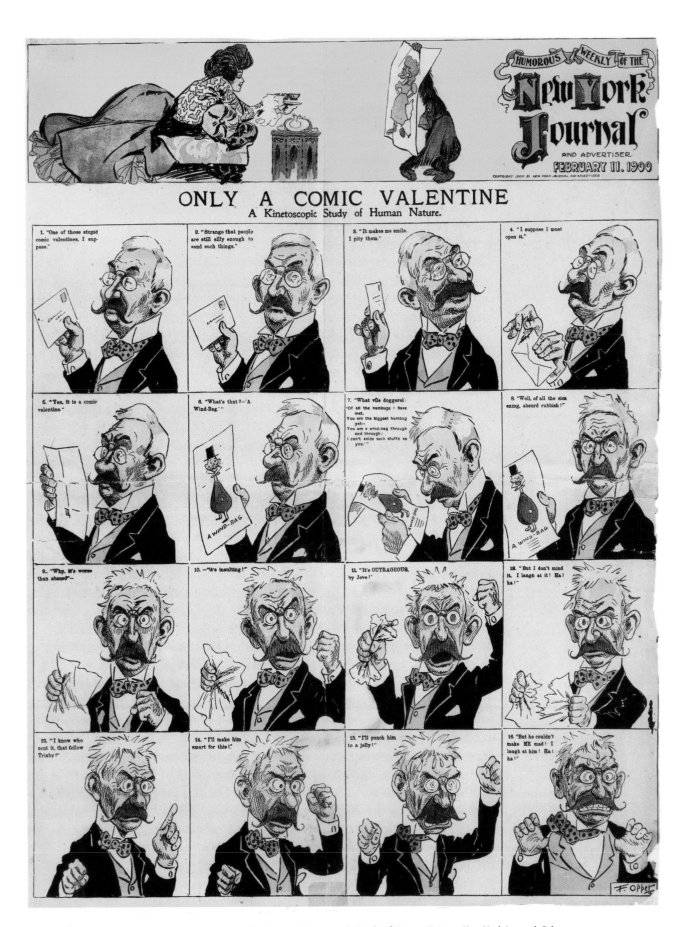

Figure 6.19 **Frederick Burr Opper, *Only a Comic Valentine: A Kinetoscopic Study of Human Nature*, New York Journal, February 11, 1900.**

In this "Kinetoscopic Study of Human Nature," the protagonist gradually discovers the insulting character of the Valentine's Day card that an anonymous admirer has sent to him. This page, which is clearly inspired by A. B. Frost's parody of chronophotography published twenty years earlier, represents a key moment in the adoption of Muybridge's grid in the color comics supplement.

A. B. FROST AND THE PHOTOGRAPHIC REVOLUTION

Figure 6.20 **Arthur Burdett Frost, Untitled,** *Harper's Bazar* **20, no. 38, September 17, 1887. Wood engraving.**

Some of the most inventive cartoonists of the period, however, were clearly concerned that sequential action, as recorded by mechanical means, was only a minute part of the rich realm of visual irony and that the formula would actually freeze, once and for all, many of the parameters with which comic artists had wittily played for many generations. Now it seemed that cartoonists, if they wanted to be successful, had to be permanently locked up in this predefined relationship with their readers, mimicking the deadpan, mechanical tone of a rival medium. From the point of view of the comic tradition, this was an undeniable impoverishment.

A. B. Frost, among others from the older generation, refused to jump on the bandwagon. In *Carlo*, his only book-length comic (drawn in Europe but serialized in the American press in 1914), he brilliantly pursued the conception of ironic and dynamic timing that he had invented twenty years before. Many talented cartoonists of the younger generation apparently had similar reservations about the popular form: Gustave Verbeek, Peter Newell, Winsor McCay, and Lyonel Feininger (to name a few) produced strikingly original solutions to circumvent the standard sequential formula.

Critical posterity has more than validated these efforts, but the history of the comic strip in the twentieth century shows that, at the time, these artists were working against the tide. The strategic importance of the form (for the U.S. press) and its symbiotic relationship with the language of the moving pictures was to make the comic strip a cornerstone of the media culture for at least half a century. Actually, the artists who had embraced that challenge around 1900 such as Opper, Outcault, Swinnerton, and Dirks were already working hard on the next stage of the race. Tinkering with one of the oldest devices of their trade (the antique *label*, or phylactery), they were already well on their way to starting the audiovisual revolution before anyone else. It was only a matter of transforming the device into the modern speech balloon.

Figure 6.21 **Rudolf Dirks,** *The Katzenjammer Kids Dig a Tunnel in the Snow*, *New York Journal*, **December 16, 1900.**

Figure 7.1 **George Cruikshank, *Cruikshank's Comic Almanack* (London: Charles Tilt, 1840). Etching.**

Humorous and satiric images published by Cruikshank from the 1830s through the 1850s played a role in bridging Hogarth's engravings (often replete with scriptural elements) and Outcault's Yellow Kid splash-pages at the end of the century. The commercial language of posters, which conquered the walls of London during this period, frequently rubbed shoulders with that of the labels.

7

From the Label to the Balloon

The Creation of an Audiovisual Stage on Paper

For the contemporary reader, the act of reading comics is a perfectly transparent task. This does not mean, however, that the language of comics is natural or simple; what its transparency suggests is that we are able to read it fluently.

This familiarity constitutes a pernicious trap for the historian, who may be tempted to believe that some solutions were adopted only because their simplicity and effectiveness made them *obvious* solutions. The real question is why, at a given period, certain solutions begin to perform their job so well that they provide an impression of simplicity and efficiency.

In this respect, the history of the word balloon is exemplary. Today, the balloon seems to be the most natural way to attribute the gift of speech to a drawing in a sequential narrative. It is a convention, of course, but insofar as it perfectly performs its role, we do not see how it connects to the historical period in which it began to take on this role. Merely noting that it is a simple and effective solution, well suited to the job, seems to settle the matter.

Yet how do we explain away the problem that all observers have stumbled upon, which can be summarized in one question: Why was it, prior to the end of the nineteenth century, that authors who readily used the balloon in other contexts *never* used it in their picture stories?

Töpffer himself had used "speech balloons" in some of his cartoons, and the device appears frequently in George Cruikshank's collections of comic images. Balloons were common in cartoons in *Punch*, and the word balloon had been omnipresent in the graphic satires of the English-speaking world from the seventeenth century. All comic artists were aware of the device, yet none of them dreamed of using it within the framework of a picture story. If the word balloon was as obvious a solution as we now think it is—simple, natural, and efficient—this is inexplicable. In reality, we need to examine its role in the context of graphic satire, a field in which it had been anchored for centuries, in order to understand what made it incompatible with the picture-story genre until the audiovisual revolution that took place between 1896 and 1905.

What we today call "speech balloons" were not always known as such. As we shall see, terminology is not an insignificant matter. The word *phylactery*, from the Greek, defines a type of amulet worn in antiquity as a talisman against illness. The New Testament uses the word to describe the orthodox Jewish practice of wearing strips of parchment or vellum upon which Hebrew texts have been written. A phylactery, in the medieval period, was taken to designate

Figure 7.2 **Thomas Rowlandson, *An Irish Howl*, 1799. Facsimile by T. Fairholt, 1848. Wood-engraving.**

Graphic satires privileged allegorical and emblematic images in which the talking banners naturally had their place. Because they are deployed in an abstract dimension that eschews the laws of space and time, such representations generally preclude any form of narrative development.

the curled scrolls that were inserted as captions in various types of representations (architecture, sculpture, graphic arts). Specialists are careful to note that these captions only very rarely represent words spoken by characters (Alexandra-Bidon 1990). Most often, they function as simple labels indicating the names of the angels or evangelists who wear them, or the first lines of works of which they are the authors. *Label* is precisely the word that was traditionally used in English to designate its routine use within the framework of graphic satire (Fairholt 1854, 257).

The satirical images in which labels appear are essentially emblematic and allegorical. In these purely intellectual constructions, characters and settings have both a literal meaning (the "scene" presented by the image) and a hidden meaning that the reader must decode. On the literal level,

the image can signify absolutely everything, or nothing at all. The tableau is nothing more than a hieroglyph; its message need not be any more plausible or coherent than the scrambled code of an encrypted text. This freedom also allows creators of satiric images to embed topical items (public figures and events) within the wildest fantasies. In the world of emblems, the most strikingly surreal images can be created without consequence.

In this context, the reason why labels cannot be read as simple balloons becomes clearer. There is nothing natural in the construction of emblems and allegories; such figures live in the dimension that is unveiled in baroque theatre when the action is interrupted in order to reveal the truth of the tragedy in the form of a living tableau—a world of eternal truths in which nei-

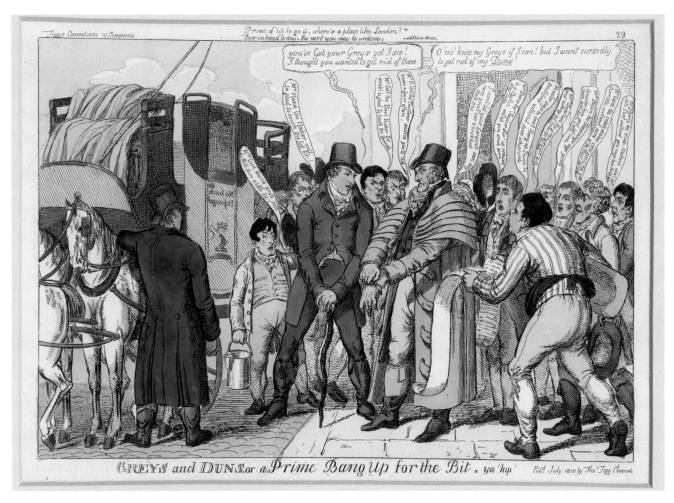

Figure 7.3 **Anonymous, *Greys and Duns*, Tegg Caricatures, London, July 1810.**

While it appears realistic, the scene, in fact, hides a satirical message and thus calls for a nonnarrative kind of reading. This decipherment process justifies the introduction of labels.

ther time nor space play any role. How could figures frozen in a timeless hieroglyph speak freely, like characters in a comic strip?

On the other hand, the original function of the device—its labeling function—is, in this context, perfectly appropriate. In emblematic satire, the real function of labels is the same as that of phylactery in medieval times: the device allows the elements in a hieroglyph or in a rebus to clarify their function, to *present themselves.*

This function determines in a very precise way the kinds of utterance they can produce and the context in which they can be used. "Talking scrolls" are only meaningful in the timeless and abstract dimension of a puzzle that the reader is invited to solve.

The self-presentation function explains, of course, the often stiff and hieratic aspects that the "speeches" reported by labels take on for those who naïvely read them as modern word

balloons. Satirists (like the English caricaturist James Gillray during the Napoleonic period) showed an astonishing verve in the singular art of the self-presenting soliloquy, yet if one does not take the trouble to interpret the labels in light of the title and caption that provide the first keys to these images, the character's speech is generally incomprehensible.

The fact that the label was totally dedicated to the deciphering of the puzzle submitted to the reader made it incompatible with the temporal and spatial development of picture stories. An image taking part in a progressive action is *open*; it encourages the reader to elaborate (more or less consciously) hypotheses about what might follow. On the other hand, the presence of a label stops time and contributes to the closing off of the image itself. It prompts the (active and playful) form of deciphering a stand-alone puzzle—a rebus without a past or a future.

Figure 7.4 **George Cruikshank, *George Crui-kshank's Omnibus* (London: Tilt and Bogue, 1841). Etching.**

Puns and metaphors abound in Cruikshank's work. In his cartoons, the label plays its traditional role as a self-presentational device that, in conjunction with the cartoon's title, is meant to help the reader decipher the picture's meaning.

Over the course of his long career, George Cruikshank extended the use of the label well beyond graphic satire and into various visual games that only kept a vague association with the emblems, but that preserved the traditional function of the device and its existence in the current of humorous illustration until the middle of the nineteenth century. For example, his collections of humorous images often contrived to run down an idea in all of its forms: each page reflected different variants of a pun to which the title gave the key. In this playful context, the labels maintained their usual function as a self-presentational speech of identification and elucidation.

One of the pioneers of the American comic strip, James Swinnerton, spoke of the moment in the mid-1890s that drove the creation of the modern form of the word balloon: "It was not the fashion to have balloons showing what the characters were saying," Swinnerton said in an interview in the 1940s, "as that was supposed to have been buried with the English Cruikshank. But along came the comic supplements, and

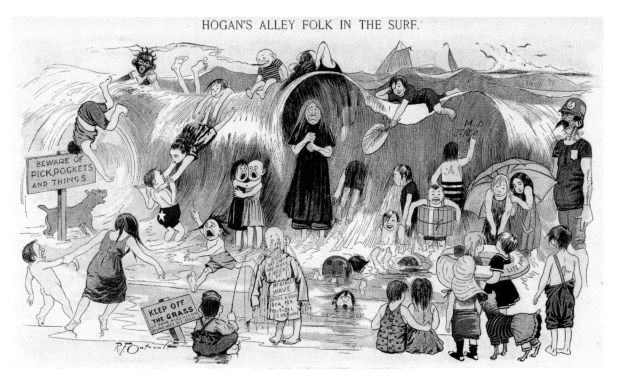

Figure 7.5 **Richard F. Outcault, *Hogan's Alley*, *New York World*, June 14, 1896.**

The wave in the background materializes a verbal metaphor (the "McKinley wave," anticipated in the coming election). Typical of Outcault's emblematic satires, the image presents a frozen tableau that is both timeless and surreal (one of the children rests on the wave as if it were a sofa, while another writes graffiti on it).The Yellow Kid's nightshirt first adopted its role as a label in this image. Midway between the placard, the sandwich board, and the speaking banners, in Outcault's hands this device often hesitates between the usual function of self-presentation and that of commercial self-promotion. Note that Hogarth himself, in some of his engravings, might have already played with the double meaning of the word *label*.

with Dick Outcault's *Yellow Kid*, the balloons came back and literally filled the comic sky" (Gaines 1942). This testimony credits the important part Cruikshank played in maintaining the label tradition and confirms the role played by Outcault in resurrecting it. It does not shed much light, however, on the subtle revolution that accompanied the transformation of the device in the modern comic strip.

The modern speech balloon sprang forth from the eclectic jumble of *The Yellow Kid*. As mentioned previously (at the end of chapter 5), Outcault's teeming images recall those of Hogarth and Cruikshank while creating graphic spaces of a bewildering heterogeneity. Elements of slapstick often conflate with the traditional tone of graphic satire in his cartoons. Outcault thus rediscovered the two modes of freezing an image that Hogarth had illustrated in the plates of his *Analysis of Beauty* (see chapter 1): the emblematic freeze (which holds figures in timeless poses beyond physical constraint) and the suspended action (which fixes a movement in one instant of time).

The tension between these two modes played, in Outcault's images, a part similar to the part it played in Hogarth's work. By allowing the emblematic freeze to *interface* with snapshots of suspended action, Outcault, like Hogarth, created a polygraphic space where the timeless grammar of the hieroglyphic could *interpret* the ever-changing dialects of the world in action and assign them new meanings and new stylizations. The resurrection of the old label in the form of the modern speech balloon is a specialized example of this process.

Labels returned in three different ways in *The Yellow Kid*. The most spectacular of these was not the most original: the discourse written on the Kid's nightshirt ensured the usual self-presentational function. This solution first appeared—not by chance—in a typically emblematic cartoon (fig. 7.5).

Outcault also used labels to represent the voice of the little boy who, almost each week, fell from a window in the background of the image. The stoic boy comments on his descent, and here again the label fills its standard function: by its

Figure 7.6 **Richard F. Outcault, *Hogan's Alley* (detail), September 13, 1896.**

The labels in Outcault's images—including the parrot's speech balloon—continue to function as they did in Cruikshank's images. But by its mere presence, the parrot contradicts the traditional meaning of the device by evoking the idea (ludicrous at the time) that it could be considered a simple sound image independent of the textual structure that underlies the image.

very presence it confirms the surreal timelessness of a fall without impact. It is a fragment of tableau vivant, lacking both a past and a future, typical of the emblematic tradition. At the same time, a subtler effect is in play here. Outcault's furiously heterogeneous panoramas are also spiced with credible slapstick incidents whose consequences are perfectly predictable. Hesitating between these two reading schemes, the boy's fall becomes even more fascinating; in the way of certain optical illusions, it oscillates between two incompatible forms of freeze-frame.

Here we turn to the third and most interesting use of the label: the parrot's speech balloon, of which Outcault made a specialty over time (even if the idea was not originally his own). To begin with, it is important to understand that this particular effect actually represented, for the reader of this period, a comical incongruity. To explain why, however, is not easy today, because we belong to the audiovisual era. What

the parrot's balloon evoked, at the time, was a transgression of the underlying structure of *scriptural* decipherment on which the traditional label depended. Remember that to grasp the meaning of a speech scroll in an emblematic cartoon, one had to carefully read the title and the caption, and understand how each label connected a piece of the puzzle to the general theme.

The image of the parrot introduced a disturbing disconnect in this system, because the bird evokes, irresistibly, an utterance that is a pure sound image: speech without a speaker. By its very presence, the parrot comically interferes with the framework of meaning and authority to which the label was traditionally attached. As an utterance without a speaker, a pure sound image, the parrot's label jubilantly suggests that it does not belong to that structure and can float freely in the picture, as if to say: Look, no strings attached here! Hence the change in terminology: it

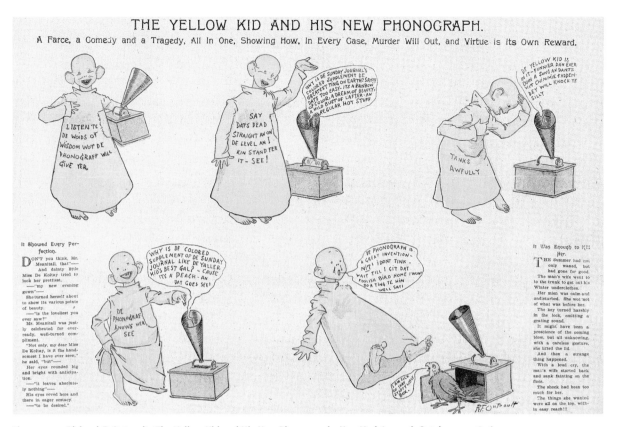

Figure 7.7 Richard F. Outcault, *The Yellow Kid and His New Phonograph*, *New York Journal*, October 25, 1896.

is not a label or a phylactery anymore. It is much more like a balloon, a bubble, a puff of smoke.

At first, the autonomy of the parrot's word balloon was only a pretense, a way of framing its message in the visual incongruity of the talking parrot, which clearly contradicted the label's proper function. The public seemed to like the joke, however, and Outcault was always ready to give the public what it wanted. By a stroke of luck, he then found himself ideally placed to assimilate this "speech without a speaker" with an invention recently released by Edison's lab. In 1889, at the Paris Universal Exposition, tens of thousands of people had come to listen to twenty-five phonographs speaking dozens of languages, and Outcault was the Edison lab's official illustrator at the time (Blackbeard 1995). As a member of the team that accompanied the American inventor to Paris, he had witnessed the immense popular success of the new invention with his own eyes.

Historians of the media interested in the cultural impact of the phonograph describe the experience of the talking machine as a "new form of citation" (Gitelman 2003, 166–167). As one onlooker marveled at the time: "The really

remarkable aspect of the device arose . . . in literally reading itself [as if] instead of perusing a book ourselves, we drop it in the machine, set the latter in motion and behold! The voice of the author is heard repeating his own composition" (Gitelman 2003, 159).

The well-known strip *The Yellow Kid and His New Phonograph*, which many American historians take to be the first real example of the modern comic-strip form, show us how Outcault comically reinterpreted this new form of quotation marks in terms of the parrot's speech balloon.

In typical self-presentational mode, the machine proffers a pompous self-promotional discourse for the newspaper itself (specifically, for the color supplement). What is implied by the parrot's sudden emergence from the talking box is that this authoritative Master's Voice does not fool Outcault. The bird mocks the symbolic link between author and phonographic quotation and redefines the talking box as a parroting machine that can only produce a sound image—speech without a speaker. Shocked by this revelation, the Yellow Kid literally tumbles into the audiovisual sphere.

1ʳᵉ année. — Nᵒ 17. 10 centimes. 22 juin 1889.

LE
Petit Français illustré
JOURNAL DES ÉCOLIERS ET DES ÉCOLIÈRES

L'ABONNEMENT : UN AN, SIX FRANCS
Part du 1ᵉʳ de chaque mois.

Armand COLIN & Cⁱᵉ, éditeurs
5, rue de Mézières, Paris

ÉTRANGER : 7 fr. — PARAIT CHAQUE SAMEDI
Tous droits réservés.

Le phonographe d'Édison; à gauche la pile électrique qui met en mouvement l'appareil; en avant, les cylindres de cire durcie qui reçoivent les *phonogrammes*, et les tuyaux qui s'adaptent à l'appareil pour écouter la répétition des sons enregistrés.

Le *phonographe*[1], inventé par le célèbre ingénieur américain Edison, est un instrument qui enregistre la parole et la reproduit à volonté. L'opérateur se place dans la position indiquée par la gravure. Le son de la voix fait vibrer une membrane qui met en mouvement, dans l'intérieur de l'appareil, une aiguille très fine. Cette aiguille trace des creux en traits imperceptibles sur un cylindre de cire que fait tourner un moteur électrique.

Pour faire répéter au phonographe, au bout d'un temps quelconque, les paroles qu'il a reçues, on remplace le tube dans lequel on a parlé par un tuyau en caoutchouc à deux branches terminées par de petites ampoules de verre percées d'un trou. On s'introduit dans les oreilles ces ampoules destinées à transmettre les sons. On remet alors en mouvement le cylindre sur lequel une aiguille, disposée comme la première, communique à une membrane très sensible les vibrations que lui imprime la surface inégale du cylindre. Ces vibrations reproduisent les articulations et le son même de la voix de la personne dont l'instrument a enregistré la parole.

1. De deux mots grecs *phonê*, voix, *graphô*, j'écris.

Figure 7.8 **Edison's Phonograph, cover of *Le petit français illustré*, June 22, 1889.**

Figure 7.9　James Swinnerton, *Fight? Oh, No! Only Two Old Friends Meeting*, 1900.

Around 1900, cartoonists like Swinnerton and Opper worked hard to find the best way to use the speech balloon in the context of the pantomime gag. This early example by Swinnerton appears to point to the twentieth-century solution. The dialogue between the two Frenchmen cannot be separated from their body language. The gag relies on the fact that the situation, as a whole, presents an enigma to the native onlookers (who fear that it might turn into physical violence). This bundling together of speech and action without any hierarchy became central to the reading structure of the modern comic strip as an "audiovisual stage on paper." It presented a new kind of synthesis that was perhaps best mediated by the figure of a foreigner whose language, gesticulation, and intentions form an "audiovisual" code that cannot be parsed by conventional linguistic, textual, or social strategies. This early solution (also adopted by Opper; see fig. 7.10) suggested that characters that appear on the "audiovisual stage on paper" were to be approached holistically, with the same amused but vigilant wariness that we reserve for exalted foreigners.

Some historians are surprised that artists did not embark immediately on the road toward comics with speech balloons after Outcault's "phonograph" page (indeed, it took several years for Outcault's peers to adapt and generalize the principle). Again, their perplexity stems from their familiarity with the modern form of the comic strip. *The Yellow Kid and His New Phonograph* represents much more than a "first example" of the new form. The page is the very site where the "audiovisual stage on paper" was defined, not as an obvious solution but, quite the contrary, as an incongruity—a confrontation, filled with irony, between two incompatible forms of graphic quotation (the traditional label versus the parrot's speech balloon), which Outcault astutely put to use to map, on paper, two incompatible conceptions of Edison's speaking machine ("His Master's Voice" versus the parroting box). The gag was a striking illustration of

the type of semiotic work that comic illustrators accomplished in the nineteenth century, where archaic solutions were resurrected in order to interpret the modern world.

The Yellow Kid and His New Phonograph was never meant to light the fuse of a new genre; it was just a very clever standalone cartoon. The commercial success of the phonograph, however, considerably facilitated the adoption of the balloon at the expense of the older label in the following years. As the public got used to the talking machine, its ability to parrot sound images quickly superseded its initial conception as a device whose purpose was to relay "authorized quotations" directly from the author's voice. Outcault's comparison with the parrot's speech balloon was increasingly vindicated by the way the public used Edison's machine. In fact, even the shape of the phonograph's loudspeaker and the recording microphones suggested a styl-

Figure 7.10 **Frederick Burr Opper, *Alphonse and Gaston*, ca. 1902.**

Alphonse and Gaston, entangled in their endless kindness, suffer from a chronic inability to react to imminent danger. The dialogue carried by the word balloons belongs to the same space and time frame as physical action. The balloon must be read as a "sound object," embedded in spatially situated action, and the dialogue now participates fully in the visual pantomime. This breakthrough allowed Opper and Swinnerton to establish an "audiovisual stage on paper," where the word balloon is fully synchronized with the behavioral signature of the different characters.

ized version of the balloon and its tail. The older metaphor of the label as a written scroll could not long hold out against such powerful associations.

Nonetheless, the way the balloon actually worked remained open to some creative research and development. Recall that the use of the old label was quite constrained: it presupposed a certain type of abstraction (the timelessness of the rebus or the emblem), a certain kind of reading (the deciphering of a titled and captioned image forming a closed problem), and even a certain mode of enunciation (a self-presentational discourse). These constraints, which had existed for centuries, would not be removed by a simple wave of the magic wand.

Around 1900, cartoonists began to experiment. The most popular genre at the time was the wordless story in the *Fliegende Blätter* tradition: short, diagrammatic sequences of slapstick that seemed to "read themselves." The problem was to find a way to synchronize a device (the speech balloon) that had just been redefined by

its connection to the phonographic sound image, with a form of wordless story that was engaged in a mirroring match with the motion picture. Edison's labs had already worked on the audiovisual hypothesis in purely technical terms by trying to combine the phonograph and the Kinetoscope in one machine (incidentally, a well-known illustration depicting the experimentation with such a prototype was drawn by Outcault for Edison's trade magazine!). The problem facing cartoonists, however, was of a different nature. It much more closely resembled what would happen thirty years later to Charlie Chaplin, Buster Keaton, and other burlesque masters with the appearance of talking film.

In wordless pantomimes (drawn on paper), the real author of the story is a graphic character engaged in a world of mechanical forces. The body builds a visual discourse in which the chain of cause and effect provides syntax. How are we to insert balloons in such a world other than in the form of simple exclamations, stereotyped quotations, or isolated sound images? In

other words, how are we to synchronize action and sound images in a fluid and living manner without creating conflicts of authority?

Most scholars of this period consider Frederick Burr Opper and James Swinnerton as the most significant contributors to the use of word balloons in pantomime burlesque (Marshall 1989, 60). A comparison between two of Opper's flagship series sheds light on the principle according to which the word balloon was deployed around 1900.

The first series is essentially a pantomime: *Maud the Mule* is named after a quadruped whose only characteristic is a stubborn temperament. When Maud decides to stop walking, on a railway line for instance, nothing can be done to budge her, not even the arrival of the locomotive. All the gags in the series revolve around this leitmotif. In 1902, Opper gave Maud a sister series, *Alphonse and Gaston*, which transposed this behavioral signature onto the linguistic level. Alphonse and Gaston are two stereotypical Frenchmen whose pathological politeness renders them incapable of reacting to imminent catastrophes. Their interminable exchanges of politesse—"After you, my dear Gaston!"; "I will not, my dear Alphonse!"—were a transparent transposition of the mule's physical behavior.

The principal effect of this transposition was to synchronize the speech balloon with the world of slapstick. Alphonse's and Gaston's verbal procrastinations—as well as their word balloons—had become objects as permanent, solid, visible, and predictable as the train that was bearing down on these two likeable cretins tangled in their polite exchanges. By creating a "signature dialogue" that mirrored the repetitive-compulsive manias of pantomime characters, Opper had literally tied their balloons to the world of action.

The word balloon in the modern comic strip situates speech in the space-time of slapstick without any reference to an extraneous authority. Contrary to the traditional function of dialogue in a theater production, the device is not meant to suggest the hidden substructure of an authored text but to entangle the sound image produced by the character in the kinds of spatial relationships and mechanical forces that define visible objects and bodies. This usage (which Hergé exploited with sheer brilliance in the creation of Haddock, Calculus, and the Thompsons—each of whom had a particularly striking "verbal/behavioral signature") provided a sufficient level of synchronization with comic pantomime to anchor all other possible speech modes in sequential action. That is how, thirty years before talking cinema, the comic strip created an audiovisual stage on paper.

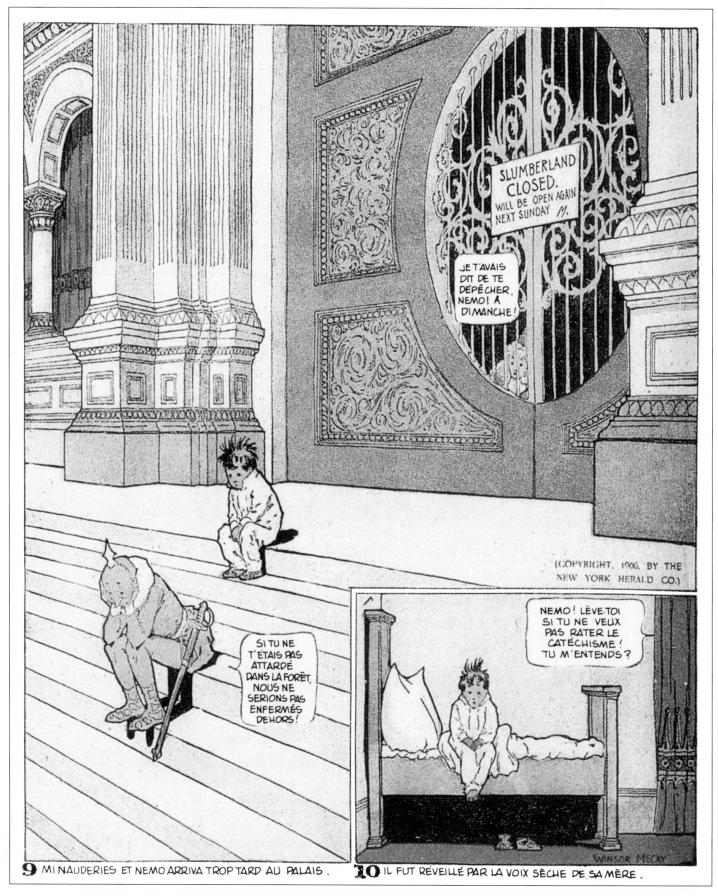

Figure 8.1 **Winsor McCay, *Little Nemo in Slumberland*, *New York Herald*, February 25, 1906.**

The portico of Slumberland Palace was inspired by the golden doors of the Modern Transportation Building at the 1893 Chicago World's Columbian Exposition. The baroque architecture of this memorable world's fair was a major source of McCay's architectural imagination.

Winsor McCay

The Last Baroque

Winsor McCay's *Little Nemo in Slumberland* (1905) offers a fascinating example of a work that explores almost all of the possibilities of the form, or medium, in which it is produced. Since its rediscovery in the 1960s, the series has been treated like an artistic miracle that could only have been conceived by an incomparable genius. Created just a few years after the modern comic strip was settled in its twentieth-century tracks, the series does indeed push the limits of the genre well beyond what might reasonably have been expected in such a short period of time.

If we hope to understand this "miracle," however, we need to place it in the very particular context of the early 1900s. The limits McCay sought to overcome were not those of the twentieth-century form taken as a whole, of course, but only those of the popular form that was developing at the time he was invited to join the *New York Herald* (a competitor of the papers owned by Hearst and Pulitzer). The series McCay created upon his arrival in New York presented a calculated and perceptive response to the popular production of the time. McCay wanted to elevate the artistic level of the genre so as to attract a more sophisticated public. To achieve that, he meant to create the most striking alternative imaginable to the simple formulas adopted by his peers.

Coming as he did from the world of dime museums and the circus (he had worked as an artist for ten years in this field), it was natural for McCay to look sternly upon the "attractions" of his colleagues and competitors. He knew how mechanical they were, and his entire body of work stands as a condemnation of their cheap artificiality and lack of ambition. In this, he encountered the same fundamental questions about *life* that ambitious men like Hogarth, Töpffer, Doré, Barnard, and Frost had tackled before him. Like them, McCay knew that comic art was always about contrasting the sterile rhetoric of automation and fixed formulas with the verve of a lively thought.

Created about a year before *Little Nemo*, *Little Sammy Sneeze* (1904) formed a striking diptych with McCay's flagship work. In appearance, the two strips are spectacularly antithetical: *Little Sammy* is prosaic and deliberately repetitive in its form, while *Nemo*'s pages change structure every week and project readers into a fantasy-filled universe. In fact, the series are two faces of the same coin, and their differences can

Figure 8.2 **Winsor McCay, *Little Sammy Sneeze*, Hachette version, 1905.**

be explained by a simple shift in strategy: *Little Sammy Sneeze* is an extremely insightful parody of the popular comic strip of the time, while *Little Nemo in Slumberland* develops a genuine counterproposal.

We have already seen how the emerging form of the comic strip during the period of the newspaper wars tended to serialize the autistic, repetitive behaviors of their lead characters, whose mechanical compulsions and odd quirks were actually quite similar to those of Töpffer's creations sixty years earlier. *Little Sammy Sneeze* parodies these characters who, day after day, ceaselessly perform their own specialty like automatons: Maud the Mule's refusal to advance, no matter what it costs her master; Little Jimmy systematically forgetting the missions with which he is charged; Alphonse and Gaston entangled in their etiquette; the Katzenjammer Kids engaged in their nth gag against the Captain; and so on.

Little Sammy Sneeze pushed this principle toward its most absurd limit and underscored the obvious family resemblance between gags of this type and cinematographic pranks. To begin with, McCay took up the six-panel grid structure of A. B. Frost's earliest chronophotographic

parodies (see chapter 6) and reinforced the cinematic connotation by subjecting Little Sammy to a perpetual sneeze—an affliction that referred to a famous article published ten years earlier in *Harper's Weekly*, "The Kinetoscopic Record of a Sneeze" (Phillips 1894), in which the phases of a sneeze were illustrated with eighty-one photographs taken one-fortieth of a second apart.

The somatosensory system and primary bodily functions were recurrent themes in McCay's work (Nemo's dreams, Henrietta's hunger, Sammy's sneezes, the Rarebit Fiend's dreams), and the *Harper's* article must have been of particular interest to him. It describes the sneeze as an involuntary physiological reflexive action whose sequence is invariable. To highlight the mechanical aspect of the phenomenon, McCay scrupulously breaks down Sammy's sneeze into five identical key phases in each episode, while other characters are shown pursuing some simple, leisurely activity around the little boy. The nasal eruption always occurs in the fifth panel, disrupting the chess game, the dinner, the birthday party. The sixth panel shows the immediate consequences for Sammy: usually, a kick in the ass.

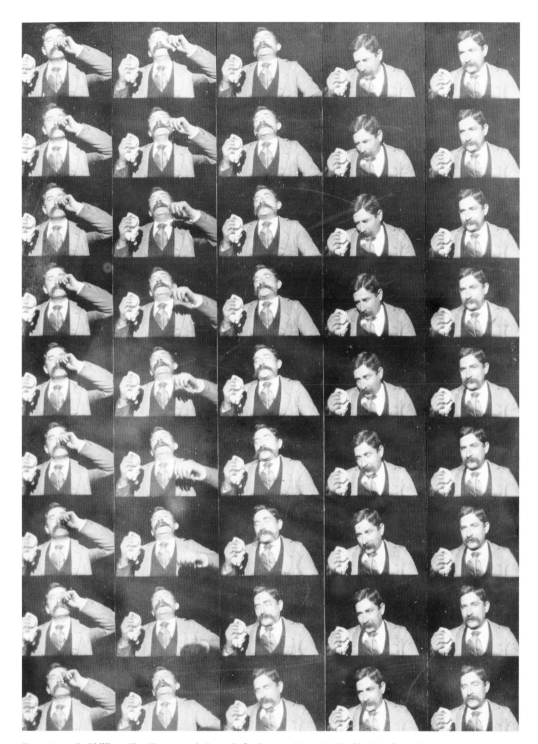

Figure 8.3 **B. Phillips,** *The Kinetoscopic Record of a Sneeze,* **Harper's Weekly, March 3, 1894.**

The immutable formula of *Little Sammy Sneeze* is a sarcastic comment on the mischievous gag. The sneeze, which the *Harper's* article describes as a physiological chain reaction, takes the place of the rascal's prank, which, once loosed on the victim, precipitates his or her reality into chaos. In other words, the sense of galloping causality—on which the rhetoric of such gags depends entirely—is lowered, in *Sammy,* to the level of an irrepressible need to sneeze.

The first lesson of this parody is already apparent: McCay suggests, ironically, that Sammy—like the Katzenjammer Kids, like Maud the Mule, like Little Jimmy—is nothing but a puppet pulled by mechanical forces, an optical toy playing in an endless loop. Every episode opposes this artificial loop to the open-ended variety of everyday life.

Little Sammy raises deep issues about the living body in action. Created only a few years

Figure 8.4 **Winsor McCay,** *Little Sammy Sneeze*, **Hachette version, 1905.**

before McCay's pioneering venture in film animation, the series opens a window on his early thoughts about the cinematographic medium in its relation to life and movement. His particularly strict use of the chronophotographic grid in *Little Sammy* suggests that he was, at that time, turning back to a question that Muybridge, Eakins, and Frost had already explored in the 1880s (see chapter 6): in the mechanical recording of a living creature in motion, what can the gap between two images teach us about *life*?

As it happened, the author of the *Harper's* article made an observation about the sneeze that was clearly relevant to the problem; he noted "a curious phenomenon . . . in which something like a collapse occurs during no more than a fraction of a second" (Phillips 1894). In *Little Sammy*, this short "epileptic" gap in consciousness (which afflicts the sneezer just before the explosion) is always located in the same place: between the fourth and fifth panels, just before the explosive culmination of the sneeze and the sudden disintegration of everyday life. It is worth noting here that the six-panel breakdown was a frequent formula for wordless slapstick gags, and that the fifth image was the traditional site for pandemonium. In comic strips of the period,

the interval between the fourth and fifth panels was thus an established and particularly significant interval—a discontinuity—which had its exact counterpart in prank-driven films, whose chain reactions inexorably led to a similar tipping point the instant just before the trap was sprung and the soot balloon exploded, or water suddenly gushed from the hose.

In early cinema, when films were still constituted in one shot, such instantaneous transitions between order and chaos operated as an internal (diegetic) form of editing—a puncture in the continuous flux of the shot, marking a clear, symbolic *cut*. The instantaneous disappearances in Georges Méliès's films provoked the same magical jump by momentarily stopping the camera in the middle of an action and stealthily changing an element of the scene "between two frames." More than a century later, the proliferation of special-effects movies show that the fascination for this powerful (and slightly menacing) primary form of editing is still intact.

Under the guise of apparent simplicity, McCay's *Little Sammy Sneeze* raised a principal question for understanding the cinematographic language. In his book *In the Blink of an Eye*, Walter Murch, one of the greatest film editors

Figure 8.5 **Thomas Rowlandson, *The English Dance of Death*, 1815.**

Like the figure of Death in Hans Holbein's *Danse Macabre* (here, in Rowlandson's version), the sneeze of Little Sammy un-expectedly interrupts the chronicle of an ordinary daily activity. Filmed pranks were presented in a similar fashion, with the quick springing of a trap (or a water hose) that provoked the instantaneous disintegration of a familiar reality. As in some of Georges Méliès's works (where cuts were made to create magical effects like decapitations or the appearance of ghostly apparitions), the instantaneous shift from order to disorder in these single-shot short films gave an unsettling, morbid value to the idea of jumping between two planes of reality.

of our time, wonders about the mysterious facil-ity with which we operate in the discontinuous space-time of an edited film (Murch 2001, 5). If there is nothing in life to prepare us for this kind of experience, how can such a segmented patch-work function so well?

Murch argues that we are always in the pro-cess of "editing" the film of our own existence, and that the unconscious blinking of our eyes, which so often punctuates our thoughts, repre-sents one of the most obvious symptoms of this editing process (Murch 2001, 57–63). In fact, a simple experiment in front of a mirror is enough to observe the phenomenon: if you stare at your left eye then swiftly switch your gaze to the right, both eyes appear to remain immobile. Your brain has mysteriously "cut" the transition movement.

Little Sammy Sneeze suggests the same physi-ological answer that Walter Murch provides to the conundrum. If Murch is correct, if the way our mind "edits" reality explains the facility with which we accept the discontinuities of an edited film, it also means that reading comics is closer to the experience of cinema than we expected,

because our minds surely operate in the same manner—by way of small "collapses"—when we move from one panel to the next. This physiolog-ical interpretation of the phenomenon is exactly what *Little Sammy Sneeze* suggests, with a warn-ing: the shift between two shots or between two panels is, in fact, a minor form of epilepsy, which, at maximum impact, could throw everyday life into absolute chaos.

In his biography of Winsor McCay, John Canemaker judges Sammy "an unappealingly de-signed character," dull witted, gauche, rude, and unable to learn anything (Canemaker 1987, 65). The remark is, of course, completely beside the point. *Little Sammy Sneeze* is a witty allegory of the mechanical forces that constantly push life toward oblivion. In other words, it is an allegory of death, similar in essence to Hans Holbein's *Danse Macabre*, which depicts Death's sudden appearance in various scenes of contemporary life. (The link will appear less incongruous if we recall that another series by McCay paid an explicit tribute to John Bunyan's *The Pilgrim's Progress*.) Death is, of course, the most radical

Figure 8.6 **Winsor McCay,** *Gertie the Dinosaur*, **1914.**

interval that can separate two frames in our sequential lives—the most catastrophic loss of order and information imaginable.

Yet the mystery that McCay really wanted to tackle was not about death but about life. How does one breathe *life* into comic art? As the story goes, it was upon seeing one of his son's flipbooks that he came to experiment with animated movies, a pioneering technique that created the illusion of life by *adding*—not subtracting—information between two drawings. McCay, of course, knew that he was not the first to be interested in that question. He was a great admirer of A. B. Frost, who used the visual differences between successive panels as temporal, dynamic cues to describe the arc of action, vitality, and emotion that his characters underwent (see chapter 6). Muybridge's pioneering work, on which Frost's was based, appeared to lead straight to film animation. Ultimately, the Muybridge-Frost lineage led to McCay's crowning achievement in the field: the operatic consecration of animated life that was *Gertie the Dinosaur* (1914).

Before experimenting with film animation, however, McCay had explored yet another way of turning the "fatal interval" of mischievous pranks into something more positive. In *Little Nemo*, his most famous comic-strip creation, a major discontinuity occurs between the collapsing dream and the awakening in the last panel: the dream ends so that daily routines can resume until next Sunday's supplement, where the

dream is magically restored—an unending cycle that mimics the diurnal rhythm of human life.

Unlike the little automatons that repeat the same destructive mechanical scripts as if they were trapped in the regular clatter of a film projector, *Little Nemo* explores the ever-changing interior landscape of a lively imagination. But what makes the series so special in the whole tradition of comic art is, above all, its ambition to put beauty (in the Hogarthian sense) on center stage. *Nemo* is a truly baroque labyrinthine voyage, filled with serpentine lines, kaleidoscopic effects, perforated panels, and flamboyant architecture. For the first time, in *Nemo*, a conception of beauty that had been haunting comic artists like a guilty secret since the eighteenth century became explicit. Before that, the lively arabesque of Hogarth's "line of beauty" had always been lingering in the aisles, a counterpoint to the cartoonist's denunciation of pretentious academism and mechanical stupidity; in *Little Nemo*, it proudly takes charge of the show, and it is only because McCay's baroque streak was essentially naïve and honest that the series falls just short of being academic. A self-educated virtuoso who had spent his formative years in the dime museums and circuses of Cincinnati and Chicago, Winsor McCay was an ambitious but not a pretentious man.

Little Nemo didn't emerge full-fledged from McCay's imagination alone. Thematically, the series was inspired by the traditional British

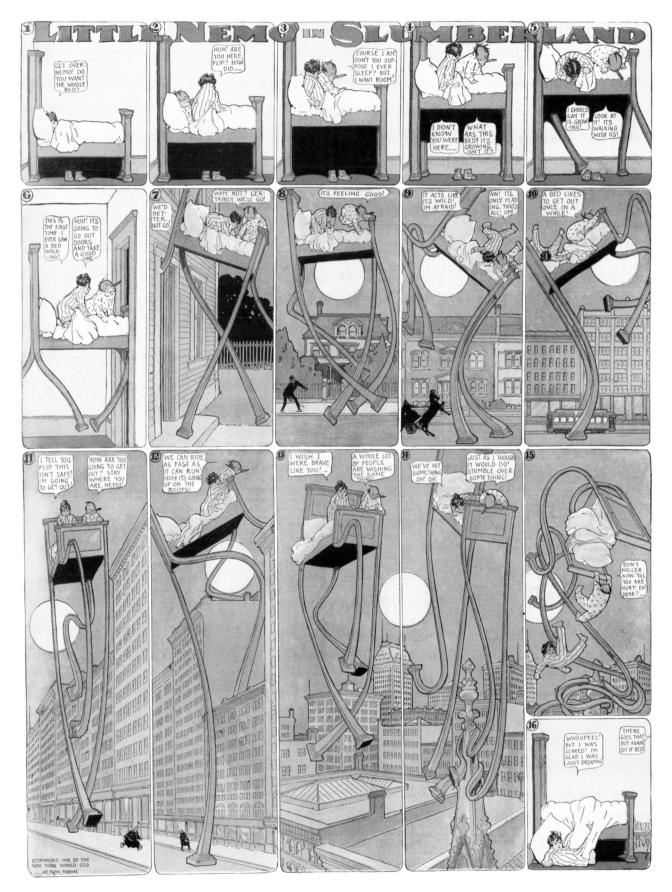

Figure 8.7 **Winsor McCay, *Little Nemo in Slumberland*, *New York Herald*, July 26, 1908.**

Figure 8.8 **Rip, *Un projet téméraire*, original art. *Images Enfantine*, Ancienne Maison Quantin, series no. 5, 1888. Source © CIBDI.**

I would like to particularly thank Gilles Ciment, who first noted the similarities between *Little Nemo* and certain pages in the Fonds Quantin and who has allowed us to reproduce this document here. Thanks also to Antoine Sausverd and Michel Kempeneers for their helpful articles and for their work on the Fonds at the Cité internationale de la bande dessinée et de l'image.

Christmas pantomimes, which comic artists had been celebrating with illustrations and picture stories in every winter supplement of the *Illustrated London News* and the *Graphic* for half a century. Slumberland's magical world of fairies, giants, magicians, and princesses was an unmistakable tip of the hat to the London theatrical extravaganzas, whose lavish production values were matched by McCay's virtuoso treatment of trompe l'oeil architecture, fantastic casts, costumes, and special effects. The classy reference to this very British genre of entertainment was certainly not lost on the contemporary American reader. Another European influence, however, went unnoticed—and for a very long time. It has only been discovered recently that a number of *Little Nemo*'s early pages (including the very first one) were inspired by the layouts and color schemes of the picture stories published by the Maison Quantin in Paris in the 1880s and 1890s (Sausverd and Kempeneers n.d.). In the beautifully produced (and expensive) Quantin albums *Images Enfantines*, the narratives were bland, but the artists frequently integrated the layouts of their picture stories into elegant geometric structures, some of which McCay emulated in the first episodes of *Little Nemo*—as he emulated their rich and subtly graduated colors schemes.

To take inspiration in European art was, typically, an institutional strategy on McCay's part, a way to position the *New York Herald* well above the indigenous kind of comic strips published by popular concurrence. *Little Nemo* was conceived by a brilliant craftsman who probably saw as the challenge of his artistic career the chance to create, with the full support of his newspaper, a project specifically designed to strike the public with awe. A more obvious—and crucial—model in this endeavor was the Chicago World's Columbian Exhibition of 1893, the most ambitious institutional project of the era, whose baroque architecture was a constant leitmotif in *Little Nemo*.

Notwithstanding the French influence on the early episodes, the one level at which *Little Nemo* is completely original and personal is that of McCay's page composition; his ever-changing kaleidoscopic layouts seem driven by a logic of their own. If their inventiveness was meant to contrast with the repetitive, metronomic beat of *Little Sammy Sneeze* (itself inspired by Edison's Kinetoscope), what was the engine behind *Nemo*? The answer lies in the overt references to the Columbian Exhibition. McCay's ambition in *Little Nemo* was clearly to go beyond the fundamental dichotomies of the comic tradition (academic art versus comic art, creation driven by institution versus creation driven by attraction) and resolve them in a truly baroque way. A shrewd entertainer, he knew that a display of institutional and academic hubris was not enough to captivate the crowds. Even the Columbian Exhibition would have failed miserably without the visceral excitement of its Ferris wheel and roller coasters, and the lively patchwork of exotic styles (the mosques, Viennese streets, South Sea island huts, pagodas) displayed along the exhibition's Midway, the prototype of all amusement parks (Adams 1991, 19–40). This was a model that an ambitious artist/entrepreneur could live with, a model that went beyond traditional comic art while losing nothing of its visual excitement and dynamism—a truly neobaroque form of contemporary entertainment.

In *Little Nemo*, McCay sets a new challenge for the emergent comic strip form: attraction for attraction, why not change the passive cinematographic model for the lively sensations offered by Coney Island? In *Sammy Sneeze*, the repetitive grid of six near-identical frames put the reader into the role of a spectator watching a mechanical gag on a screen; *Little Nemo* throws its reader into a fluid first-person space undergoing perpetual transformation. This was the whole point of McCay's ever-changing layouts: to diagrammatize the experience of an amusement park, where everything conspires to provoke uncontrolled muscular reactions and propel the public into comical and disordered states with moving floors, spinning barrels, and so forth (Adams 1991, 45). From its very first pages, Nemo's Slumberland was meant to provide such sensation—vertigo, dizziness, falls, racing, slipping—and transform the reading process into a personal, immersive adventure.

The inner world of somatic experience was primordial for McCay, who explored this theme at length in his *Dream of the Rarebit Fiend*, probably his most intimate creation. The visual language he developed in *Little Nemo* was the ideal vehicle for fueling this very personal theme with

high-culture motives and high-octane, visceral entertainment. Each *Nemo* panel was adroitly composed to simulate the capture of a fleeting instant (objects and characters were often caught just as they were leaving the frame) and to sharply contrast with its neighboring panel (with solid masses and empty spaces alternating rhythmically). Like Frost before him, McCay used these subtle visual clues to enhance the stroboscopic effect of cutting from image to image by discrete, instantaneous jumps. But the complex, dynamic layouts of McCay's pages raised Frost's original conception to another level. The "epileptic" gap between two consecutive frames no longer referred to the external principle of studying movement with the help of a chronophotographic or Kinetoscopic apparatus. *Little Nemo in Slumberland* suggested a much more intimate physiological phenomenon: the subjective, kaleidoscopic editing of sensations produced by one's own body during a visit to an amusement park.

• • •

"Sequential art" is a purely axiomatic concept that obviously captures very important features of the modern comic strip in the age of sequential recording machines, but is of no real help to us in understanding the inception, around 1900, of an audiovisual stage on paper. The shift cannot be summed up in a few formal axioms. To understand it, we must consider the deep roots of graphic culture and comic tradition, as well as purely circumstantial factors like the peculiar context of the newspaper wars.

During a short period, around 1900, production was dictated exclusively by the need to optimize the commercial impact of comic supplements. Relying on trial and error and the logic of attraction, the artists working at the time for the Pulitzer and Hearst presses compiled a compact, streamlined "package" of heterogeneous traits ("cuteness," the mischievous prank theme, serialized characters, the speech balloon, the repetitive grid), each of which had, as we have seen, its peculiar cultural pedigree and its timely raison d'être (in particular as a response to the popularization of sequential recording devices such as the cinematograph and the phonograph). The rather barbaric form that resulted from this period of tinkering (roughly, between 1896 and 1905) would later prove to be extremely robust and productive in a century teeming with new audiovisual media (radio, talking movies, television). In the decades to come, however, the popular press remained the comic strip's most vital environment. After the initial episode of "gleeful anarchism," a long period of institutionalization followed during which the habit-building "funny folks" played a decisive role in the commercial success and circulation of American newspapers (see chapter 5).

However, the fact that ambitious and creative artists like Winsor McCay could so quickly come up with rich alternatives to the simple slapstick gag format proves that comic art's reconfiguration around 1900 was much more complex than the prototypical form of the mischievous prank might suggest at first sight.

The resilience of the comic strip in the twentieth century, its capacity to adapt and innovate in a rapidly evolving media world, cannot be explained by the 1900 transition to the audiovisual stage on paper alone. To understand the form's inner dynamism and full potential, we must recognize its deep cultural continuity with the comic art tradition of the eighteenth and nineteenth centuries and its capacity to perform as a powerful semiotic laboratory. Self-propelled characters who appear to act and speak on their own may have invaded the "audiovisual stage on paper," but it was always very much part of their charm and magic that their puppeteer would often make his presence known by displaying a brand of reflexive and digressive irony whose roots extended back to the eighteenth-century experimental comic novel. *Little Nemo*'s collapsing panels, like McCay's live interaction with the animated *Gertie*, revealed an even deeper undercurrent in the comic tradition, a typically baroque impulse to perforate the frame and entrap the spectator in a labyrinthine world of wistful illusion (Ndalianis 2004).

In the romantic and Victorian periods, the comic artist was a polygraphic interpreter who responded to every "new way of seeing" with ingenious stylizations and schematizations. This kind of work is still a significant part of the creative cartoonist's job description, especially in the modern form of the graphic novel, which connects seamlessly to the rich nexus of graphic solutions forged in the nineteenth century.

Figure 8.9 **Winsor McCay,** *Little Nemo in Slumberland*, *New York Herald*, **September 23, 1906.**

Figure 8.10 **Saul Steinberg,** *Le Labyrinthe* **(Paris: Éditions Delpire, 1960).**

The best comic artists of the twentieth and twenty-first centuries have continued to focus on the central problem that pushed Hogarth, Töpffer, Doré, Corbould, Barnard, Frost, McCay, and many others to their greatest work: how do we report on the sequential world of action without condemning life itself to a one-dimensional prison? How do we preserve life's point of view, its infinite range and infinite variety, in a medium that playfully pretends to adopt the rhetoric of the modern industrial world? Given a mouse, a cat, and a brick, and the unstoppable flux of progress, how do we wrap up the antics of cute (but utterly mechanical) graphic pets in the arabesque of a lively digression?

Figure 8.11 **George Herriman, *Krazy Kat*, May 14, 1916.**

Bibliography

Adams, J. A. 1991. *The American Amusement Park Industry.* Boston : Twayne Publishers.

Alexandre, A. 1892. *L'art du rire et de la caricature.* Paris: Quantin, Librairies-Imprimeries Réunies.

Alexandre-Bidon, D. 1990. "Ecrire le son au Moyen Âge." *Entre l'oral et l'écrit, ethnologie française* 20 (July–September): 319–327.

Anonymous. 1820. "Sur les physionomies imitées et sur les rapports de la physiognomonie avec l'art du comédien." In Lavater, *L'art de connaître les hommes.*

Austin, G. 1966. *Chironomia; or, a Treatise on Rhetorical Delivery.* Carbondale: Southern Illinois University Press. First published in 1806.

Bakhtin, M. 1982. *The Dialogic Imagination: Four Essays.* Edited by Michael Holquist. Austin: University of Texas Press.

Baudelaire, C. 1999. "Quelques caricaturistes étrangers." In *Ecrits sur l'art.* Paris: Le livre de poche. First published in 1857.

Beerbohm, R. L., L. De Sa, and D. Wheeler. 2003. "Töpffer in America." *Comic Art*, no. 3. Oakland: Buenaventura Press.

Beiman, N. 1987. "The Comic Zoo of T. S. Sullivant." *Nemo: The Classic Comics Library*, no. 26 (September): 12–40. Seattle: Fantagraphics.

Bender, J., and M. Marrinan. 2010. *The Culture of Diagram.* Stanford: Stanford University Press, 2010.

Bergson, H. 1900. *Laughter: An Essay on the Meaning of the Comic.* Translated by Cloudesley Brereton and Fred Rothwell. Project Gutenberg, July 26, 2009. Http://www.gutenberg.org/files/4352/4352-h/4352-h.htm.

Blackbeard, B. 1995. *R. F. Outcault's The Yellow Kid.* Northampton, Mass.: Kitchen Sink Press.

Buchanan-Brown, J. 2005. *Early Victorian Illustrated Books: Britain, France and Germany, 1820–1860.* London: British Library; New Castle, Del.: Oak Knoll Press.

Canemaker, J. 1987. *Winsor McCay: His Life and Art.* New York: Abbeville Press.

Crafton, D. 1995. "Pie and Chase: Gag, Spectacle, and Narrative in Slapstick Comedy." In *Classical Hollywood Comedy*, edited by Kristine Brunovska Karnick and Henry Jenkins, 106–119. New York: Routledge.

Crary, J. 1992. *Techniques of the Observer: On Vision and Modernity in the Nineteenth Century.* Cambridge: MIT Press.

Donald, D. 1996. *The Age of Caricature: Satirical Prints in the Reign of George III.* New Haven: Yale University Press.

Engel, J. J. 1785. *Ideen zu einer Mimik.* 2 vols. Published in French as *Idées sur le geste et l'action théâtrale*, Paris, 1795. Reprinted, Paris: Slatkine Reprints, 1979.

Fairholt, F. W. 1854. *A Dictionary of Terms in Art.* London: Virtue, Hall, and Virtue.

Fanning, C. 2009. "Sterne and Print Culture." In Keymer, *The Cambridge Companion to Laurence Sterne.*

Fielding, H. 1981. Preface to *Joseph Andrews.* London: Penguin Books. First published in 1742.

Foster, K. A. 1997. *Thomas Eakins Rediscovered.* New Haven: Yale University Press.

Fougasse. 1956. *The Good-Tempered Pencil.* London: Max Reinhardt.

Fowler, A. 1982. *Kinds of Literature.* Oxford: Clarendon Press.

Freeman, R. 1948. *English Emblem Books.* London: Chatto and Windus.

Frost, A. B. 2003. *Stuff and Nonsense.* Seattle: Fantagraphics; Angoulême, France: Éditions de l'An 2.

Gaines, M. C. 1942. "Narrative Illustration: The Story of the Comics." *Print: A Quarterly Journal of the Graphic Arts* 3, no. 2 (Summer).

Gates, A. I. 1921. "The Habits that Hold the Reader." *Circulation* (September).

Gautier, L. 1974. *Un bouquet de lettres de Rodolphe Töpffer.* Lausanne: Payot.

Gitelman, L. 2003. "Souvenir Foils: On the Status of Print at the Origin of Recorded Sound." In *New Media, 1740–1915*, edited by Lisa Gitelman and Geoffrey B. Pingree. Cambridge: MIT Press.

Gombrich, E. H. 2006. *The Preference for the Primitive.* London: Phaidon Press.

Groensteen, T., and B. Peeters. 1994. *Töpffer, l'invention de la bande dessinée.* Paris: Hermann.

Gunning, T. 1995. "Crazy Machines in the Garden of Forking Paths: Mischief Gags and the Origins of Film Com-

edy." In *Classical Hollywood Comedy*, edited by Kristine Brunovska Karnick and Henry Jenkins, 87–105. New York: Routledge.

Harper, C. 1892. *English Pen Artists To-Day*. London: Percival.

Hogarth, W. 1955. *The Analysis of Beauty*. Edited by Joseph Burke. Oxford: Clarendon Press. First published in 1753.

———. 1997. *The Analysis of Beauty*. Edited by Ronald Paulson. New Haven: Yale University Press.

Holbach, Baron P.-H. T. d'. 1770. *Système de la Nature ou des loix du monde physique et du monde moral*. Vol. 1. London: n.p.

Ivins, W. M. 1996. *Print and Visual Communication*. Cambridge: MIT Press. First published in 1953.

Jobard, M. 1857. *Les nouvelles inventions aux expositions universelles*. Brussels: E. Flatau.

Kaenel, P. 1996. "La muse des croquis." In Maggetti, *Töpffer*.

———. 2005. *Le métier d'illustrateur*. Geneva: Droz.

Kayser, W. 1957. *The Grotesque in Art and Literature*. New York: McGraw-Hill.

Keymer, T., ed. 2009. *The Cambridge Companion to Laurence Sterne*. Cambridge: Cambridge University Press.

Kunzle, D. 1973. *The History of the Comic Strip*. Vol. 1, *The Early Comic Strip*. Berkeley: University of California Press.

———. 1984. "Histoire de Mr Cryptogame (1845); une bande dessinée de Rodolphe Töpffer pour le grand public." *Genava* 32.

———. 1990. *The History of the Comic Strip*. Vol. 2, *The Nineteenth Century*. Berkeley: University of California Press.

———. 1992. "*Mr. Lambkin*: Cruikshank's Strike for Independence." In Patten, *George Cruikshank: A Revaluation*.

———. 1998. "Precursors in American Weeklies to the American Newspaper Comic Strip: A Long Gestation and a Transoceanic Cross-breeding." In *Forging a New Medium: The Comic Strip in the Nineteenth Century*, edited by Pascal Lefèvre and Charles Dierick. Brussels: VUB University Press.

———. 2007. *Father of the Comic Strip: Rodolphe Töpffer*. Jackson: University Press of Mississippi.

Lavater, G. 1820. *L'art de connaître les hommes par la physionomie*. Vol. 7. Paris: Depélafol.

Lessing, G. E. 1754. *Bibliothèque théâtrale*. Vol. 1.

———. 1853. *Laocoon: An Essay on the Limits of Painting and Poetry*. Translated by E. C. Beasley. London: Longman, Brown, Green, and Longmans.

Lorenz, K. 1971. "Part and Parcel in Animal and Human Societies." In *Studies in Animal and Human Behavior*, vol. 2. Cambridge: Harvard University Press.

Maggetti, D., ed. 1996. *Töpffer*. Geneva: Skira.

Mainardi, P. 2011. "From Popular Prints to Comics." *Nineteenth Century Art Worldwide* 10, no. 1 (Spring). Http://www.19thc-artworldwide.org.

Marshall, R. 1983. "Penmen of the Past: T. S. Sullivant." *Nemo: The Classic Comics Library*, no. 1 (June): 70–74. Seattle: Fantagraphics.

———. 1989. *America's Great Comic Strip Artists*. New York: Abbeville Press.

Mathews, N. M. 2005. *Moving Pictures: American Art and Early Film, 1880–1910*. Manchester, Vt.: Hudson Hills Press.

McCardell, R. L. 1905. "Opper, Outcault, and Company: The Comic Supplement and the Men Who Make It." *Everybody's Magazine*, May 10, 763–772.

Menninghaus, W. 1999. *In Praise of Nonsense: Kant and Bluebeard*. Translated by Henry Pickford. Stanford: Stanford University Press.

Moretti, F. 2005. *Graphs, Maps, Trees: Abstract Models for Literary History*. London: Verso.

Murch, W. 2001. *In the Blink of an Eye*. 2nd ed. Los Angeles: Silman-James Press.

Muzelle, A. 2006. *L'Arabesque: La théorie romantique de Friedrich Schlegel dans l'Athenaüm*. Paris: Paris-Sorbonne University Press.

Ndalianis, A. 2004. *Neo-Baroque Aesthetics and Contemporary Entertainment*. Cambridge: MIT Press.

Paschall, W. D. 2001. "The Camera Artist." In Sewell, *Thomas Eakins*.

Patten, R. L., ed. 1992. *George Cruikshank: A Revaluation*. Princeton: Princeton University Press. First published in 1974.

Paulson, R. 1972. *Rowlandson: A New Interpretation*. London: Studio Vista, 1972.

———. 1974. "The Tradition of Comic Illustration from Hogarth to Cruikshank." In Patten, *George Cruikshank: A Revaluation*.

———. 1991. *Hogarth, "The Modern Moral Subject," 1697–1732*. New Brunswick: Rutgers University Press.

———. 1996. *The Beautiful, Novel, and Strange: Aesthetics and Heterodoxy*. Baltimore: Johns Hopkins University Press.

Phillips, B. 1894. "The Kinetoscopic Record of a Sneeze." *Harper's Weekly*, March 3.

Reed, H. M. 1993. *The A. B. Frost Book*. Charleston, S.C.: Wyrick and Company.

Sangsue, D. 1987. *Le récit excentrique: Gautier, de Maistre, Nerval, Nodier*. Paris: José Corti.

Sausverd, A., and M. Kempeneers. n.d. "Inventory of the Plates of the Quantin's 'Imagerie Artistique.'" *SIGNs: Studies in Graphical Narratives*, supplement 1/01. Pisa: Felici Editore.

Sewell, D., ed. 2001. *Thomas Eakins*. Philadelphia: Philadelphia Museum of Art.

Shaftesbury, A., Earl of. 1713. *Second Characters, or the Language of Form*.

———. 1790. *Characteristics*. Vol. 3. Basel: Tourneisen and Legrand. Available online at Google Books.

Schank, R. C., and R. P. Abelson. 1977. *Scripts, Plans, Goals, and Understanding: An Inquiry into Human Knowledge Structures*. Hillsdale, N.J.: Lawrence Erlbaum.

Smolderen, T. 2005. "Thackeray and Töpffer: The Weimar Connection." *International Journal of Comic Art* 7, no. 2 (Fall/Winter).

Töpffer, R. 1837. "Notice sur l'histoire de Mr Jabot." *Bibliothèque universelle de Genève*, no. 18 (June): 334–337. Reprinted in Groensteen and Peeters, *Töpffer, l'invention de la bande dessinée.*

———. 1839. "Notice sur la contrefaçon de l'histoire de Mr Jabot." *Bibliothèque universelle de Genève*, no. 20 (April): 342–343. Reprinted in Groensteen and Peeters, *Töpffer, l'invention de la bande dessinée.*

———. 1983. *Du progrès dans ses rapports avec le petit bourgeois.* Bazas, France: Le temps qu'il fait. First published in 1835.

———. 1998. *Réflexions et menus propos d'un peintre genevois, ou Essai sur le beau dans les arts.* Paris: École nationale supérieure des beaux-arts, 1998. First published in 1848.

———. 2004. *Correspondance complète.* Vol. 2. Edited by Jacques Droin. Geneva: Droz.

Vischer, F. T. 1845. *Die Jahrbücher der Gegenwart und ihre Helden.* Stuttgart: Julius Weiss.

Von Goez, F. 1783. *Lenardo und Blandine.* Augsburg: n.p

Index

The Dispersion of the Works of all Nations

Designed & Etched by George Cruikshank